THE IDEALS GUIDE TO

HISTORIC

PLACES OF WORSHIP

IN THE UNITED STATES

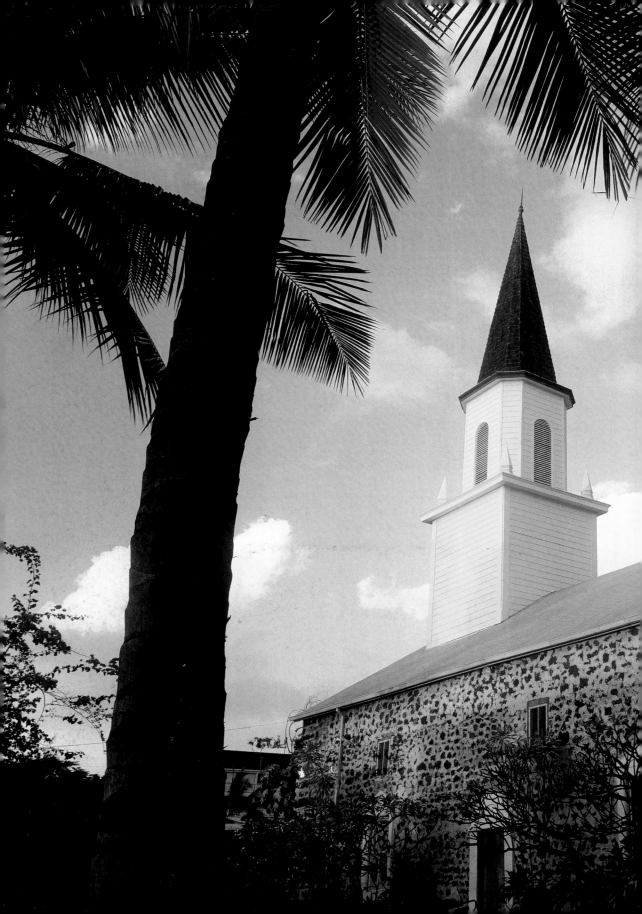

THE IDEALS GUIDE TO

HISTORIC
PLACES OF WORSHIP
IN THE UNITED STATES

BY NANCY J. SKARMEAS

IDEALS PRESS
NASHVILLE, TENNESSEE

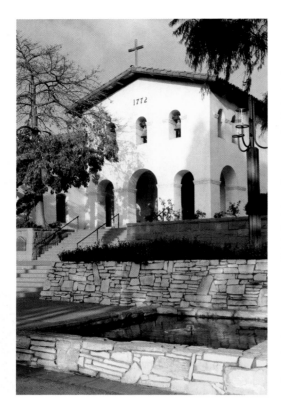

ISBN 0-8249-4304-X

Published by Ideals Press
An imprint of Ideals Publications
A division of Guideposts
535 Metroplex Drive, Suite 250
Nashville, Tennessee 37211
www.idealsbooks.com

10 9 8 7 6 5 4 3 2 1

Publisher, Patricia A. Pingry
Editor, Lisa C. Ragan
Art Director, Eve DeGrie
Designer, Marisa Calvin
Copy Editor, Katie Patton

Library of Congress Cataloging-in-Publication Data

Skarmeas, Nancy J.
 The Ideals guide to historic places of worship in the United States / by Nancy J. Skarmeas
 p. cm.
 ISBN 0-8249-4304-X (alk. paper)
 1. Church buildings—United States. I. Title: Guide to historic places of worship in the
 United States. II. Title.
 BR565.R34 2004
 277.3—dc22
 2004005817

Front cover photograph: Princeton University Chapel; photo by R. Krubner/H. Armstrong Roberts
Back cover photograph: San Francisco de Asís Church; photo by R. Kord/H. Armstrong Roberts
Title page photograph: Mokuaikaua Church; Jeff Gnass Photography
Photograph, this page: Mission San Luis Obispo; Ed Cooper photo

Color separations by Precision Color Graphics, Franklin, Wisconsin
Printed and bound in the U. S. A. by RR Donnelley

Note: Hours, prices, and site details in this guide are subject to change. Please call sites for the most current information prior
to planning your travel.

TABLE OF CONTENTS

INTRODUCTION

So much of America's national story can be read through her houses of worship. There are the obvious examples, like Boston's Old North Church, where two lanterns hung in the steeple on an April night in 1775 signaled the start of the American Revolution, or the Alamo, which witnessed the heroism of many brave Texans during their battle for independence from Mexico. But there are countless other stories, less well known, like that of the Kansas church settled by abolitionists bent upon making Kansas territory free from slavery, or of the mission churches of Montana, or of the Virginia church where Memorial Day was born. In the annals of our diverse American places of prayer can be found stories of faith, courage, and heroism, of pioneers and soldiers, of presidents and poets, of ordinary people and extraordinary times. Travelers keen on gaining a unique perspective on the history of any particular area of America do well to consider the local churches.

Of course, the number of churches with a claim to a place in our history is far greater than any one volume could include. Inevitably, a collection such as this cannot be comprehensive; but here are gathered a great majority of our nation's most historic houses of worship. Each has played a role in a moment or era of American history. Some have counted great heroes and leaders among their congregations; others have rung with the words of great orators. Some were swept up in the momentous events that swirled around them; others changed the course of those events. And some have survived so well through the ages that they have become historical treasures in their own right, priceless reflections of times gone by.

From the churches of our Puritan forefathers to the houses of worship that gave inspiration to the founders of our nation, from churches that were touched by the American Revolution and the Civil War to those that helped shape the Civil Rights movement, this volume pays tribute to the prominent role that our American churches, synagogues, cathedrals, temples, tabernacles, and meetinghouses have always played in our great national story and to the wonderful treasures these houses of worship offer to travelers with a taste for history.

EXPLANATORY NOTES

Since the great majority of houses of worship included in this book have been honored as National Historic Sites, that information has been omitted. In addition, most every place of worship welcomes visitors at worship services. Call the sites to obtain current times for worship services.

■ The green squares on the maps represent the general location of the places of worship. Although interstates, federal highways, and some state highways are sometimes included for orientation, space limitations prevent precise directions. In some states, the map shows only the area of the state that includes the place of worship.

NORTHEAST

Historic churches are not difficult to find in the cities and towns of the Northeastern United States. There are the churches of the Puritans—simple, unadorned, white-spired gems that have survived the years to become the classic evocation of New England. There are the houses of worship that played their roles, large and small, in the battle for American independence. There are churches whose pulpits echoed with the words of the great abolitionists and whose quiet places once offered solace to slaves escaping on the Underground Railroad. From the village greens of Vermont to the bustling urban centers of Boston and New York City, the Northeast is rich with places of worship that played a significant role in the history of America.

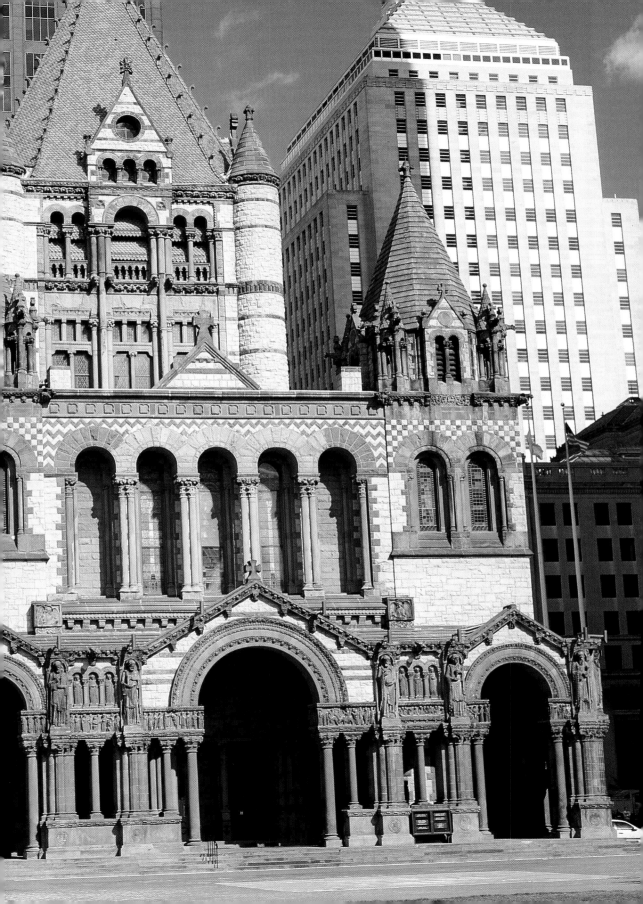

NEW HAMPSHIRE

& VERMONT

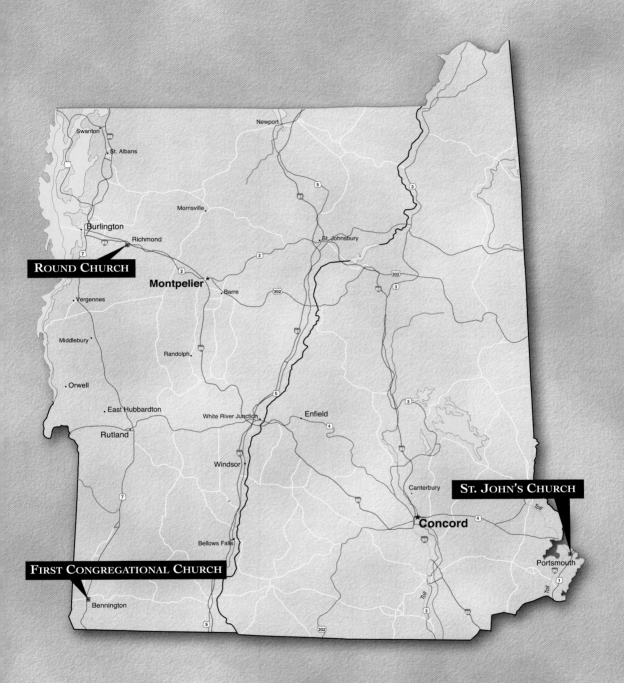

Swanton

St. Albans

Newport

Morrisville

Burlington

Richmond

St. Johnsbury

ROUND CHURCH

Montpelier

Barre

2

302

5

Vergennes

91

302

Middlebury

Randolph

89

Orwell

5

East Hubbardton

White River Junction

Enfield

4

Rutland

Windsor

91

Canterbury

3

ST. JOHN'S CHURCH

7

89

Concord

93

4

Toll

Bellows Falls

Portsmouth

FIRST CONGREGATIONAL CHURCH

95

Toll

Bennington

3

93

5

202

Toll

1

0 100 Miles

0 100 KM

St. John's Church

101 Chapel Street, Portsmouth, New Hampshire 05801

PHONE: 603-436-8283

HOURS: Daily

ADMISSION: No fee charged

WHEELCHAIR ACCESSIBLE: Limited access

WEBSITE: www.stjohnsnh.org

St. John's Church was built in 1807 to replace Queen's Chapel, which was destroyed by fire in 1806. The church contains a collection of seventeenth- and eighteenth-century antiques, including a 1745 steeple bell brought from Nova Scotia by colonial soldiers. After the bell was damaged by the 1806 fire, it was recast by Paul Revere. One of St. John's pews bears a plaque commemorating its most famous parishioner, Daniel Webster. St. John's also holds one of the four American copies of what is known as the Vinegar Bible, so named due to a misspelling of the word "vineyard" as "vinegar." Inside the church visitors can see an eighteenth-century baptismal font, several original box pews, and the Brattle Organ. Imported from England prior to the year 1708, the Brattle Organ is the oldest functioning pipe organ in the United States. St. John's also owns a set of communion silver that was presented to Queen's Chapel by Queen Caroline and is still used on special occasions.

First Congregational Church (Old First Church)

Monument Avenue, Bennington, Vermont 05201

PHONE: 802-447-1223

HOURS: Saturday and Sunday, Memorial Day through June; daily, July through mid-October

ADMISSION: No fee charged

WHEELCHAIR ACCESSIBLE: Portable ramp, with notice

WEBSITE: www.oldfirstchurchbenn.org

The First Congregational Church of Bennington, also known as the Old First Church, is best known as the final resting place of poet Robert Frost. Although Frost was not a member of the church, he lived just outside of Bennington, and he recited his poem "The Black Cottage" at Old First Church's rededication in 1937. A few years later, after the untimely deaths of his wife and son, Frost purchased two cemetery plots for a family resting place in the church cemetery. Frost's gravestone is inscribed "I had a lover's quarrel with the world," and it sits among the graves of Americans dating as far back as the Revolutionary War. The congregation of Old First Church formed in 1762, and the current Old First Church sanctuary was built in 1805 and became the first church building in the state erected solely for the purpose of worship. Old First Church has officially been designated by the Vermont legislature as "Vermont's Colonial Shrine."

ROUND CHURCH

25 Round Church Road, Richmond, Vermont 05477
PHONE: 802-434-4119
HOURS: Saturday and Sunday, Memorial Day through Columbus Day;
daily, Independence Day through Labor Day
ADMISSION: No fee charged
WHEELCHAIR ACCESSIBLE: Full access
WEBSITE: www.vmga.org/chittenden/roundchurch.html

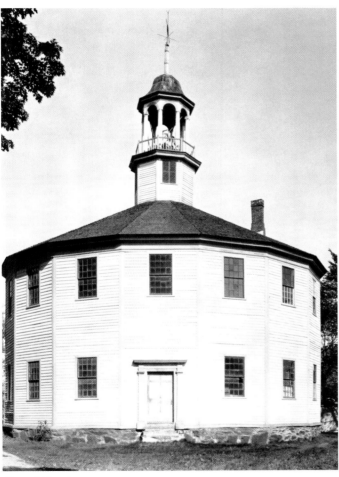

Round Church

Five Protestant congregations, all from different denominations, banded together from 1812 until 1813 to build Richmond's Round Church as a community meetinghouse. The unique shape of the church is actually a sixteen-sided polygon. Local lore tells that the shape was chosen so there would be "no corners for Satan to hide in." During a visit to Vermont, automaker Henry Ford tried to buy the Round Church and move it to his home in Dearborn, Michigan; but the people of Richmond refused to part with their favorite landmark. Inside the church are a raised pulpit, a horseshoe-shaped gallery, and box pews. Visitors to the church today can learn more of the Round Church's history from tour guides and view historic photographs on display as well as an 1820 organ.

MASSACHUSETTS

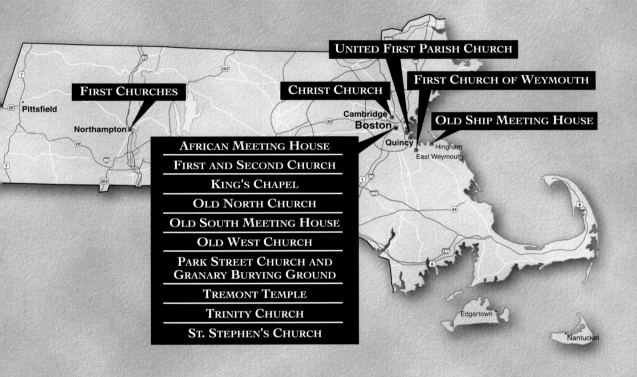

UNITED FIRST PARISH CHURCH

FIRST CHURCH OF WEYMOUTH

FIRST CHURCHES

CHRIST CHURCH

OLD SHIP MEETING HOUSE

AFRICAN MEETING HOUSE

FIRST AND SECOND CHURCH

KING'S CHAPEL

OLD NORTH CHURCH

OLD SOUTH MEETING HOUSE

OLD WEST CHURCH

PARK STREET CHURCH AND
GRANARY BURYING GROUND

TREMONT TEMPLE

TRINITY CHURCH

ST. STEPHEN'S CHURCH

Pittsfield

Northampton

Cambridge
Boston

Quincy

Hingham
East Weymouth

Edgartown

Nantucket

0 100 Miles

0 100 KM

AFRICAN MEETING HOUSE

8 Smith Court, Boston, Massachusetts 02114
PHONE: 617-725-0022
HOURS: Closed for renovations
until 2005 or 2006
ADMISSION: No fee charged
WHEELCHAIR ACCESSIBLE: Full access
WEBSITE: www.afroammuseum.org/site14.htm

African Meeting House

Boston's African Meeting House was the site where William Lloyd Garrison formed the New England Anti-Slavery Society in 1832 and where Frederick Douglass recruited members for the Massachusetts 54th Regiment of black Civil War soldiers. It also housed Boston's first school for black children. The First African Baptist Church was formed in 1805 and the building was erected the following year. Today it is America's oldest black church structure. It houses the Museum of Afro-American History where visitors can view artifacts such as the "imposing stone" that William Lloyd Garrison used to lay out his anti-slavery newspaper, *The Liberator;* a ceremonial sword that belonged to Colonel Robert Gould Shaw, the commander who led the 54th Regiment during the Civil War; and slate pencils, marbles, and other relics from the nineteenth-century school that once operated out of the Meeting House's basement.

FIRST AND SECOND CHURCH IN BOSTON

66 Marlborough Street, Boston, Massachusetts 02116
PHONE: 617-267-6730; 800-359-1630
HOURS: Monday through Friday
ADMISSION: No fee charged
WHEELCHAIR ACCESSIBLE: Full access
WEBSITE: www.fscboston.org

Founded by the Massachusetts Bay Company, the First Church of Boston was the first institution organized in Boston; its covenant dates from July 30, 1630, while the town itself was not named and chartered until September 7 of that same year. Nineteen years later, the Second Church formed out of the First Church; this was the church of famous Puritan pastors Increase and Cotton Mather.

The two churches rejoined in 1970, and the present meetinghouse was consecrated in 1972, thereby giving the oldest church in Boston the newest church structure. The interior includes memorials to many of the notable members of the congregation, some of whom were John Quincy Adams, Charles Francis Adams, Anne Bradstreet, Anne Hutchinson, Paul Revere, and John Winthrop.

KING'S CHAPEL

Tremont and School Streets, Boston, Massachusetts 02108
PHONE: 617-227-2155
HOURS: Daily, June through mid-November; Saturdays year-round
ADMISSION: Donation suggested
WHEELCHAIR ACCESSIBLE: Limited access
WEBSITE: www.kings-chapel.org

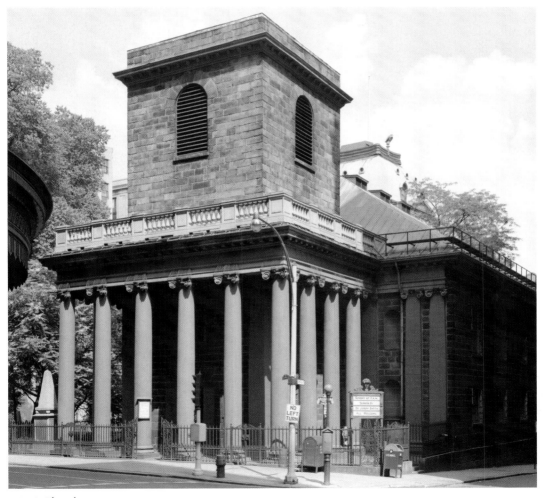

King's Chapel

King's Chapel was formed in 1686 and built in 1688 as Boston's first Anglican church and features a one-ton bell cast in 1816 by Paul Revere that is still rung before every service. The building that stands today was completed in 1749. King's Chapel Burying Ground dates to 1631 and is the oldest in the city of Boston. The burying ground is the final resting place of some of the city's earliest settlers, including Massachusetts Bay Colony governor John Winthrop, Mary Chilton, the first pilgrim to touch Plymouth Rock, Robert Winthrop, the first governor of Connecticut, and Elizabeth Pain, buried in 1704, who was the model for Hester Prynne in Nathaniel Hawthorne's *The Scarlet Letter*.

OLD NORTH CHURCH

193 Salem Street, Boston, Massachusetts 02113
PHONE: 617-523-6676
HOURS: Tours available daily; groups should call ahead
ADMISSION: Donation suggested
WHEELCHAIR ACCESSIBLE: Full access
WEBSITE: www.oldnorth.com

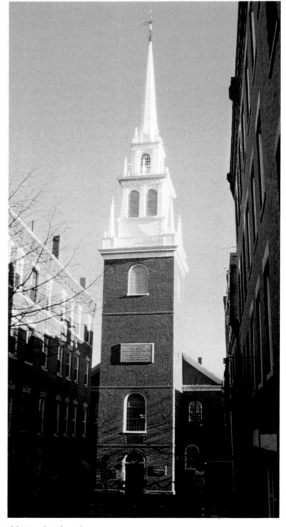

Built in 1723, Old North Church's place in history was secured on an April night in 1775 when sexton Robert Newman hung two lanterns in its steeple, signaling to Paul Revere and his network of messengers that the British were moving toward the village of Lexington by way of the Charles River—by sea—intent upon seizing the colonists' military stockpiles. Revere then set off on horseback to alert the local militias, who were ready and waiting for the British Redcoats on the Lexington town green the following day. The window through which Newman fled after hanging the lanterns in 1775 was once bricked over but is now visible. The steeple now holds a lantern hung by President Gerald Ford in 1976 during America's bicentennial celebration. The church features box pews marked with the names of the original owners and hand-stitched altar rail kneelers that depict events in the church's history.

Old North Church

OLD SOUTH MEETING HOUSE

310 Washington Street, Boston, Massachusetts 02108

PHONE: 617-482-6439

HOURS: Daily; closed Thanksgiving, Christmas Eve, Christmas, and New Year's Day

ADMISSION: Nominal fee

WHEELCHAIR ACCESSIBLE: Full access

WEBSITE: www.oldsouthmeetinghouse.org

On December 16, 1773, more than five thousand people gathered at Old South Meeting House to protest the British tea tax. The result of the meeting was the Boston Tea Party, when the Sons of Liberty dumped 342 chests of British tea into the Boston harbor. Visitors to the church today can see an original tea label from one of the tea chests thrown into the harbor. Old South Meeting House has also counted many prominent Americans among its congregation, including African-American poet Phillis Wheatley and Samuel Adams. Benjamin Franklin was baptized at Old South in 1706. Old South today exhibits a pew plan that lists the names of the families in 1729 who rented pews, including Benjamin Franklin's family. Old South also displays a book of poetry by Phillis Wheatley. During the American Revolution, British soldiers used the

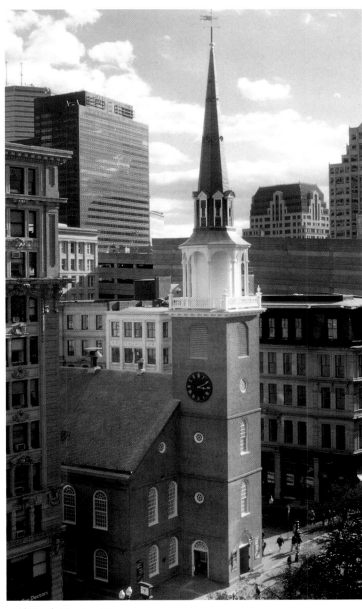

Old South Meeting House

church's pews and pulpit as firewood and the meetinghouse itself as a riding academy. A horseshoe found under the floorboards after the British fled Boston is displayed in the church. After the Revolution, the church was restored and housed an active congregation until 1875. No longer an active church today, Old South is often the location of reenactments of historic debates as well as public meetings.

OLD WEST CHURCH

131 Cambridge Street, Boston, Massachusetts 02126
PHONE: 617-227-5088
HOURS: Monday through Friday
ADMISSION: No fee charged
WHEELCHAIR ACCESSIBLE: Full access
WEBSITE: www.oldwestchurch.org

Built in 1806, Old West Church had two ministers in its early years who were devoted to freedom for all Americans. Rev. Charles Lowell ended the practice of segregated seating in the congregation; he also opened the church's Sunday school classes to children from across Boston, regardless of income or church membership. One young Bostonian who attended those Sunday school classes at Old West was American author Louisa May Alcott. Another American author who attended Old West Church was James Russell Lowell, Rev. Lowell's son. Under the leadership of Rev. Lowell's successor, Cyrus Bartol, Old West became a stop on the Underground Railroad and many escaped slaves hid in the church's attic on their way to freedom. Visitors to the church today can view a wood relief plaque of the congregation's original 1737 building.

PARK STREET CHURCH
AND GRANARY BURYING GROUND

One Park Street, Boston, Massachusetts 02108
PHONE: 617-523-3383
HOURS: Tuesday through Saturday, July and August;
winter hours by appointment only. Burying ground open daily.
ADMISSION: No fee charged
WHEELCHAIR ACCESSIBLE: Limited access
WEBSITE: www.parkstreet.org

Founded in 1804, Park Street Church maintains the 1660 Granary Burying Ground, one of the oldest in Boston. Among the more than six thousand graves are those of Paul Revere, Samuel Adams, John Hancock, and the victims of the Boston Massacre. Park Street's address is nicknamed "Brimstone Corner" because powder for the War of 1812 was stored in a crypt in the church's basement. In the late nineteenth century the church was a bulwark of

the abolition movement, including William Lloyd Garrison among its speakers. The song "America" (My Country 'Tis of Thee), by Samuel Francis Smith, was first sung at Park Street Church on July 4, 1831. Today, the church displays a replica of the original score. Park Street Church also contributed to the War Between the States: five members lost their lives in Civil War battles.

TREMONT TEMPLE

88 Tremont Street, Boston, Massachusetts 02108
PHONE: 617-523-7320
HOURS: Daily
ADMISSION: No fee charged
WHEELCHAIR ACCESSIBLE: Full access
WEBSITE: www.tremonttemple.org

Abraham Lincoln delivered an address at Tremont Temple before he became president. Founded in 1838 as the first integrated church in America, Tremont Temple was the first church in New England to proclaim the Emancipation Proclamation and the first church in Boston to preach the abolitionist message from the pulpit. Tremont Temple also helped to house fugitive slaves in the years preceding the Civil War. Tremont Temple has welcomed other well-known speakers in the past, including Charles Dickens, who delivered the first reading of *A Christmas Carol* this side of the Atlantic at Tremont Temple in 1867. Ministers Billy Graham, D. L. Moody, and Billy Sunday all preached here at one time.

Tremont Temple

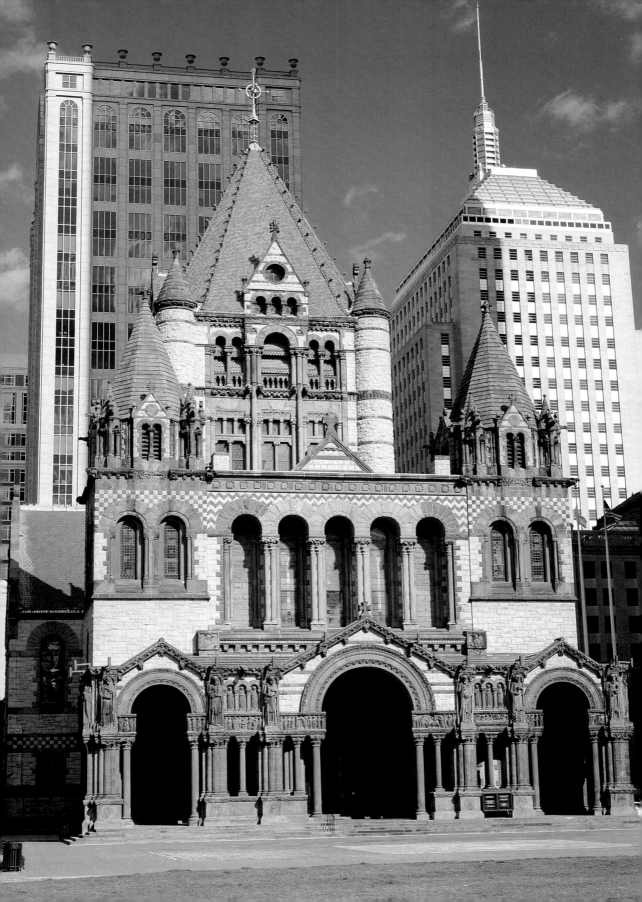

TRINITY CHURCH

Copley Square, Boston, Massachusetts 02116

PHONE: 617-536-0944
HOURS: Daily
ADMISSION: Nominal fee
WHEELCHAIR ACCESSIBLE: Limited access
WEBSITE: www.trinityboston.org

From 1869 until 1891, Phillips Brooks served as the rector of Trinity Church, which was founded in 1733. Brooks is known as the author of the lyrics to the Christmas carol "O Little Town of Bethlehem." Brooks was also a nationally-known civic leader, and upon his death in 1893, the entire city of Boston closed for a day and citizens commissioned a statue in his honor that now stands adjacent to the church. Inside Trinity are murals and stained glass windows by American artist John La Farge. The stained glass window that depicts Christ offering blessing was requested by Brooks, who wanted to look upon the window as he preached.

ST. STEPHEN'S CHURCH

401 Hanover Street, Boston, Massachusetts 02109

PHONE: 617-523-1230
HOURS: Daily
ADMISSION: No fee charged
WHEELCHAIR ACCESSIBLE: No access
WEBSITE: None

Founded in 1714 and known first as New North Church, St. Stephen's counted both Paul Revere and his father among its members. A bell that had been cast by Revere was hung in the belfry of the 1804 building, but was cracked while being used as a city fire alarm in 1872 and was replaced. The church's dome features a copper roof connected with hand-wrought nails crafted by Revere. The church's interior features the carvings of Simeon Skilling, a shipbuilder who became known for his carved figureheads on the ships in Boston harbor.

CHRIST CHURCH

Zero Garden Street, Cambridge, Massachusetts 02138

PHONE: 617-876-0200
HOURS: Daily
ADMISSION: No fee charged
WHEELCHAIR ACCESSIBLE: Full access
WEBSITE: www.cccambridge.org

Opposite: Trinity Church

Christ Church

Christ Church was built in 1761 to serve as a Church of England church for students at Harvard. During the Revolutionary War, Christ Church closed for worship services and was used as a barracks for the Continental Army, and some of the organ's pipes were melted down for use as Patriot musket balls. At the entrance of the church, visitors can see a bullet hole in one of the wood planks, and hanging above the bullet hole is a brass plaque which describes this souvenir from the Revolution. Outside the church's windows, the Continental Army, led by General George Washington, encamped on the Cambridge Common in 1775 and 1776. At the request of Martha Washington the church held a worship service on New Year's Eve, 1775, for the Washingtons and the commander's staff. The church crypt includes the remains of a Lt. Brown, a British officer from the Revolution. Another famous American at Christ Church was Teddy Roosevelt, who worshiped here while he was a student at Harvard in the late 1870s.

FIRST CHURCH OF WEYMOUTH

17 Church Street, East Weymouth, Massachusetts 02189

PHONE: 781-335-1686

HOURS: Daily

ADMISSION: No fee charged

WHEELCHAIR ACCESSIBLE: Limited access

WEBSITE: None

First Church of Weymouth is best known as the church of Abigail Adams, wife of President John Adams and mother of President John Quincy Adams. Abigail's father, William Smith, was pastor of First Church from 1734–1783. Visitors to the church can see a pewter replica of an antique communion set cast by another American patriot, Paul Revere. The congregation of the First Church of Weymouth was gathered in 1623 by the twenty-one families who settled Weymouth after arriving from England, giving the First Church of Weymouth the oldest continuing congregation in the United States. In 1682 a meetinghouse was built, but in the spring of 1751 the structure caught fire and burned down. Unfortunately, several barrels of the town's gunpowder were stored in the loft of the church, and in the words of Rev. William Smith, "It made a surprising noise when it blew up." The church was rebuilt and later replaced by the present structure, the congregation's fifth, in 1833.

OLD SHIP MEETING HOUSE

90 Main Street, Hingham, Massachusetts 02043

PHONE: 781-749-1679

HOURS: Sunday through Friday, July and August; by appointment September through June

ADMISSION: No fee charged

WHEELCHAIR ACCESSIBLE: Full access

WEBSITE: www.oldshipchurch.org

Old Ship Meeting House

Founded in 1635 and built in 1681, Old Ship Meeting House is America's only surviving seventeenth-century Puritan meetinghouse and the nation's oldest wood frame house of worship in continuous use. The exposed timber truss framing of the roof was built on the ground and raised in three days in July of 1681 and, from below, looks like an inverted ship's hull. Old Ship's name probably originates from the fact that it was a coastal landmark for ships. Additional maritime details in the church include a belfry designed like a captain's walk and a compass rose pattern painted on the ceiling of the belfry. The church has its original pulpit, many of the high-backed box pews from 1755, and a christening bowl made before 1600 and probably brought to the New World by Hingham's first settlers.

FIRST CHURCHES OF NORTHAMPTON

129 Main Street, Northampton, Massachusetts 01060
PHONE: 413-586-9392
HOURS: Monday through Friday
ADMISSION: No fee charged
WHEELCHAIR ACCESSIBLE: Full access
WEBSITE: www.firstchurches.org

First Churches of Northampton

Founded in 1661, the First Church of Northhampton became one of the most influential New England Puritan churches under the leadership of Rev. Solomon Stoddard. Stoddard was joined by his grandson Jonathan Edwards in the pastorate in 1726. Edwards, who attended Yale and served as president of Princeton, became famous for his "Sinners in the hands of an angry God" sermon and his involvement in the first "Great Awakening." The First Churches of Northampton today is comprised of two congregations that combined in the 1970s: the First Church of Northampton and the First Baptist Church of Northampton. The First Churches today constitutes one congregation that meets in one church building, which features a life-size, sculpted memorial plaque of Edwards that was created by artist Herbert Adams in 1900. Visitors

can also view a slide show on the lives of Jonathan and Sarah Edwards as well as a display of Edwards material from the church's historical library.

United First Parish Church (Unitarian) in Quincy

1506 Hancock Street, Quincy, Massachusetts 02169
Phone: 617-773-1290
Hours: Tours daily from mid-April through mid-November
Admission: No fee charged
Wheelchair Accessible: Limited access
Website: www.ufpc.org

Formed in 1636, United First Parish Church is often called the "Church of the Presidents" in honor of John Adams and his son John Quincy Adams, both of whom were lifelong members of the church and are buried, along with their wives, Abigail Adams and Louisa Catherine Adams, in the family crypt at the church. The church building itself, completed in 1828, was financed in part by John Adams and John Quincy Adams. Many men of the church served in the Revolutionary War, and another American Patriot, John Hancock, attended United First Parish long before he became president of the Continental Congress. He was baptized here by his father, Rev. John Hancock, who was minister from 1726 to 1744. The church's patriotic spirit continued throughout the Civil War. The minister of the church from 1860 until 1876, Rev. John Doane Wells, took a leave of absence from his pastoral duties to lead a regiment in the Union army. Church member Charles Francis Adams Jr., the great-grandson of John Quincy Adams, led a regiment of African-American soldiers during the war and earned distinction as the first regiment to occupy Richmond, Virginia. The church displays marble memorials and busts that honor both Adams presidents and their wives, as well as revolving exhibits of replicas of original papers belonging to the Adams presidents.

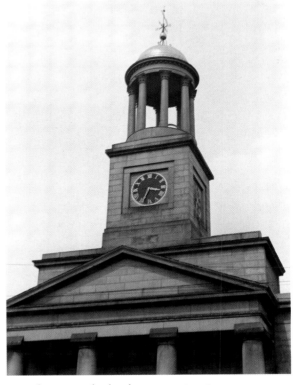

United First Parish Church (Unitarian) in Quincy

RHODE ISLAND

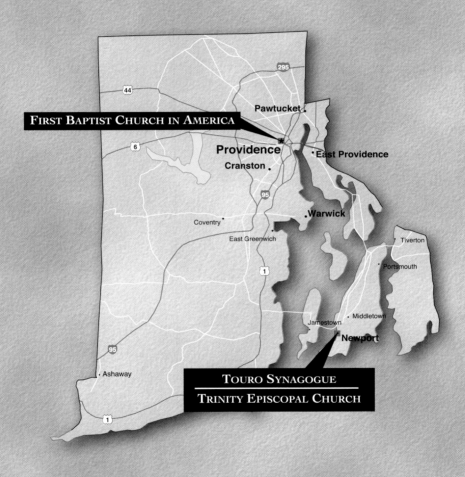

FIRST BAPTIST CHURCH IN AMERICA

Pawtucket

Providence

East Providence

Cranston

Warwick

Coventry

East Greenwich

Tiverton

Portsmouth

Jamestown

Middletown

Newport

TOURO SYNAGOGUE
TRINITY EPISCOPAL CHURCH

Ashaway

0 20 Miles

0 20 KM

TOURO SYNAGOGUE

85 Touro Street, Newport, Rhode Island 02840

PHONE: 401-847-4794

HOURS: Tours available; call for schedule

ADMISSION: Nominal fee for large groups tours only

WHEELCHAIR ACCESSIBLE: No access

WEBSITE: www.tourosynagogue.org

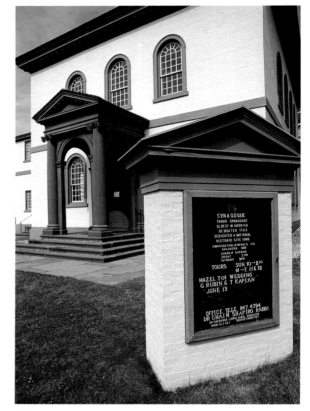

Touro Synagogue

During the American Revolution, British troops commandeered Touro Synagogue for use as a military hospital from 1776 until 1779, when the city was liberated by French soldiers. General George Washington attended a town meeting held at Touro Synagogue in 1781, and in 1790 Washington wrote a letter to Touro's congregation and promised that America would give to "bigotry, no sanction; to persecution, no assistance." A copy of Washington's letter hangs in the sanctuary today. Founded in 1658, Touro Synagogue was completed in 1763 and includes the Amsterdam torah, which is more than five hundred years old.

TRINITY EPISCOPAL CHURCH

Queen Anne Square, Spring and Church Streets, Newport, Rhode Island 02840

PHONE: 401-846-0660

HOURS: Daily, Independence Day through Labor Day;
Monday through Friday, May, June, September, October; other hours by appointment

ADMISSION: No fee charged

WHEELCHAIR ACCESSIBLE: Limited access

WEBSITE: www.trinitynewport.org

George Frederick Handel tested Trinity Episcopal Church's pipe organ before it was shipped from England, and the first organist at Trinity Church was Charles Pachelbel, son of the

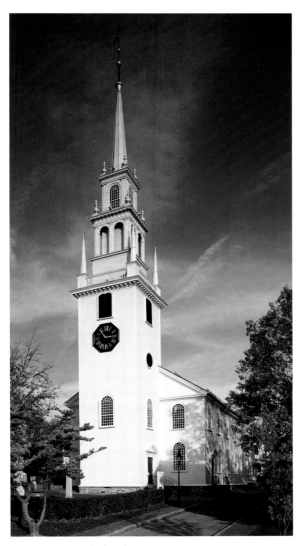
Trinity Episcopal Church

German organist and composer Johann Pachelbel. Trinity's distinguished guests have included George Washington in its early years. Admiral Charles de Ternay, commander of the fleet that escorted Rochambeau to America during the Revolutionary War, is buried in the adjacent cemetery. Founded in 1698, the current church building was erected in 1726 and contains two Tiffany stained glass windows and the only center-aisle, three-tiered, wineglass pulpit in America.

FIRST BAPTIST CHURCH IN AMERICA

75 North Main Street,
Providence, Rhode Island 02903
PHONE: 401-454-3418
HOURS: Monday through Friday;
a guided tour every Sunday
following worship
ADMISSION: No fee charged
WHEELCHAIR ACCESSIBLE:
Limited access
WEBSITE: www.fbcia.org

When the Massachusetts Bay Colony banished Roger Williams in 1636, he fled south and founded the settlement of Providence. Two years later Williams founded the first Baptist church in the New World and, eventually, the state of Rhode Island, based upon his ideal of religious freedom. Many out-of-work shipwrights from Boston helped build the present church in 1775, after the Port of Boston was closed because of the Boston Tea Party. Artifacts discovered on the church grounds are displayed inside and include cannon shot from the Revolutionary War and antique fire buckets. By 1861 and the start of the Civil War, every young man in the congregation had enlisted in the army, and in June of that year the entire Rhode Island Second Regiment met in the First Baptist sanctuary to listen to the sermons.

CONNECTICUT

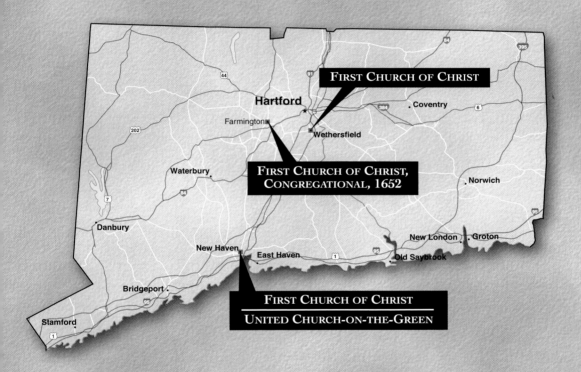

FIRST CHURCH OF CHRIST

FIRST CHURCH OF CHRIST, CONGREGATIONAL, 1652

FIRST CHURCH OF CHRIST
UNITED CHURCH-ON-THE-GREEN

Hartford

Farmington

Coventry

Wethersfield

Waterbury

Norwich

Danbury

New Haven

East Haven

New London

Groton

Old Saybrook

Bridgeport

Stamford

0 50 Miles

0 50 KM

FIRST CHURCH OF CHRIST, CONGREGATIONAL, 1652

*75 Main Street, Farmington,
Connecticut 06032*
PHONE: 860-677-2601
HOURS: Tours available
by appointment only
ADMISSION:
No fee charged
WHEELCHAIR ACCESSIBLE:
Full access
WEBSITE:
www.firstchurch1652.org

First Church of Christ, Congregational, 1652

Formed in 1652, First Church of Christ, Congregational assisted the kidnapped Africans who found themselves in Connecticut after their mutiny on the slave ship *Amistad* in 1839. John Quincy Adams represented the Africans in the Supreme Court battle over whether they were slaves or free men, and in 1841, the Court declared that the Africans were free and could return to Sierra Leone, their native land. Members of First Church offered the former captives housing, clothing, work, and education in Farmington until they could raise the money to sail home. It was within the walls of First Church that the Africans were first introduced to the community and it was at First Church that they said their goodbyes when they returned to their homeland. A portrait of the *Amistad* leader, Sengbe, hangs in the church's parish house.

FIRST CHURCH OF CHRIST IN NEW HAVEN

511 Temple Street on the New Haven Green, New Haven, Connecticut 06511

PHONE: 203-787-0121

HOURS: Guided tours available Sunday after the 10 A.M. service
or by appointment. Crypt tours available from April through October
on Thursdays and Saturdays.

ADMISSION: No fee charged

WHEELCHAIR ACCESSIBLE: Limited access

WEBSITE: None

Formed in 1638 by English colonists, First Church of Christ features a burial ground that includes over fifteen hundred graves that date as far back as 1687 and includes that of

Benedict Arnold's first wife, Margaret. Also buried here is James Pierpont, one of the founders of Yale University. The church's interior features a Tiffany window over the pulpit that depicts the scene of the first minister, John Davenport, standing on a rock and preaching to the settlers.

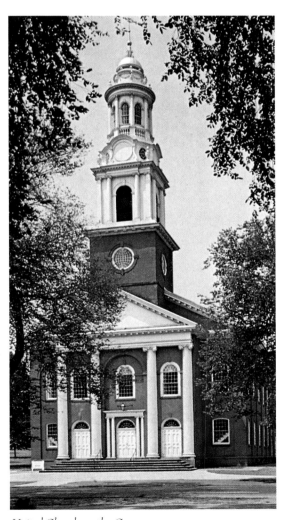

UNITED CHURCH-ON-THE-GREEN

*270 Temple Street,
New Haven, Connecticut 06511*

PHONE: 203-787-4195

HOURS: By appointment only

ADMISSION: No fee charged

WHEELCHAIR ACCESSIBLE:
Full access to sanctuary

WEBSITE: www.newlights.org

Formed in 1742 as "North Church," members of United Church-on-the-Green have, throughout its history, been leaders in the fight for equality for all people. In 1839, church leaders stepped forward and commited to the care of fifty-three Africans who were taken into custody

United Church-on-the-Green

from the slave ship *Amistad* and deposited in New Haven. Church member and attorney Roger Sherman Baldwin provided legal services to the African men, women, and children through the district and circuit courts, and Baldwin was at the side of former president John Quincy Adams when he argued the case before the Supreme Court and won. When it came time for the Africans to return to Sierra Leone, five missionaries from United Church-on-the-Green sailed with them. Roger Sherman Baldwin's father, Roger Sherman, was also a member of the church and was the only signer of all four founding documents of the United States: The Continental Association of 1774, The Declaration of Independence, The Articles of Confederation, and The Federal Constitution.

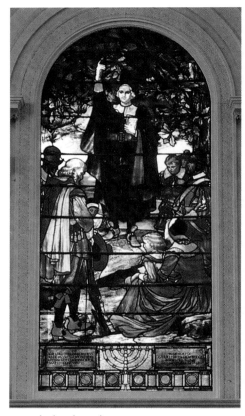

United Church-on-the-Green

FIRST CHURCH OF CHRIST

250 Main Street, Wethersfield, Connecticut 06109
PHONE: 860-529-1575
HOURS: Monday through Friday
ADMISSION: No fee charged
WHEELCHAIR ACCESSIBLE: Full access
WEBSITE: www.firstchurch.org

Formed in 1635, First Church of Christ counted Jonathan Edwards, George Washington, and John Adams among its worshipers at one time. Edwards, early theologian and literary giant, worshiped here from 1716–1719, while he sought his undergraduate degree from Yale University (which he completed at age sixteen). His grandson, Timothy Dwight, who later became a leader in New England religious life, worshiped here during the American Revolution, and the church's cemetery, which dates back to the 1600s, includes a stone for Elisha Williams, who was a tutor and cousin of Edwards. George Washington worshiped here briefly in 1781 while he was in town planning the decisive battle of Yorktown. When John Adams visited the church, it is said that he climbed the bell tower, looked out upon the surrounding countryside, and called it "the most grand and beautiful prospect in the world." The current church was built in 1761.

Opposite: First Church of Christ, Wethersfield

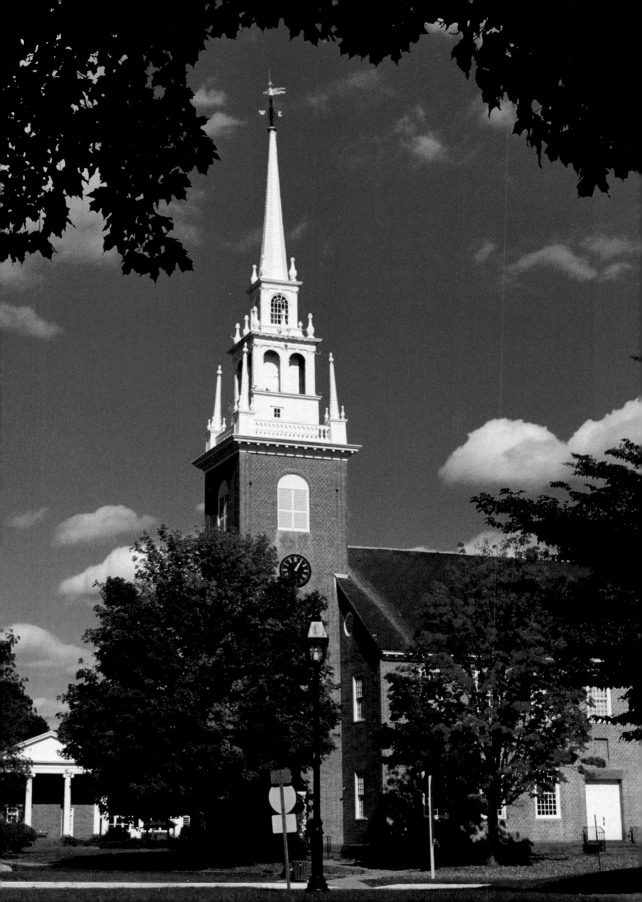

NEW YORK

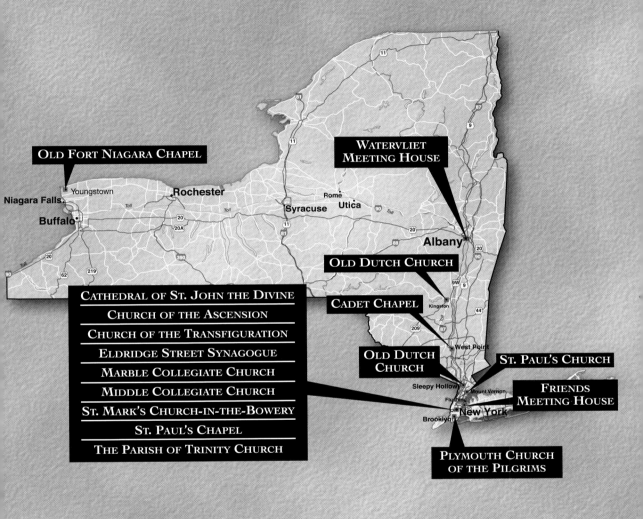

OLD FORT NIAGARA CHAPEL

WATERVLIET
MEETING HOUSE

Niagara Falls
Youngstown
Rochester
Rome
Utica
Syracuse
Buffalo

OLD DUTCH CHURCH

CADET CHAPEL

Albany

Kingston

CATHEDRAL OF ST. JOHN THE DIVINE
CHURCH OF THE ASCENSION
CHURCH OF THE TRANSFIGURATION
ELDRIDGE STREET SYNAGOGUE
MARBLE COLLEGIATE CHURCH
MIDDLE COLLEGIATE CHURCH
ST. MARK'S CHURCH-IN-THE-BOWERY
ST. PAUL'S CHAPEL
THE PARISH OF TRINITY CHURCH

OLD DUTCH
CHURCH

ST. PAUL'S CHURCH

FRIENDS
MEETING HOUSE

Sleepy Hollow
Flushing
Mount Vernon
New York
Brooklyn
West Point

PLYMOUTH CHURCH
OF THE PILGRIMS

0 100 Miles

0 100 KM

WATERVLIET MEETING HOUSE

Watervliet Shaker Historic District, 875 Watervliet Shaker Road, Albany, New York 12211

PHONE: 518-456-7890

HOURS: Tuesday through Saturday; closed January and all major Federal holidays

ADMISSION: Nominal fee for group tours (no fee for children under 18);
no fee charged for self-guided walking tours

WHEELCHAIR ACCESSIBLE: Limited access

WEBSITE: http://crisny.org/not-for-profit/shakerwv

Part of the 1776 Watervliet Shaker Historic District, the first Shaker settlement in America, the 1848 Meeting House on site has survived as the community's second house of worship. The site also includes the grave of Mother Ann Lee, founder and leader of the American Shakers, as well as the graves of 443 other Shakers. The meetinghouse is the only one of its kind left standing and was built during the peak of the

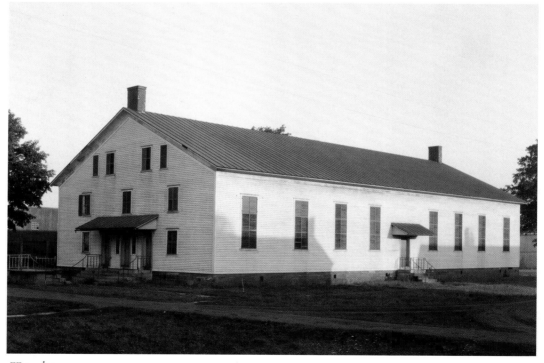

Watervliet

Shaker experiment in America. It was built with seating on one side for "the world's people," non-Shakers who came to visit during Sunday worship services, and the building includes a special door for these outsiders separate from the Shakers' own door.

PLYMOUTH CHURCH OF THE PILGRIMS

Hicks and Orange Street, Brooklyn, New York 11201
PHONE: 718-624-4743
HOURS: Sunday through Friday; tours offered after Sunday services or by appointment, Monday through Friday
ADMISSION: No fee charged
WHEELCHAIR ACCESSIBLE: Limited access
WEBSITE: www.plymouthchurch.org

Founded in 1847 and built in 1849, Plymouth Church of the Pilgrims was known as the "Grand Central Depot" of the Underground Railroad. Plymouth's first minister was Henry Ward Beecher, brother of *Uncle Tom's Cabin* author Harriet Beecher Stowe. A 1914 statue of Beecher created by Mount Rushmore sculptor Gutzon Borglum stands in the church garden. A portrait of a slave girl whose freedom was bought by the congregation is displayed in the church arcade, as is a fragment of Plymouth Rock. Visitors can also see where fugitive

Plymouth Church of the Pilgrims

slaves hid in the church's basement while navigating the Underground Railroad to freedom. Abolitionists William Lloyd Garrison, Wendell Phillips, John Greenleaf Whittier, and Sojourner Truth also spoke to the Plymouth congregation. President Abraham Lincoln visited the church in 1860, Charles Dickens read *A Christmas Carol* here in 1868, and Mark Twain worshiped here while living in New York City. In 1963, Martin Luther King Jr. spoke during the worship service about his "American Dream."

Statue of Henry Ward Beecher

FRIENDS MEETING HOUSE

157-16 Northern Boulevard, Flushing, New York 11554
PHONE: 718-358-9636
HOURS: Sunday; tours by appointment Monday through Saturday
ADMISSION: No fee charged
WHEELCHAIR ACCESSIBLE: Limited access
WEBSITE: www.nyym.org/flushing

During the Revolutionary War the Friends Meeting House was commandeered by the British for a prison, a hospital, and a hay warehouse, and George Washington visited the Meeting House in 1789 and 1790. The Friends Meeting House has been in continuous use as a religious meeting place since 1694 and survives as the oldest house of worship still in use in New York City as well as the second oldest Quaker meeting-

Friends Meeting House

house in the country. Inside are original, forty-foot long oak beams, a cast iron stove more than two and a half centuries old, and hand-forged iron hinges and latches on the doors.

OLD DUTCH CHURCH

272 Wall Street, Kingston, New York 12401

PHONE: 845-338-6759

HOURS: Monday through Friday; tours by appointment

ADMISSION: Nominal fee for tours

WHEELCHAIR ACCESSIBLE: Full access

WEBSITE: www.olddutchchurch.org

First erected in 1660, Old Dutch Church's building was rebuilt after being burned by British soliders in 1777, and was subsequently used as an armory during the Civil War. The cemetery adjacent to the Old Dutch Church contains gravestones dating back as far as 1710, including the grave of New York's first governor, George Clinton. Clinton was also a brigadier general in the Revolutionary War and vice president under both Thomas Jefferson and James Madison. A plaque mounted on the front of the church commemorates George Washington's visit to Kingston with Clinton in 1782.

Old Dutch Church

ST. PAUL'S CHURCH

897 S. Columbus Avenue, Mount Vernon, New York 10550

PHONE: 914-667-4116

HOURS: Monday through Friday; closed all Federal holidays

ADMISSION: Nominal fee

WHEELCHAIR ACCESSIBLE: No access

WEBSITE: www.nps.gov/sapa

Founded in 1665, St. Paul's parish is one of the oldest in New York state. The current eighteenth-century building that survives today was used as a field hospital after the 1776 Battle at Pell's

St. Paul's Church

Point during the American Revolution. The adjoining cemetery covers more than five acres and includes approximately nine thousand graves. The oldest grave dates to 1704. Sara Delano Roosevelt, mother of President Franklin Delano Roosevelt, helped to raise funds for a 1942 restoration of the church's interior to its eighteenth-century appearance. The site is now part of the National Park Service and includes a Visitors Center/ Exhibits Museum.

CATHEDRAL OF ST. JOHN THE DIVINE

1047 Amsterdam Avenue, New York, New York 10025

PHONE: General information, 212-316-7540; tours, 212-932-7347

HOURS: Daily

ADMISSION: Nominal fee

WHEELCHAIR ACCESSIBLE:
Limited access

WEBSITE: www.stjohndivine.org

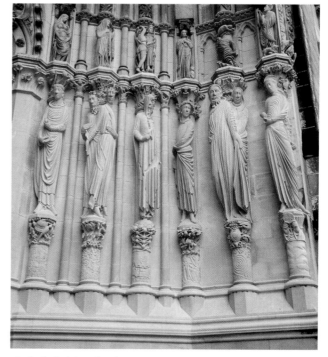

Cathedral of St. John the Divine

Although the Cathedral of St. John the Divine, a work in progress since 1892, is only two-thirds complete, this enormous structure is the largest Gothic cathedral in the world. In the early years of the twentieth century, a model of the completed cathedral stood on display in Grand Central Station. One week after the interior was completed on November 30, 1941, work on the cathedral came to an abrupt halt with the news of Japanese forces attacking American ships at Pearl Harbor.

There is a spot inside the cathedral today called Pearl Harbor Arch that has been left untouched since the stonemason working on that arch halted his job upon hearing of the Pearl Harbor attack.

CHURCH OF THE ASCENSION ─────────────

Fifth Avenue at Tenth Street, New York, New York 10011
PHONE: 212-254-8620
HOURS: Monday through Friday
ADMISSION: No fee charged
WHEELCHAIR ACCESSIBLE: Limited access
WEBSITE: www.ascensionnyc.org

Founded in 1827, the Church of the Ascension was the setting for the marriage of President John Tyler and Julia Gardiner in 1844, and a plaque in the church commemorates this historic union. The church became a free pew parish in 1893 and shifted from relying on the income of rented pews to relying on voluntary giving. In 1929, days after the stock market crash, the church's minister suggested that the church doors should remain open at all times, twenty-four-hours a day. The Church of the Ascension was the first house of worship in the city that kept its doors open at all hours, and homeless men were allowed to sleep in the pews throughout the years of the Depression. The Church of the Ascension features stained glass windows and a mural of the Ascension by American artist John La Farge and stained glass windows by Tiffany.

THE CHURCH OF THE TRANSFIGURATION ─────────

One E. Twenty-ninth Street, New York, New York 10016
PHONE: 212-684-6770
HOURS: Daily
ADMISSION: No fee charged
WHEELCHAIR ACCESSIBLE: Full access
WEBSITE: www.littlechurch.org

American author O. Henry (William Sydney Porter), best known for his short story "The Gift of the Magi," often attended services at the Church of the Transfiguration and even mentioned the church in several of his stories. When O. Henry died in 1910, his funeral was held here. During the Civil War, escaped slaves found refuge at the Church of the Transfiguration, and the church doors were even locked at times to protect the slaves who sought a safe haven there. The church also established bread lines after the Civil War and continued the lines through the Great Depression of the 1930s. The transept of the sanctuary includes the Edwin Booth window by John La Farge, which depicts Booth, a famous nineteenth-century actor, as Hamlet, a role he played many times. A member of the parish, Booth was also brother to John Wilkes Booth, who assassinated Abraham Lincoln.

ELDRIDGE STREET SYNAGOGUE

12–16 Eldridge Street, New York, New York 10002

PHONE: 212-219-0888

HOURS: Sunday, Tuesday, and Thursday; also by appointment

ADMISSION: Nominal fee

WHEELCHAIR ACCESSIBLE: No access

WEBSITE: www.eldridgestreet.org

Worshipers at Eldridge Street Synagogue in the early decades of the twentieth century included scientist Jonas Salk, performers Eddie Cantor, Edward G. Robinson, and Paul Muni, and artists Ben Shahn and Max Gropper. As part of ongoing restoration work on the 1887 building, today Eldridge Street offers tours and special programs about the synagogue's place in American history. Artifacts and vintage photographs are displayed in the synagogue's lower level and include an old spittoon, an antique gavel once used in the synagogue to keep order, and old neighborhood signs that were printed in a mixture of Yiddish, Hebrew, and English.

MARBLE COLLEGIATE CHURCH

Fifth Avenue and W. Twenty-ninth Street, New York, New York 10001

PHONE: 212-686-2770

HOURS: Monday through Friday

ADMISSION: No fee charged

WHEELCHAIR ACCESSIBLE: Full access

WEBSITE: www.marblechurch.org

Outside Marble Church stands a statue of Norman Vincent Peale, who was Senior Minister here from 1932 to 1984. Peale's book, *The Power of Positive Thinking,* made him internationally famous and drew thousands to hear his sermons at Marble Church. One of four churches founded by a single Consistory in 1628, the Marble Collegiate building was completed in 1854. The pews are the original mahogany, and its spire houses a bell which has tolled the death of U. S. presidents since 1862.

Marble Collegiate Church

Marble Collegiate Church

MIDDLE COLLEGIATE CHURCH

Second Avenue at 181st Street, New York, New York 10055

PHONE: 212-477-0666

HOURS: Monday through Friday

ADMISSION: No fee charged

WHEELCHAIR ACCESSIBLE: No access

WEBSITE: www.middlechurch.org

Middle Collegiate Church houses the New York "liberty bell." The bell hung in Middle Church's first building and tolled on July 9, 1776, to announce the signing of the Declaration of Independence. Some of the first to hear the bell sound were Washington's own troops, who were stationed in New York. In 1776 British troops occupied New York City during most of the Revolutionary War and Middle Collegiate was used by the British as a prison for hundreds of American Patriot soldiers. During the occupation, Middle Church hid their liberty bell from the British soldiers and returned it to the belfry when the war ended. The bell sounded again when Washington was inaugurated president and has tolled the inauguration and death of every president since.

St. Mark's Church-in-the-Bowery

131 E. Tenth Street, New York, New York 10003

PHONE: 212-674-6377

HOURS: Monday through Friday

ADMISSION: No fee charged

WHEELCHAIR ACCESSIBLE: Full access

WEBSITE: www.stmarkschurch-in-the-bowery.com

The land upon which St. Mark's Church sits was once part of Governor Peter Stuyvesant's plantation, where a chapel was built in 1660 as part of his estate. When Stuyvesant died in 1678 he was buried in the family vault beneath the chapel. In 1793, Stuyvesant's great-grandson donated the chapel and the land to the Episcopal Church and Alexander Hamilton provided legal help to incorporate St. Mark's, which was built on the property in 1799. The cemetery includes the graves of Revolutionary War hero Nicholas Fish and former American vice president Daniel Tompkins. The remains of Commodore Matthew Calbraith Perry, who helped open Japan to American trade in 1854, were interred in St. Mark's churchyard temporarily, from 1858 until about 1868, at which time his body was moved to a family burial ground. The site of his burial is still marked today. Many famous poets have lectured at St. Mark's, including William Carlos Williams, Edna St. Vincent Millay, and Carl Sandburg.

St. Paul's Chapel

Church Street between Fulton and Vesey Streets, New York, New York 10007

PHONE: 212-602-0874

HOURS: Daily; group tours by appointment

ADMISSION: No fee charged

WHEELCHAIR ACCESSIBLE: Limited access

WEBSITE: www.saintpaulschapel.org

George Washington, St. Paul's most notable worshiper, attended a special Thanksgiving service at the chapel after his first inauguration as U. S. president in 1789. The chapel held a memorial service for Washington in 1799, and his inaguration was commemorated almost a hundred years later in 1889 with President Benjamin Harrison and again in 1989 with President George Bush. President Washington was a regular parishioner at St. Paul's Chapel and nearby Trinity Church while New York was the nation's capital. Above Washington's pew in St. Paul's is an eighteenth-century oil painting of the Great Seal of the United States, which was adopted in 1782. Outside St. Paul's is a monument to Revolutionary War hero Major General Richard Montgomery, who was killed during the colonial attack on Quebec in 1775 and is now buried at St. Paul's. The funeral service of President James Monroe was also held here in 1831.

Opposite: Trinity Church

THE PARISH OF TRINITY CHURCH

Broadway at Wall Street, New York, New York 10006

PHONE: 212-602-0800

HOURS: Daily

ADMISSION: No fee charged

WHEELCHAIR ACCESSIBLE: Full access

WEBSITE: www.trinitywallstreet.org

Chartered in 1697 by King William III of England, Trinity Church's first building dated to 1698. The burying ground which remains includes the graves and memorials of many historic figures, including Alexander Hamilton and his wife Elizabeth; Lewis Francis, a signer of the Declaration of Independence; Albert Gallatin, Secretary of the Treasury under presidents Thomas Jefferson and James Madison; as well as four members of the Continental Congress and three Revolutionary War soldiers. The present church building was completed in 1846, and Trinity's museum today features a variety of historic artifacts.

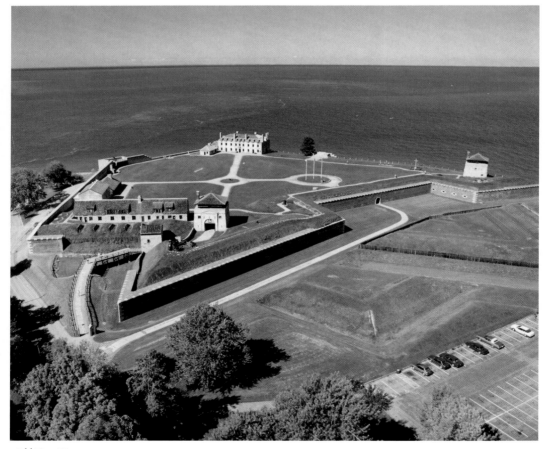

Old Fort Niagara

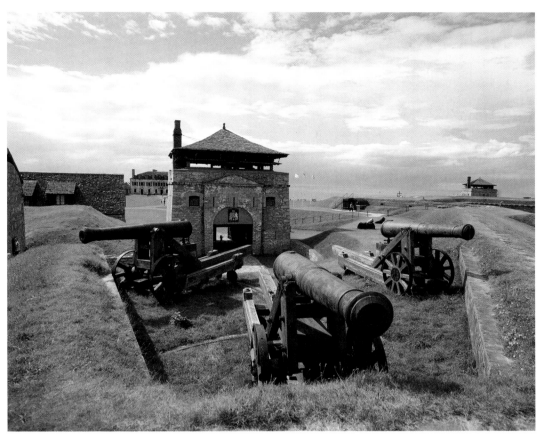

Old Fort Niagara

OLD FORT NIAGARA CHAPEL

Robert Moses Parkway North, Youngstown, New York 14174

PHONE: 716-745-7611

HOURS: Daily; closed Thanksgiving, Christmas, and New Year's Day

ADMISSION: Nominal fee

WHEELCHAIR ACCESSIBLE: Limited access

WEBSITE: www.oldfortniagara.org

When France constructed the first permanent fortress at Niagara in 1726, a Roman Catholic chapel was included in the large, fortified stone house. Today, the building is known simply as the French Castle. In 1757, a new chapel was erected elsewhere on the grounds, and this chapel was used in turn by the British, who captured the fort in 1759, and the Americans, who claimed the fort in 1796 by treaty and later dismantled the new chapel sometime during the 1800s. Today, Old Fort Niagara flies three flags, French, British, and American, over the parade ground in honor of the three nations in the Fort's history. Old Fort Niagara remained an active fortress until World War I, and today the restored stone buildings are open to the public as an historic

site and museum. The original chapel on the second floor of the French Castle, now the oldest building on the Great Lakes, is refurbished with furnishings appropriate to the 1700s.

OLD DUTCH CHURCH OF SLEEPY HOLLOW (REFORMED CHURCH OF THE TARRYTOWNS)

U. S. Route 9, Sleepy Hollow, New York 10591
PHONE: 914-631-1123
HOURS: Daily, Memorial Day through October
ADMISSION: No fee charged
WHEELCHAIR ACCESSIBLE: No access
WEBSITE: www.rctodc.org

American novelist Washington Irving immortalized the Old Dutch Church in his tale *The Legend of Sleepy Hollow.* The legendary Headless Horseman was said to tether his horse nightly in the graveyard of the Old Dutch Church, and an ancient wooden bridge near the church was the place of his encounter with Ichabod Crane. Washington Irving is buried in the cemetery of the Old Dutch Church, which also includes the remains of Eleanor Van Tassel Brush, who was reportedly Irving's inspiration for the character Katrina Van Tassel in his classic tale. Old Dutch Church is the oldest church in New York state and was originally constructed in 1685 to serve as the Manor church for Frederick Philipse, Lord of the Manor of Philipsburg. The congregation today uses the Old Dutch Church in the summer months and on special occasions. The balcony of the church includes a display of antique Bibles as well as church memorabilia collected from three centuries.

THE OLD AND NEW CADET CHAPELS

United States Military Academy, West Point, New York 10996
PHONE: 845-938-3412; 845-938-2308
HOURS: Daily; public access only for services or guided tours;
contact the West Point Visitors Center at 845-938-2638 for more information
ADMISSION: No fee charged for entrance to chapels; nominal fee for daily tour
WHEELCHAIR ACCESSIBLE: Full access
WEBSITE: www.usma.edu/Chaplain

The Old Cadet Chapel on the grounds of the United States Military Academy at West Point, built in 1836, served as the first house of worship at the Academy. The chapel features plaques to all the generals of the American Revolution; a blank plaque represents the traitorous Major General Benedict Arnold. Among the Academy's graduates who worshiped here were William Tecumseh Sherman, Ulysses S. Grant, and Thomas "Stonewall" Jackson. The chapel was replaced by a larger, more modern facility, but the neoclassical building was saved and moved, stone by stone, to its present location at the West Point Cemetery. The new Cadet Chapel, built

in 1910, features a pew with silver plates engraved with the signatures of all the Superintendents, including General MacArthur, General Taylor, and General Westmoreland. The stained glass Sanctuary Window features the Academy's motto: "Duty, Honor, Country."

Cadet Chapel

MIDDLE ATLANTIC

From the simple beauty of Virginia's oldest colonial churches to the grandeur of Washington's National Cathedral, the churches of the middle Atlantic states are wonderfully preserved and eager to share their stories. The churches of some of our earliest presidents are here, as are those of many of the great Patriots who fought for American independence and laid the foundation of our national government. In this region where there is truly history at every turn, houses of worship are no exception; in the combined annals of the churches of the these states can be traced the enthralling narrative of America's birth and coming of age.

PENNSYLVANIA

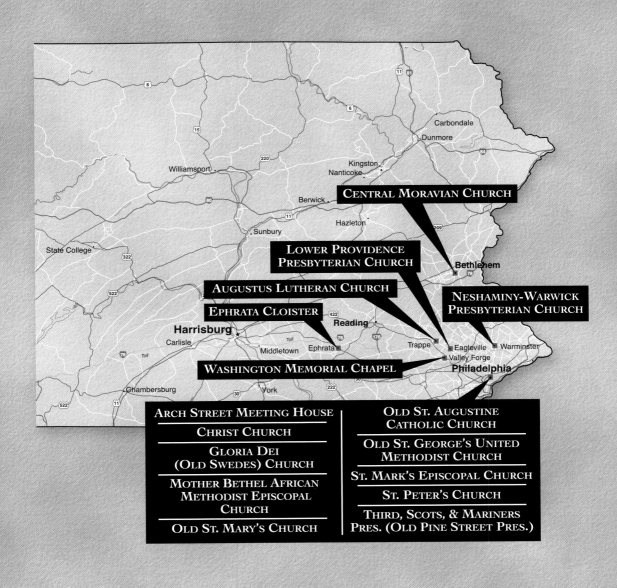

CENTRAL MORAVIAN CHURCH

LOWER PROVIDENCE
PRESBYTERIAN CHURCH

AUGUSTUS LUTHERAN CHURCH

NESHAMINY-WARWICK
PRESBYTERIAN CHURCH

EPHRATA CLOISTER

WASHINGTON MEMORIAL CHAPEL

ARCH STREET MEETING HOUSE	OLD ST. AUGUSTINE CATHOLIC CHURCH
CHRIST CHURCH	OLD ST. GEORGE'S UNITED METHODIST CHURCH
GLORIA DEI (OLD SWEDES) CHURCH	ST. MARK'S EPISCOPAL CHURCH
MOTHER BETHEL AFRICAN METHODIST EPISCOPAL CHURCH	ST. PETER'S CHURCH
OLD ST. MARY'S CHURCH	THIRD, SCOTS, & MARINERS PRES. (OLD PINE STREET PRES.)

0 100 Miles

0 100 KM

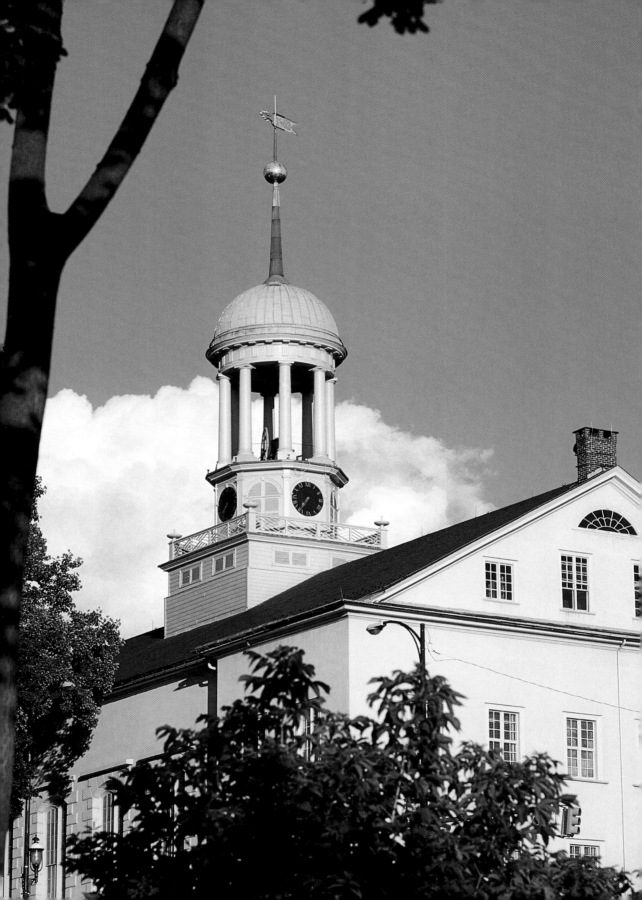

CENTRAL MORAVIAN CHURCH

Main and Church Streets, Bethlehem, Pennsylvania 18018

PHONE: 610-866-5661

HOURS: Museum open Tuesday through Sunday; sanctuary tour after 11 A.M. Sunday service

ADMISSION: Nominal fee for museum; no fee charged for sanctuary

WHEELCHAIR ACCESSIBLE: Full access

WEBSITE: www.enter.net/~cmc/

George and Martha Washington, Benjamin Franklin, Count Casimir Pulaski, John and Samuel Adams, most members of the Continental Congress, and the Marquis de Lafayette have all worshiped with the Moravians of Bethlehem, Pennsylvania. Many Native Americans also worshiped with the Moravians here, including fifty-one chiefs and tribesmen of the Iroquois Nation, who worshiped here when passing through Bethlehem. The building that serves the congregation today was completed in 1806, and the circular belfry houses a clock made in 1754, the oldest American-made working tower clock in the country. The Central Moravian Church has the oldest trombone choir in the United States as well as the first American performance of Haydn's oratorio *The Creation* in 1811 and Bach's *Mass in B Minor* in 1900, which earned the church its status as a National Landmark of Music. A musuem is located in the *Gemeinhaus,* or community house, which is believed to be the largest eighteenth-century log house in America.

LOWER PROVIDENCE PRESBYTERIAN CHURCH

3050 West Ridge Pike, Eagleville, Pennsylvania 19403

PHONE: 610-539-6635

HOURS: Monday through Friday

ADMISSION: No fee charged

WHEELCHAIR ACCESSIBLE: Full access

WEBSITE: www.lppcmin.org

The Lower Providence Presbyterian Church includes the history of two congregations that reunited in 1758: the Norriton congregation and the Providence congregation. Members of both churches participated in the American Revolution, and the Norriton congregation alone provided thirteen officers, eighteen soldiers, and one chaplain. Following the Battle of Germantown during the American Revolution, the Norriton Church served as a hospital where George Washington visited the wounded. Worshipers at the church also included Benjamin Franklin and David Rittenhouse. The stone church building, now known as the Old Norriton Church, was built in 1698 in West Norriton and was restored in the Colonial style in 1940. The congregation uses the Old Norriton Church today for special services and events.

Opposite: Central Moravian Church

Ephrata Cloister

632 West Main Street, Ephrata, Pennsylvania 17522

Phone: 717-733-6600

Hours: Daily

Admission: Nominal fee

Wheelchair Accessible: Access to most areas

Website: www.phmc.state.pa.us/bhsm/toh/ephrata/ephratacloister.asp?secid=14

Ephrata Cloister served as a military hospital for about 260 soldiers during the American Revolution, and sixty soldiers were buried on the grounds. Founded in 1732, Ephrata Cloister

Ephrata Cloister

supported about three hundred members who worked and worshiped there at its height, and in 1750, the Brotherhood published a 1,500-page book called the *Martyrs' Mirror* for the Mennonites, which was the largest book published in colonial America. The cloister no longer houses an active congregation, and visitors today can explore the nine original buildings and two original cemeteries of the twenty-eight acre complex. Visitors can tour the community's 1741 meetinghouse, called the *Saal*. The main room includes an original pulpit bench and table, two eighteenth-century candlesticks, and a Bible from early eighteenth-century Germany. Visitors can also see examples of original *Frakturs* (handwritten and embellished documents that recorded births and baptisms) and music manuscripts that are displayed throughout the site. The site also includes a Visitors Center and a Museum Store.

ARCH STREET MEETING HOUSE ———

320 Arch Street, Philadelphia, Pennsylvania 19106
PHONE: 215-627-2667
HOURS: Monday through Saturday
ADMISSION: Donation suggested
WHEELCHAIR ACCESSIBLE: Full access
WEBSITE: www.archstreetfriends.org

Built in 1804, the Arch Street Meeting House is the largest Quaker meetinghouse in the world, and it is still used for services. The site of the meetinghouse was an original land grant given in 1693 by William Penn to the Quakers of Philadelphia to use as a burial ground. For more than one hundred years it was used for that purpose and it is estimated that more than twenty thousand bodies are buried here. Death from the yellow fever epidemics of the mid-1790s contributed to the large number of burials. Burials continued here until 1803, with additional sites provided for important citizens such as Revolutionary War hero Samuel Nicholas, who founded the Marine Corps, and Lucretia Mott, a noted abolitionist. There are exhibits describing William Penn's life in the east wing, as well as dioramas, artifacts, and a slide show depicting Quaker life.

CHRIST CHURCH IN PHILADELPHIA ———

Second Street above Market, Philadelphia, Pennsylvania 19106
PHONE: 215-922-1695
HOURS: Daily
ADMISSION: Suggested donation; nominal fee for cemetery tours
WHEELCHAIR ACCESSIBLE: Full access
WEBSITE: www.oldchristchurch.org; www.christchurchphila.org

Christ Church is called "The Nation's Church" because George Washington, Thomas Jefferson, Francis Hopkinson, Robert Morris, Benjamin Franklin, John Penn, and Betsy

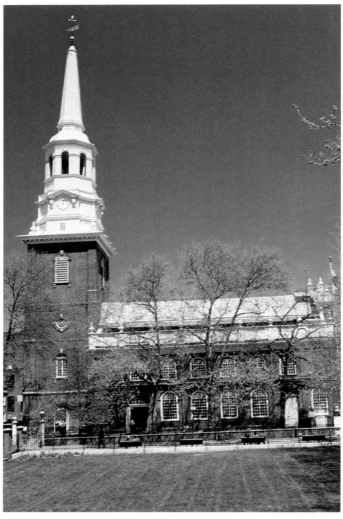

Christ Church

Ross all worshiped here as did fifteen signers of the Declaration of Independence. Declaration of Independence signers James Wilson and Robert Morris are buried in the churchyard, and William White, rector of the parish and chaplain of the Continental Congress, is buried in the chancel of the church. Christ Church Cemetery, which is the final resting place of Benjamin Franklin, his wife Deborah, and four other signers of the Declaration of Independence, is located at Fifth and Arch Streets. Construction of Christ Church began in 1695 and ended 1744, making it the first parish of the Church of England in Pennsylvania. A bas relief of King George on the church's exterior is thought to be the only such depiction of English royalty on a public building in America. Visitors to the church in July will see a 1766 prayer book in which the prayer to King George was crossed out on July 4, 1776. The church's interior also includes a baptismal font that dates from the 1300s and that served as the baptismal of William Penn. The church's steeple was paid for by lotteries organized by Benjamin Franklin, and on July 4, 1788, the steeple's bells rang in celebration all day to announce the ratification of the Constitution.

GLORIA DEI CHURCH (OLD SWEDES CHURCH) ——

Columbus Boulevard and Christian Street, Philadelphia, Pennsylvania 19147

PHONE: 215-389-1513

HOURS: Daily

ADMISSION: No fee charged

Opposite: Gloria Dei Church

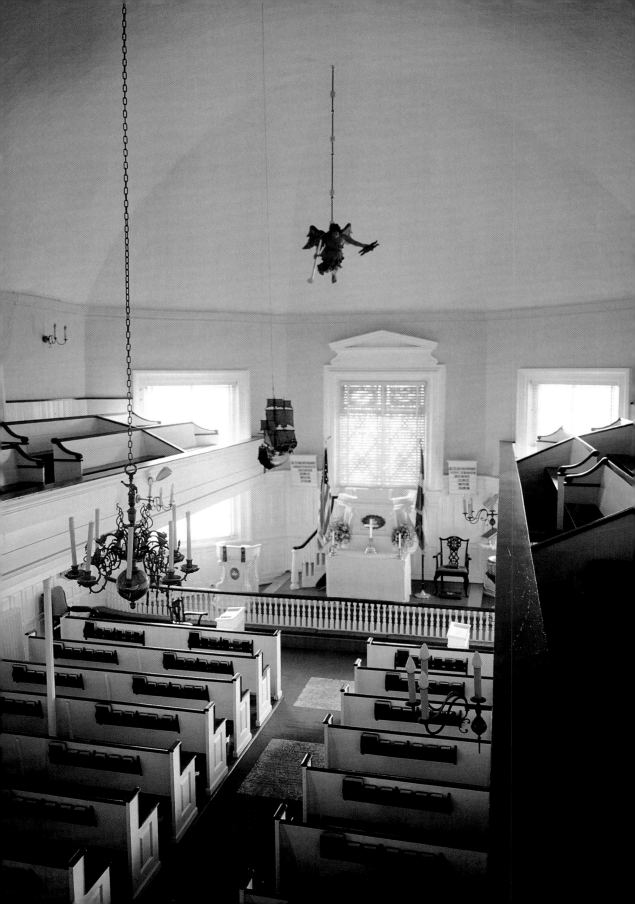

WHEELCHAIR ACCESSIBLE: Full access
WEBSITE: www.GloriaDei-OldSwedes.org; www.nps.gov/glde

Gloria Dei was the site of the marriage of Betsy Ross to John Morton, a signer of the Declaration of Independence who is also buried in the church cemetery; a plaque in the church commemorates this historic union. A memorial to Revolutionary War Patriot John Hansen, president of the Continental Congress under the Articles of Confederation, and the gravesites of five of General George Washington's officers can be found here. Gloria Dei, formerly Old Swedes Church, was built between 1698 and 1700, and it is the oldest church building in the state of Pennsylvania and the second oldest in the nation. Gloria Dei has a collection of artifacts on display for visitors, including church vestments, bibles, and photographs. Gloria Dei (Old Swedes) Church is part of the Independence National Historical Park.

MOTHER BETHEL AME CHURCH

419 Richard Allen Avenue, Philadelphia, Pennsylvania 19147
PHONE: 215-925-0616
HOURS: Tuesday through Saturday
ADMISSION: No fee charged
WHEELCHAIR ACCESSIBLE: No access
WEBSITE: www.motherbethel.org

Mother Bethel African Methodist Episcopal Church was founded in 1787 by Richard Allen, the first black bishop in America, and it is the oldest piece of property in the country continuously owned by African-Americans. Mother Bethel was an important stop in the Underground Railroad, and some current parishioners trace their roots to the slaves who found safety at Mother Bethel. Abolitionists Lucretia Mott and Frederick Douglass both spoke at Mother Bethel, as did many other African-American leaders, including William Still, A. Philip Randolph, Father Divine, Bishop Tutu, and Rosa Parks. Today, Mother Bethel houses the Richard Allen Museum on its lower level, where visitors can find artifacts from the church's history and from the life of Richard Allen. Allen and his wife Sarah are interred in a tomb inside the church.

OLD ST. MARY'S CHURCH

252 South Fourth Street, Philadelphia, Pennsylvania 19106
PHONE: 215-923-7930
HOURS: Monday through Saturday
ADMISSION: No fee charged
WHEELCHAIR ACCESSIBLE: Full access
WEBSITE: www.stmaryholytrinity.org

A plaque in St. Mary's Church commemorates it as the site of the first public religious commemoration of the Declaration of Independence, on July 4, 1779. Between the years 1777 and 1781, the Continental Congress met four times at St. Mary's, and both John Adams and George Washington attended services here. St. Mary's burial ground, which dates to 1759, is the final resting place of many famous Americans, among them John Barry, the "Father of the American Navy," who was the first colonial commander to capture a British ship during the Revolution.

Old St. Mary's Church

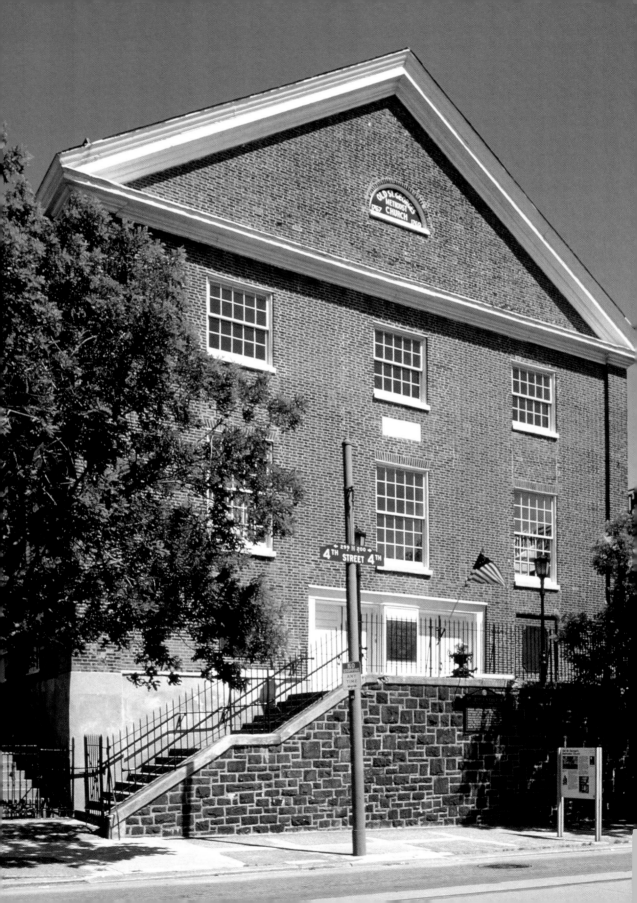

Barry later led a brigade in the battle at Trenton. George Meade, father of the Gettysburg hero of the same name, is interred here, as is Michael Bouvier, the first member of Jacqueline Bouvier Kennedy Onassis's family to live in America. The remains of Thomas Fitzsimons, signer of the Constitution and member of the Continental Congress, also lie in St. Mary's burial ground.

OLD ST. AUGUSTINE CATHOLIC CHURCH

243 North Lawrence Street,
Philadelphia, Pennsylvania 19106
PHONE: 215-627-1838
HOURS: Monday through Friday
ADMISSION: No fee charged
WHEELCHAIR ACCESSIBLE: Full access
WEBSITE: www.st-augustinechurch.com

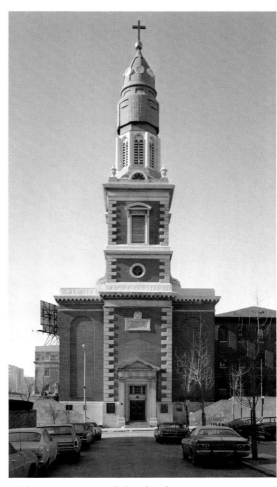

Old St. Augustine Catholic Church

In 1796, President George Washington donated money for the construction of St. Augustine Church, and at the time of its building, St. Augustine was the largest church in Philadelphia. The church's boys' school grew into Villanova University, and the Philadelphia Orchestra grew out of the work of a St. Augustine musical director. During a series of riots in 1844, the first St. Augustine Church, which housed the "Sister Bell," an exact replica of Philadelphia's Liberty Bell, was burned to the ground, but today visitors will find a rebuilt interior that includes ceiling frescoes, two tiers of stained glass windows, and a marble sanctuary.

OLD ST. GEORGE'S UNITED METHODIST CHURCH

255 North Fourth Street, Philadelphia, Pennsylvania 19106
PHONE: 215-925-7788
HOURS: Monday through Friday; weekends by appointment
ADMISSION: No fee charged
WHEELCHAIR ACCESSIBLE: No access
WEBSITE: www.geocities.com/athens/forum/1767

Opposite: Old St. George's United Methodist Church

Dedicated in 1769, St. George's is the oldest Methodist church in continuous service in the United States. Visitors to St. George's in the early years included John Adams, Ben Franklin, Betsy Ross, and Dolly Madison. During the Revolutionary War the building was used by British troops for calvary training. In 1771, Francis Asbury, the "Father of American Methodism," preached his first sermon in America at St. George's, and Richard Allen, the first African-American Methodist preacher in the United States, was ordained at St. George's in 1784. St. George's United Methodist Church displays a number of memorials on site, including a 1789 letter to the Methodist bishops from President George Washington. Historic photographs displayed include pictures of Anna Mae Jarvis, founder of Mother's Day, and the only known portrait in existence of her mother, Anna Reeves Jarvis. Next to the church is the Methodist Historical Center, which displays artifacts of early Methodism, including a communion chalice sent by John Wesley in 1785 and Wesley's own handwritten hymnal.

ST. MARK'S EPISCOPAL CHURCH

1625 Locust Street, Philadelphia, Pennsylvania 19103
PHONE: 215-735-1416
HOURS: Daily
ADMISSION: No fee charged
WHEELCHAIR ACCESSIBLE: Full access
WEBSITE: www.saintmarksphiladelphia.org

St. Mark's first rector, Joseph Wilmer, served the parish until the outbreak of the Civil War in 1861 when he resigned his post and went on to serve as spiritual advisor to General Robert E. Lee. Union General George Meade was one of St. Mark's most notable parishioners, and after Meade's funeral in 1872, his coffin was borne from the church by old friends, among whom was President Ulysses S. Grant. St. Mark's founder, Henry Reed, was a professor of literature at the University of Pennsylvania and a personal friend of William Wordsworth. At Reed's request, Wordsworth composed a sonnet on the close relation of the Church of England to the daughter church in America, the Episcopal Church, of which St. Mark's is a part.

ST. PETER'S CHURCH OF PHILADELPHIA

Third and Pine Streets, Philadelphia, Pennsylvania 19106
PHONE: 215-925-5968
HOURS: Daily
ADMISSION: No fee charged
WHEELCHAIR ACCESSIBLE: Full access
WEBSITE: www.stpetersphila.org

Founded in 1758 as a chapel of ease for Christ Church, St. Peter's Church once numbered

four signers of the Declaration of Independence amongst its worshipers. George Washington visited St. Peter's from time to time when he accompanied his friend Samuel Powel, mayor of Philadelphia. During the Revolutionary War, because British soldiers often confiscated church bells to melt down for ammunition, St. Peter's bells were taken in secret through enemy lines and hidden under the floor boards of Zion Reformed Church in Allentown. Only after the British had left Philadelphia were the bells returned to St. Peter's. St. Peter's graveyard holds the remains of John Nixon, who performed the first public reading of the Declaration of Independence at the state house on July 8, 1776. Also buried here is artist Charles Willson Peale; George Mifflin Dallas, James Polk's vice president; and seven Native American chiefs

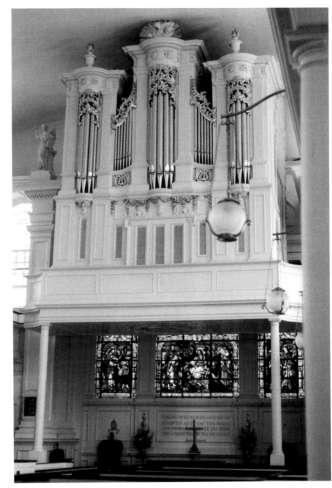

St. Peter's Church, interior

who died in Philadelphia during the smallpox epidemic of January 1793. The row of osage orange trees outside the church are believed to have been planted with clippings brought back by Lewis and Clark after their western explorations. Visitors can tour the graveyard with the aid of a marked map provided by the church. Visitors will want to note the rare interior design of St. Peter's: with the pulpit at one end of the sanctuary, the altar at the other, and box pews facing both ways, there is no true front or back to the church.

THIRD, SCOTS, AND MARINERS PRESBYTERIAN CHURCH (OLD PINE STREET PRESBYTERIAN CHURCH)

412 Pine Street, Philadelphia, Pennsylvania 19106
PHONE: 215-925-8051
HOURS: Monday through Friday; Saturday by appointment only

ADMISSION: No fee charged
WHEELCHAIR ACCESSIBLE: Full access
WEBSITE: www.oldpine.org

Third, Scots, and Mariners Presbyterian Church (Old Pine) was founded in 1768 and was known as the "Church of the Patriots." Its first pastor, George Duffield, served as chaplain to the First Continental Congress in 1774, and John Adams was counted among Old Pine's members; William Hurry, who rang the Liberty Bell the day the Declaration of Independence was read for the first time, is buried here. Seventy-five Old Pine members joined General

Third, Scots, and Mariners Presbyterian Church

Washington at Valley Forge in the winter of 1776–1777. During that winter of occupation, the British used Old Pine first as a hospital and later as a stable for their horses. They stripped the church of anything that could be sold or burned, including the sanctuary's plate and pews. They left behind the bodies of one hundred Hessian mercenaries who lie buried under the east walk of the churchyard. Today, Old Pine remains the only Presbyterian structure in Philadelphia dating back to colonial and revolutionary times.

AUGUSTUS LUTHERAN CHURCH (OLD TRAPPE CHURCH)

717 West Main Street, Trappe, Pennsylvania 19426
PHONE: 610-489-9625
HOURS: Monday through Friday
ADMISSION: No fee charged
WHEELCHAIR ACCESSIBLE: Full access
WEBSITE: www.oldaugustus.org

During the American Revolution, a company of the Pennsylvania militia of Armstrong's brigade occupied Augustus Lutheran Church's building and lawns in bivouac between the

battles of Brandywine and Germantown (between September 23 and October 2, 1777). Built in 1743, the first church building of Augustus Lutheran Church, also known as Old Trappe Church, survives today as the oldest unchanged Lutheran church building in continuous use in the United States and is now known as the Shrine of American Lutheranism. The old stone church has survived in nearly original condition, with the exceptions of boards covering the stone floor and stucco covering the stone walls. The original organ imported from Europe remains in the church, as well as the original high-backed pews. Francis R. Shunck, who was born in Trappe and became Governor of Pennsylvania in 1844, is buried in the church cemetery.

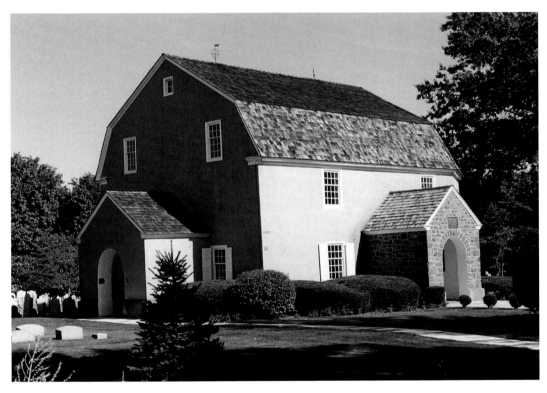

Augustus Lutheran Church

WASHINGTON MEMORIAL CHAPEL (EPISCOPAL) ——

Highway 23, Valley Forge, Pennsylvania 19481

PHONE: 610-783-0120

HOURS: Daily; call for tours

ADMISSION: No fee charged

WHEELCHAIR ACCESSIBLE: Full access

WEBSITE: www.washingtonmemorialchapel.org

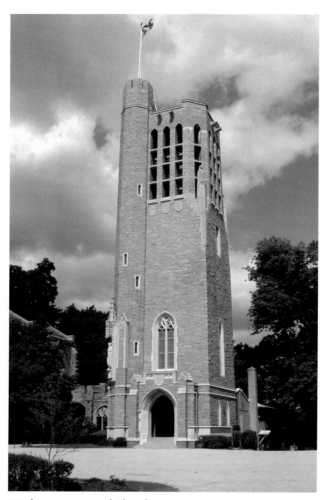

Washington Memorial Chapel

Washington Memorial Chapel was built in 1903 as a tribute to George Washington and his leadership at Valley Forge. On the 125th anniversary of Washington's evacuation from Valley Forge, the cornerstone for the Washington Memorial Chapel was laid. The first chapel built was a wooden structure that gained its own significance when President Theodore Roosevelt spoke there in 1904; it was subsequently named the Theodore Roosevelt Chapel. The main chapel building is rich in symbols of patriotism and American history. The stained glass windows feature scenes including Patrick Henry demanding liberty or death, the life of Washington, and Washington praying at Valley Forge. The choir stalls honor each of the brigades at Valley Forge and even include a uniformed soldier figure atop each stall. The seal of the President of the United States can be seen on a pew near the front of the chapel; the pew is reserved specifically for the president's use during visits to Valley Forge.

NESHAMINY-WARWICK PRESBYTERIAN CHURCH

1401 Meetinghouse Road, Warminster, Pennsylvania 18974
PHONE: 215-343-6060
HOURS: Monday through Friday; cemetery open daily from dawn to dusk
ADMISSION: No fee charged
WHEELCHAIR ACCESSIBLE: Full access
WEBSITE: www.nwpc.net

After George Washington crossed the Delaware River in August of 1777, he stopped his troops near what is now Hartsville and began a thirteen-day encampment. During this time,

Washington issued orders to hold a general court martial in the sanctuary of the Neshaminy-Warwick Presbyterian Church. It included the trial of Captain Henry "Light-Horse Harry" Lee, who was charged with "disobedience of orders." The court, however, unanimously agreed that the charges were groundless, and he was "acquitted with honor." Lee was later governor of Virginia, congressional representative, and father of Civil War general Robert E. Lee. The Neshaminy-Warwick Presbyterian Church was built in 1742, and several Revolutionary War soldiers are buried in the church cemetery.

Neshaminy-Warwick Presbyterian Church

NEW JERSEY

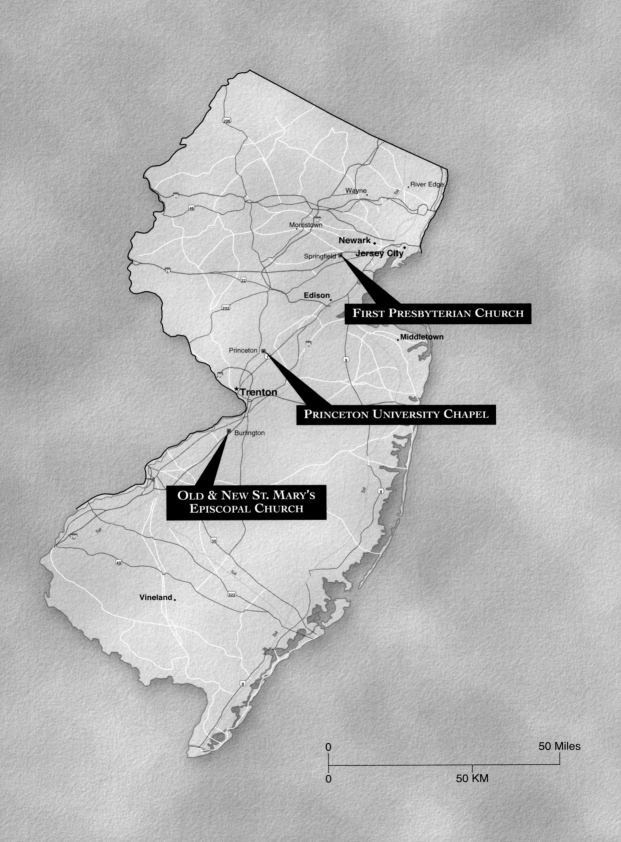

FIRST PRESBYTERIAN CHURCH

PRINCETON UNIVERSITY CHAPEL

OLD & NEW ST. MARY'S
EPISCOPAL CHURCH

0 50 Miles

0 50 KM

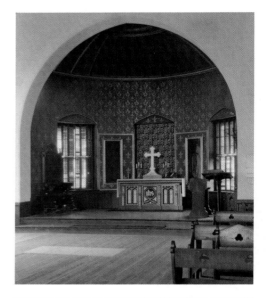

OLD AND NEW ST. MARY'S EPISCOPAL CHURCH

145 West Broad Street, Burlington, New Jersey 08016
PHONE: 609-386-0902
HOURS: New St. Mary's, daily;
Old St. Mary's, open only for special occasions
ADMISSION: No fee charged
WHEELCHAIR ACCESSIBLE: Full access
WEBSITE: www.stmarysburlington.org

In 1782, during the American Revolution, General George Washington attended services at St. Mary's after visiting Patriot soldiers in Burlington. Old St. Mary's rector, Rev. Jonathan Odell, had fled the city as a Loyalist in 1776, and regular services were halted for many years during the war. Founded in 1703, Old St. Mary's Church is the oldest Episcopal church in New Jersey, and its belfry still houses its original 1769 bell. In St. Mary's churchyard cemetery, which dates back to 1695, lie the remains of former New Jersey governor and Revolutionary War officer Joseph Bloomfield, President of the Continental Congress Elias Boudinot, Revolutionary leader and mayor of Burlington Bowes Reed, and Boudinot's son-in-law and Attorney General of the United States William Bradford, as well as several bishops of the Episcopal Church and soldiers from every war in which America fought.

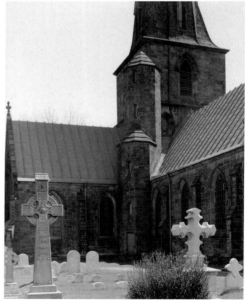

Top: Old St. Mary's Episcopal Chuch
Right: New St. Mary's Episcopal Church

PRINCETON UNIVERSITY CHAPEL

Princeton University, Princeton, New Jersey 08544
PHONE: 609-258-6244
HOURS: Daily
ADMISSION: No fee charged
WHEELCHAIR ACCESSIBLE: Full access
WEBSITE: www.princeton.edu/sites/chapel

Opposite: Princeton University Chapel

The history of the Princeton University Chapel is closely tied to the history of the university itself. Princeton University, first known as the College of New Jersey, was founded by the Presbyterian Synod in 1746. Princeton's worship services were first held that same year in the studies of the first college presidents, Rev. Jonathan Dickinson and Rev. Aaron Burr. Jonathan Edwards was president for less than one year before he died in 1758. Rev. John Witherspoon served as president of Princeton during the American Revolution, and was the only ordained clergyman to sign the Declaration of Independence; Princeton's Nassau Hall was the scene of a meeting of the Continental Congress. Woodrow Wilson served as the university's thirteenth president. The present-day University Chapel dates to 1928, and the pews were created from Army surplus wood which had been slated for use as gun carriages during the Civil War. In the chancel area, stained glass windows depict four great works of literature: Bunyan's *Pilgrim's Progress*, Dante's *Divina Commedia*, Malory's *Le Morte D'arthur*, and Milton's *Paradise Lost*. The chapel also contains a plaque that commemorates Dr. Martin Luther King Jr., who twice preached in the Chapel.

FIRST PRESBYTERIAN CHURCH

37 Church Mall,
Springfield, New Jersey 07081
PHONE: 973-379-4320
HOURS: Monday through Friday
ADMISSION: No fee charged
WHEELCHAIR ACCESSIBLE:
Limited access
WEBSITE: None

Many of the members of the First Presbyterian Church of Springfield enlisted as Patriots during the American Revolution, and the church opened its doors to warehouse supplies for the soldiers while the congregation continued to meet in the garret of the parsonage. The First Presbyterian Church in Springfield earned its place in history on June 23, 1780, when, during the Battle of Springfield, the chaplain of Colonel Elias Dayton's regiment, Rev. James Caldwell,

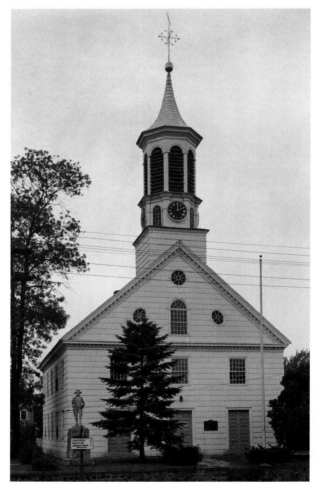

First Presbyterian Church

gave the Patriot soldiers *Watts' Psalms and Hymns* from the church to use as much-needed wadding for their guns. His cry "Give 'em Watts, boys!" became a motto of that battle. The Patriots were able to thwart the redcoats and the Battle of Springfield became the final invasion of the British into New Jersey. Before the battle ended, however, the British soldiers had set fire to most buildings in the town, including the First Presbyterian Church. The congregation rebuilt their church in 1791 and this is the structure that stands today—a classic eighteenth-century Protestant meetinghouse.

DELAWARE

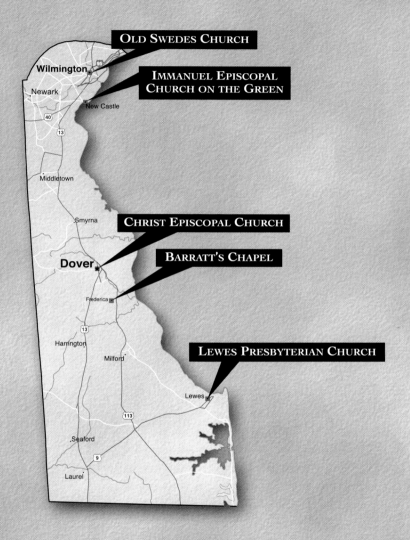

OLD SWEDES CHURCH

IMMANUEL EPISCOPAL
CHURCH ON THE GREEN

Wilmington

Newark

New Castle

Middletown

Smyrna

CHRIST EPISCOPAL CHURCH

Dover

BARRATT'S CHAPEL

Frederica

13

Harrington

Milford

LEWES PRESBYTERIAN CHURCH

Lewes

113

Seaford

9

Laurel

0 100 Miles

0 100 KM

CHRIST EPISCOPAL CHURCH

South State and Water Streets, Dover, Delaware 19901

PHONE: 302-734-5731

HOURS: Monday through Friday;
call before visiting

ADMISSION: No fee charged

WHEELCHAIR ACCESSIBLE: Full access

WEBSITE: www.christchurchdover.org

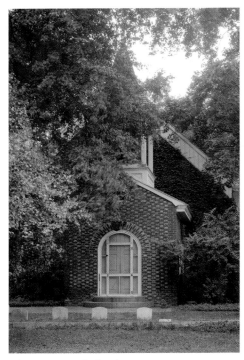

In the graveyard of Christ Episcopal Church is a monument to Delaware's Caesar Rodney, a delegate to the Continental Congress, a signer of the Declaration of Independence, a brigadier general of the Revolutionary War, and governor of Delaware. Rodney was senior warden and a member of the vestry of Christ Episcopal Church for twenty-six years. Christ Episcopal Church was founded in 1703, and the present church building and the brick wall enclosing the church yard were erected in 1734.

Christ Episcopal Church

BARRATT'S CHAPEL AND MUSEUM

6362 Bay Road, Frederica, Delaware 19946

PHONE: 302-335-5544

HOURS: Saturday and Sunday; other times by appointment

ADMISSION: No fee charged

WHEELCHAIR ACCESSIBLE:
Limited access

WEBSITE:
www.barrattschapel.org

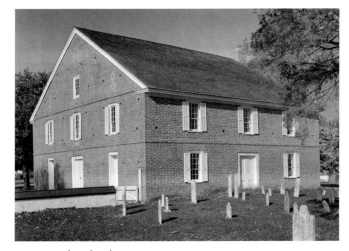

Built in 1780, Barratt's Chapel is the oldest Methodist house of worship still standing in the United States. A bronze star in the floor of the chapel marks the place where Francis Asbury, the leader of the Methodist movement in America, and Thomas Coke, a representative of John

Barratt's Chapel and Museum

Wesley, first met in 1784 to discuss the formation of the Methodist Church. Barratt's Chapel has since been called the "Cradle of Methodism." The site today includes the original 1780 chapel, a reconstructed eighteenth-century vestry, and a museum, which includes a three-thousand-volume research library, archives, and displays of artifacts. Open to the public, the archives house material dating from the eighteenth-century to the present and include sermons, memoirs, hymnals, Sunday school literature, church records, and biographies, among other items.

LEWES PRESBYTERIAN CHURCH

133 Kings Highway, Lewes, Delaware 19958
PHONE: 302-645-5345
HOURS: Daily
ADMISSION: No fee charged
WHEELCHAIR ACCESSIBLE: Limited access
WEBSITE: www.lewestoday.com/presbchurch

Matthew Wilson was the minister of Lewes Presbyterian from 1756–1790 and gained renown as an active opponent of the Tories during the Revolution. Rev. Wilson's remains lie in the church cemetery along with the graves of patriot Colonel David Hall, who also served as governor of Delaware, and veterans of the Revolutionary War, the War of 1812, and the Civil War. Lewes Presbyterian Church was founded in 1692 after Francis Makemie, called the "Father of American Presbyterianism," came from Scotland in answer to a call for a Presbyterian minister for the Maryland area.

The church displays a silver communion service given to the church by Col. Samuel Boyer Davis, a commander in the Delaware militia during the War of 1812 and great-grandson of the first pastor, Rev. Samuel Davis. There is a memorial in the vestibule to Reverend John Mitchelmore, who drowned in the Delaware River when the steamer *William Penn* burned in 1834.

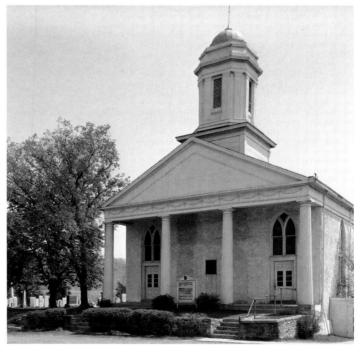

Lewes Presbyterian Churcch

IMMANUEL EPISCOPAL CHURCH ON THE GREEN ——

The Strand and Harmony Streets, New Castle, Delaware 19720

PHONE: 302-328-2413

HOURS: Monday through Friday

ADMISSION: No fee charged

WHEELCHAIR ACCESSIBLE: Limited access

WEBSITE: www.immanuelonthegreen.org

The cemetery of Immanuel Episcopal Church on the Green contains the graves of several Revolutionary War veterans as well as George Read, a signer of the Declaration of Independence, delegate to the Continental Congress, and member of the U. S. Constitutional Convention. Founded in 1689, Immanuel Episcopal Church on the Green is one of the oldest parishes in the United States.

HOLY TRINITY (OLD SWEDES) CHURCH ——

606 Church Street, Wilmington, Delaware 19801

PHONE: 302-652-5629

HOURS: Wednesday through Saturday; groups by appointment

ADMISSION: Nominal fee

WHEELCHAIR ACCESSIBLE: Limited access

WEBSITE: www.oldswedes.org

In the Battle of Brandywine during the Revolutionary War, British soldiers occupied Old Swedes. After the American Revolution, in 1791, Old Swedes Church became part of the Protestant Episcopal Church and its name became Holy Trinity (Old Swedes) Church. Completed in 1699, Old Swedes Church remains in use today and is the oldest American church building still standing as originally built. The interior of Old Swedes includes the oldest known pulpit in the United States, carved in 1698. Old Swedes' churchyard contains the graves of more than fifteen thousand people, including the remains of veterans from every American war from the Revolution to Vietnam. The Old Swedes Gift Shop is located next to the church in the restored 1690s stone farmhouse now called the Hendrickson House Museum. The museum includes 1690s furniture as well as numerous artifacts, including a foot warmer, a candlestick maker, and an antique picnic set.

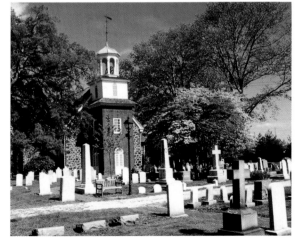

Old Swedes

Opposite: Immanuel Episcopal Church on the Green

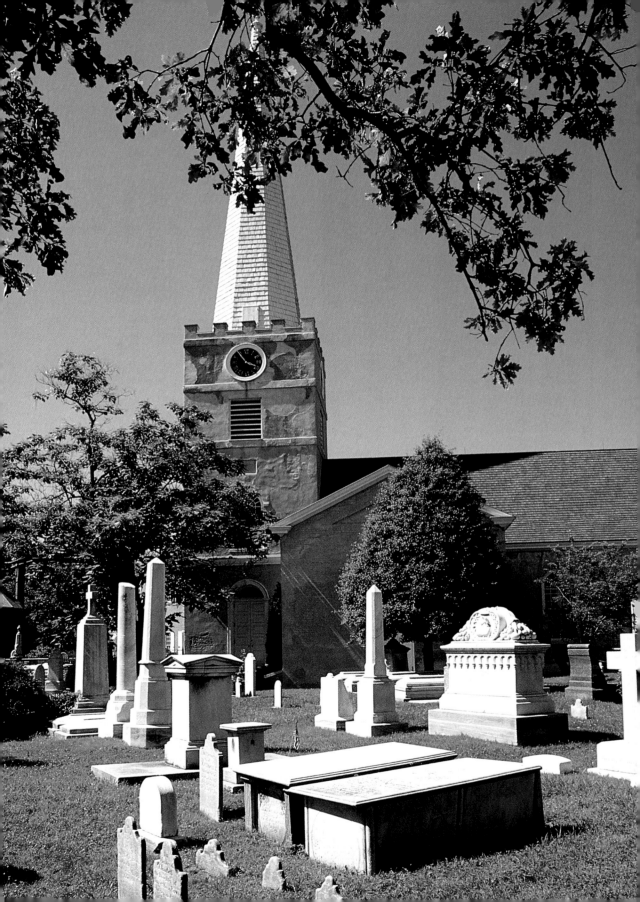

MARYLAND

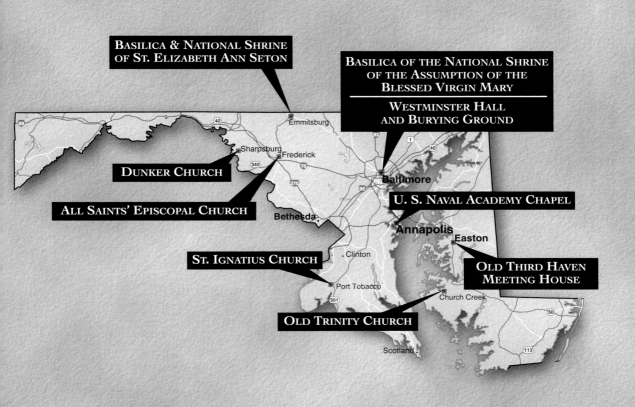

BASILICA & NATIONAL SHRINE OF ST. ELIZABETH ANN SETON

BASILICA OF THE NATIONAL SHRINE OF THE ASSUMPTION OF THE BLESSED VIRGIN MARY

WESTMINSTER HALL AND BURYING GROUND

DUNKER CHURCH

ALL SAINTS' EPISCOPAL CHURCH

U. S. NAVAL ACADEMY CHAPEL

ST. IGNATIUS CHURCH

OLD THIRD HAVEN MEETING HOUSE

OLD TRINITY CHURCH

Emmitsburg

Sharpsburg

Frederick

Baltimore

Bethesda

Annapolis

Easton

Clinton

Port Tobacco

Church Creek

Scotland

0 100 Miles

0 100 KM

U. S. NAVAL ACADEMY CHAPEL

101 Cooper Road, Annapolis, Maryland 21402

PHONE: 410-293-1100

HOURS: Daily; closed all federal holidays

ADMISSION: No fee charged

WHEELCHAIR ACCESSIBLE: Full access

WEBSITE: www.usna.edu/Chaplains

The crypt of the U. S. Naval Academy Chapel is the resting place of one of the Navy's founders, John Paul Jones, well-remembered for his reply to a British request for surrender: "I have

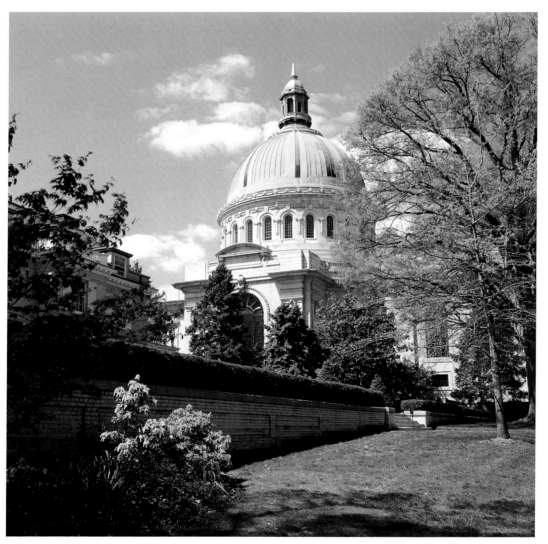

U. S. Naval Academy Chapel

not yet begun to fight!" Jones was commissioned in the Continental Navy in 1775 and was the first to hoist the Grand Union flag on a Continental warship. President Theodore Roosevelt spoke at the commemoration ceremony when Jones's remains were brought to Annapolis from France in 1905, and in 1913 Jones was buried in the crypt of the U. S. Naval Academy Chapel. Today, an honor guard stands duty whenever the crypt is

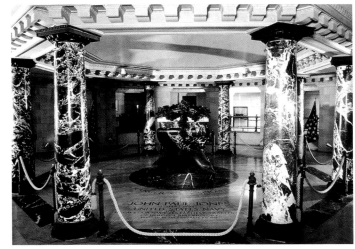

U. S. Naval Academy Chapel

open to the public. The Chapel also displays the Tiffany Studio's Rear Admiral William Sampson window as well as Admiral David Glasgow Farragut's Prayer Book, which was used on board his flagship during the Civil War.

BASILICA OF THE NATIONAL SHRINE OF THE ASSUMPTION OF THE BLESSED VIRGIN MARY (BALTIMORE CATHEDRAL)

408 North Charles Street, Baltimore, Maryland 21201
PHONE: 410-727-3565
HOURS: Daily
ADMISSION: No fee charged
WHEELCHAIR ACCESSIBLE: Full access
WEBSITE: www.baltimorebasilica.org

Known as the Baltimore Cathedral, the Basilica of the National Shrine of the Assumption of the Blessed Virgin Mary was built in 1821 and became the first major religious building constructed in America after the adoption of the Constitution. Three historical Americans influenced the design and architecture of America's first cathedral: Benjamin Henry Latrobe, the first architect of the U. S. Capitol; President Thomas Jefferson, who advised Latrobe regarding the design of the Cathedral; and John

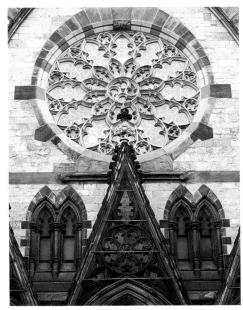

Basilica of the Assumption

Carroll, first bishop of the United States and cousin of Charles Carroll, a signer of the Declaration of Independence. The interior of the cathedral includes oil paintings given by Louis XVIII and Charles X of France. Visitors to the cathedral have included Pope John Paul II, Mother Teresa, and the Ecumenical Patriarch of Constantinople.

WESTMINSTER HALL AND BURYING GROUND

509 W. Fayette Street, Baltimore, Maryland 21201
PHONE: 410-706-2072
HOURS: By appointment only
ADMISSION: Nominal fee for entrance to the catacombs
WHEELCHAIR ACCESSIBLE: Full access
WEBSITE: www.westminsterhall.org

The most famous grave at Westminster Burying Ground is that of Edgar Allan Poe, who died in Baltimore on October 7, 1849. His young wife is buried beside him. Every year since 1949, on the night of Poe's birthday, a stranger known as the "Poe Toaster" leaves a bottle half-full of cognac and three roses on Poe's grave. Visitors will also find the graves of Revolutionary War veterans and soldiers killed during the War of 1812. Colonel James McHenry, a signer of the U. S. Constitution and the Secretary of War under Presidents Washington and Adams, lies here, as does Robert Smith, Secretary of the Navy and Attorney General under Thomas Jefferson. Westminster Church was built in 1852 over an old Presbyterian graveyard that was the final resting place of many important Marylanders. To protect the graves beneath, the new church was built on brick piers, which created a series of catacombs. Westminster is no longer an active church and is now run by Westminster Preservation Trust, Inc. The refurbished floor-to-ceiling 1882 Johnson pipe organ is still played for the public once a month.

OLD TRINITY EPISCOPAL CHURCH

1716 Taylor's Island Road, Church Creek, Maryland 21622
PHONE: 410-228-2940
HOURS: Daily, by appointment only
ADMISSION: No fee charged
WHEELCHAIR ACCESSIBLE: Full access
WEBSITE: None

Old Trinity Church, founded circa 1675, is the oldest church in the United States of America now standing in its original form and regularly used. The church was required to pay tithes to the Bishop of London until 1692 when Queen Anne granted Old Trinity Church full privileges as an independent church. In 1703 Queen Anne donated to Old Trinity a Bible, a communion service, and a pillow that she knelt on at her coronation. The church measures a tiny thirty-eight feet by twenty feet and both the walkway and interior floor are made of brick.

Of note is the historic Table of Marriages hanging on the back wall inside the church. A mandatory feature of all Episcopal churches at the time, the table provided lists of all relatives a man or woman could not marry. The church also includes a reproduction of the original three-decked pulpit.

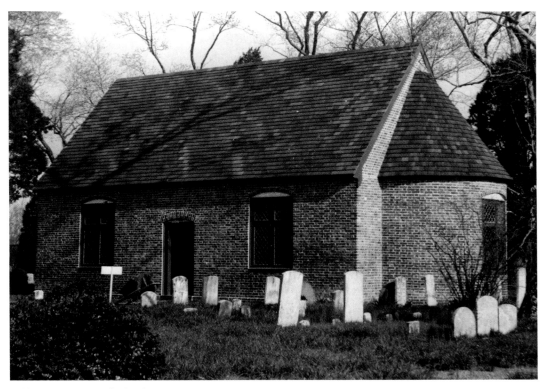

Old Trinity Episcopal Church

OLD THIRD HAVEN MEETING HOUSE

405 South Washington Street, Easton, Maryland 21601
PHONE: 410-822-0293
HOURS: Daily
ADMISSION: No fee charged
WHEELCHAIR ACCESSIBLE: Full access
WEBSITE: www.pym.org/southern-qm/thirdhaven/

Many notable Quakers worshiped at Old Third Haven Meeting House, including William Penn, John Woolman, John Fothergill, Samuel Bownas, and Rufus Jones. The Old Third Haven Meeting House is the oldest wooden church structure still in use in the United States. It boasts the oldest public library in Maryland, dating back to 1673 when George Fox, founder of the Religious Society of Friends, visited the area and sent books to the Quaker

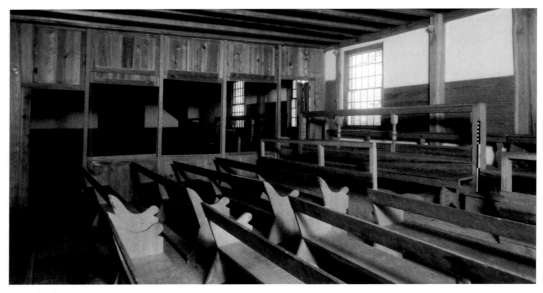

Old Third Haven Meeting House

community here upon his return to England. The meetinghouse itself was constructed in 1684, while the brick building now used in winter months was built in 1880.

Basilica and National Shrine of St. Elizabeth Ann Seton

333 South Seton Avenue, Emmitsburg, Maryland 21727

Phone: 301-447-6606

Hours: Shrine Museum open Tuesday through Sunday; basilica open daily.
Closed all major holidays as well as the last week of January and the first week of February.

Admission: No fee charged

Wheelchair Accessible: Full access

Website: www.setonshrine.org

While approximately eighty thousand Union troops encamped on the property just before the Battle of Gettysburg in June of 1863, General Carl Scars and his staff sheltered in the "White House," built to house Elizabeth Ann Seton's Saint Joseph's Academy and Free School, the country's first free school for girls staffed by sisters. St. Elizabeth Ann Seton, the first native-born citizen of the United States to be canonized, founded the Sisters of Charity of Saint Joseph's in 1809 as the first new community for religious women established in the United States. Seton's remains rest beneath her altar in the 1965 basilica, and the site today includes the Stone House (circa 1750), first home of the American Sisters of Charity; the White House (1810); the original cemetery of the Sisters of Charity, including the Seton family graves; the Mortuary Chapel (1846); and a Vistor's Center and Museum.

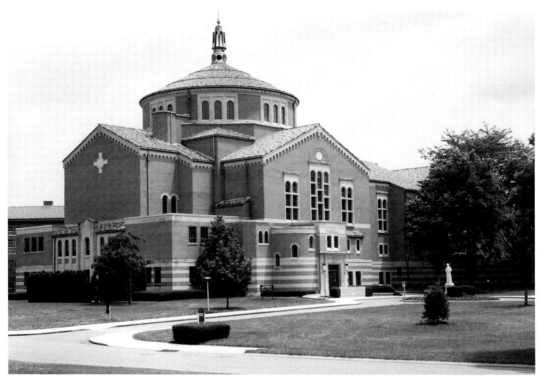

Basilica and National Shrine of St. Elizabeth Ann Seton

ALL SAINTS' EPISCOPAL CHURCH ———————

108 West Church Street, Frederick, Maryland 21701

PHONE: 301-663-5625

HOURS: Monday through Saturday

ADMISSION: No fee charged

WHEELCHAIR ACCESSIBLE: Limited access

WEBSITE: www.allsaintsmd.org

Formed in 1742, the All Saints' Episcopal Church was left with little or no clergy support and no elected vestry from 1776 until 1804 because of the impact of the American Revolution. Francis Scott Key, author of the "Star-Spangled Banner," worshiped at All Saints' Episcopal Church, as did Thomas Johnson, the first governor of Maryland. In addition, Senator Charles McCurdy Mathias and the late congressional representative Goodloe E. Byron were members of the church. One of All Saints' rectors, the Reverend William Pendleton, became a major general in the Confederate Army and Chief of Artillery of the Army of Northern Virginia. During the Civil War, All Saints' Episcopal Church, parish hall, and rectory were used as field hospitals following the Battle of Antietam in 1862. A dog statue, nicknamed "Guess," has stood sentinel at the front entrance of the church since the early nineteenth

century, except for a brief time during the Civil War when the statue was kidnapped by Confederate soldiers, who intended to melt "Guess" down for cannon balls. Union soldiers rescued the statue and returned it to its rightful home. The church displays a number of artifacts, including a *Book of Common Prayer* and a Bible published together in one volume in England in 1751 and used at All Saints' during the American Revolution.

ST. IGNATIUS CHURCH

8855 Chapel Point Road, Port Tobacco, Maryland 20677
PHONE: 301-934-8245
HOURS: Daily; call ahead to schedule tours
ADMISSION: No fee charged
WHEELCHAIR ACCESSIBLE: Full access
WEBSITE: www.chapelpoint.org

St. Ignatius is the oldest permanent Catholic mission in British North America. It was founded in 1641 by Father Andrew White, S.J., one of the first Jesuit missionaries to arrive in Maryland. The current 1798 church building includes the cornerstone that was laid by John Carroll, bishop of Baltimore and first bishop of the United States. The church has an Italian marble statue of St. Ignatius, which was given to the Jesuits by the actress Susan Hayward. On display is a "relic of the true cross" in a silver and glass case, given to Father White by Queen Henrietta Maria of England, as well as a small silver "saddle chalice," used by the early Jesuit missionaries, that can be taken apart and disguised as a bell. An old slave/servant house is located on the property. A tunnel runs from beneath the slave house to the river, which may have been used to hide priests from the British or to hide slaves as part of the Underground Railroad. The site also includes the Manor House, St. Thomas Manor, which was built in 1741 and was occupied by Union troops during the Civil War.

DUNKER CHURCH

Antietam National Battlefield, U. S. Route 65, Sharpsburg, Maryland 21782
PHONE: 301-432-5124
HOURS: Daily; closed Thanksgiving, Christmas, and New Year's Day
ADMISSION: Nominal fee
WHEELCHAIR ACCESSIBLE: No
WEBSITE: www.nps.gov/anti/dunker.htm

On September 17, 1862, Dunker Church stood riddled with bullets and cannon balls after the Battle of Antietam, the bloodiest one-day battle in American history, which left more than twenty-three thousand Union and Confederate soldiers dead, wounded, or missing. The day after the battle, representatives from the opposing sides held a truce outside the Dunker

Church; it is also claimed that the church was later used as an embalming station for the Union army. The Battle of Antietam left Dunker Church with a damaged roof and walls in great need of repair, and regular services did not resume until 1864 when the church was repaired and rededicated. Although veterans of Antietam revered the site, the church fell into disrepair and in 1921 it was leveled by a wind storm. Dunker Church was reconstructed by the National Park Service in 1961 using salvaged material such as door frames, windows, and benches from the original church as well as three thousand original bricks, and is now part of the Antietam National Battlefield.

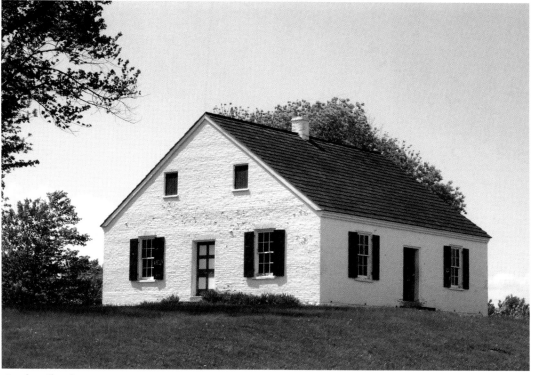

Dunker Church

WASHINGTON, D.C.

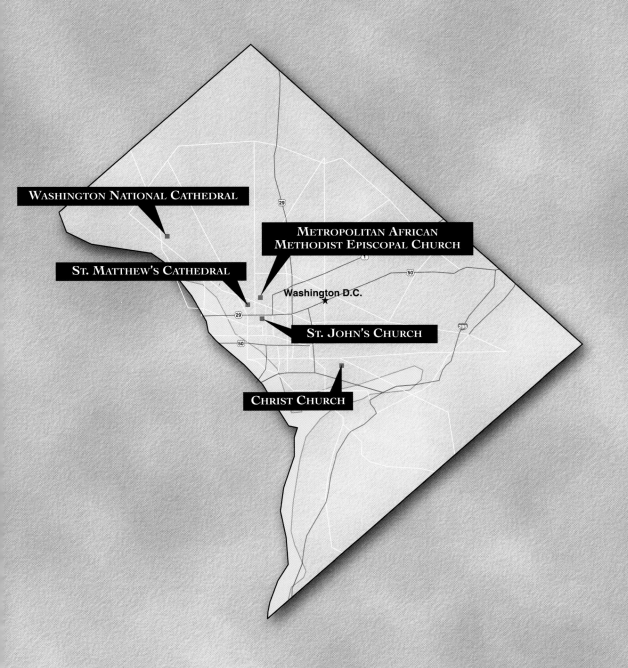

WASHINGTON NATIONAL CATHEDRAL

METROPOLITAN AFRICAN
METHODIST EPISCOPAL CHURCH

ST. MATTHEW'S CATHEDRAL

Washington D.C.

ST. JOHN'S CHURCH

CHRIST CHURCH

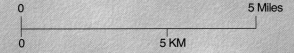

0 5 Miles

0 5 KM

CHRIST CHURCH

620 G Street SE, Washington, D.C. 20003

PHONE: 202-547-9300

HOURS: Call Monday through Thursday between 9 A.M. and 1 P.M. EST for information.

ADMISSION: No fee charged

WHEELCHAIR ACCESSIBLE: Limited access

WEBSITE: www.washingtonparish.org; www.congressionalcemetery.org

Presidents James Madison and James Monroe worshiped at Christ Church, and Thomas Jefferson attended services at the congregation's previous site in an old tobacco warehouse. Composer John Philip Sousa was baptized and married at Christ Church, and he is buried in the the church's burying ground, Congressional Cemetery, which serves as the unofficial burial ground for members of the U. S. Congress. (The cemetery is located at 18th and E Streets Southeast.) During the Civil War, Christ Church's tower was used by Union soldiers as a lookout post. Following the assassination of President Abraham Lincoln, church member David Herold was hanged for assisting the escape of John Wilkes Booth; Herold is buried in Congressional Cemetery. Also in the cemetery are the gravesites of nineteen U. S. Senators and sixty-eight members of

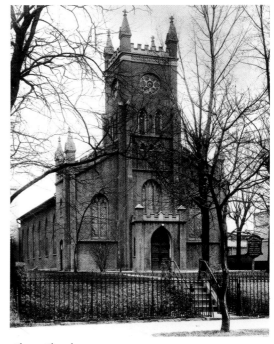

Christ Church

the House of Representatives as well as the gravesites of Confederate and Union soldiers, Cabinet officers, a vice president, a Supreme Court justice, and Civil War photographer Matthew Brady. Christ Church, which was erected in 1807, has stood on Capitol Hill for nearly two hundred years.

METROPOLITAN AFRICAN METHODIST EPISCOPAL (AME) CHURCH

1518 M Street NW, Washington, D.C. 20005

PHONE: 202-331-1426

HOURS: Monday through Friday

ADMISSION: No fee charged

WHEELCHAIR ACCESSIBLE: Full access

WEBSITE: www.metropolitanamec.org

Abolitionist and author Frederick Douglass worshiped regularly at Metropolitan AME Church, as did poet Paul Laurence Dunbar. Two standing candelabras in the sanctuary were donated by Douglass, and the pews where both Douglass and Dunbar sat during worship are identified with brass name plates. Douglass's funeral was held at Metropolitan in 1895. Frederick Douglass Hall, the church's fellowship area, displays the emancipation papers of Harriet Bond. Bond was a Union Bethel AME Church member who was freed when slaves in the District of Columbia were emancipated in April of 1862. Guest speakers at Metropolitan AME Church have included W.E.B. DuBois, Paul Laurence Dunbar, Frederick Douglass, Ida B. Wells, Booker T. Washington, Mary McLeod Bethune, and Winnie Mandela, among others. Known as the "national cathedral of African Methodism," Metropolitan African Methodist Episcopal Church was founded in 1838.

ST. JOHN'S CHURCH

1525 H Street NW, Washington, D.C. 20005
PHONE: 202-347-8766
HOURS: Daily; guided tours after the 11 A.M. Sunday service
ADMISSION: No fee charged
WHEELCHAIR ACCESSIBLE: Full access
WEBSITE: www.stjohns-dc.org

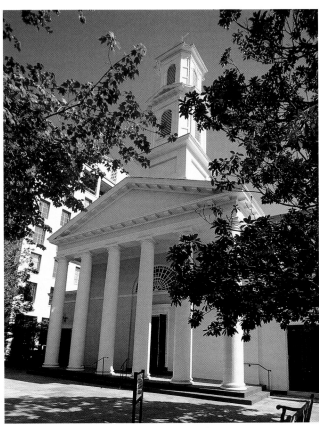

St. John's Church

For nearly two centuries, many U. S. presidents have worshiped at St. John's Church, which is known as the "Church of the Presidents." The first was James Madison, who sat in pew fifty-four in 1816; the next five presidents—James Monroe, John Quincy Adams, Andrew Jackson, Martin Van Buren, and William Henry Harrison—also worshiped weekly in pew fifty-four, which became known as the president's pew. Subsequent presidents have made a point to attend at least one service at the church, and most have signed an eighteenth-century prayer book that is kept in the president's pew. St. John's Church was designed in 1816 by Benjamin Latrobe, who also designed portions of the U. S. Capitol and the White House.

CATHEDRAL OF ST. MATTHEW THE APOSTLE

1725 Rhode Island Avenue NW, Washington, D. C. 20036

PHONE: 202-347-3215

HOURS: Daily; both self-guided and docent-lead tours available

ADMISSION: No fee charged

WHEELCHAIR ACCESSIBLE: Full access

WEBSITE: www.stmatthewscathedral.org

St. Matthew's Cathedral was the location of the November 25, 1963, funeral service for assassinated President John F. Kennedy. This day of national mourning is commemorated inside the church by a marble plaque that marks the location of the president's casket during his funeral service. In 1979 Pope John Paul II celebrated Mass here, and a bust in the cathedral of the pope commemorates his visit. The Cathedral of St. Matthew the Apostle holds an annual autumn "Red Mass" to request divine guidance for the judiciary and the legal profession, and is attended by Supreme Court justices, members of Congress, the Cabinet, and often the President of the United States. The church also has a replica of Michelangelo's *Pieta*.

WASHINGTON NATIONAL CATHEDRAL

Massachusetts and Wisconsin Avenues NW, Washington, D.C. 20016

PHONE: 202-537-6200

HOURS: Daily

ADMISSION: Donation requested

WHEELCHAIR ACCESSIBLE: Limited access

WEBSITE: www.nationalcathedral.org

Washington National Cathedral was the site of funeral services for former presidents Woodrow Wilson, Dwight Eisenhower, and Ronald Reagan. Martin Luther King Jr. spoke from the cathedral's pulpit in his last Sunday sermon prior to his assassination. Woodrow Wilson, Helen Keller, Admiral George Dewey, Bishop Henry Satterlee, and the architects Henry Vaughan and Philip Frohman are among the notable Americans buried in the National Cathedral. Washington National Cathedral was conceived in 1792 when Pierre L'Enfant, designer of basic plan for Washington, D.C., suggested a plot of land be set aside for a "great church for national purposes." Work on the cathedral was finally begun in 1907 following a ceremonial address by President Theodore Roosevelt, and the Cathedral was completed eighty-three years later, in 1990. The Cathedral is the sixth largest in the world and the second largest in the United States. Tour guides provide descriptions of the many memorials to famous persons and events in America's history.

Opposite: Washington National Cathedral

VIRGINIA

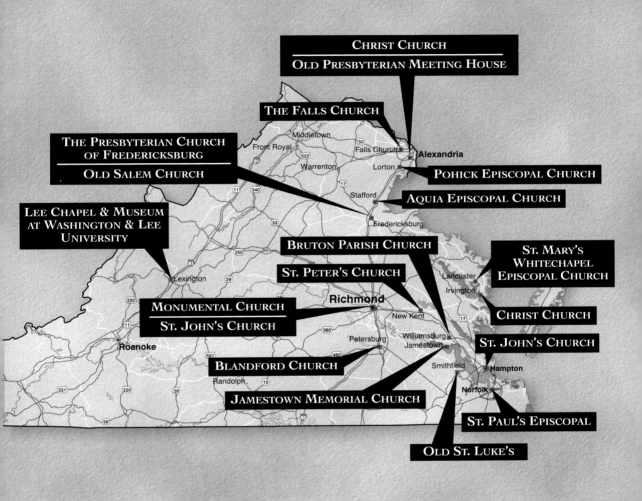

CHRIST CHURCH

OLD PRESBYTERIAN MEETING HOUSE

THE FALLS CHURCH

THE PRESBYTERIAN CHURCH
OF FREDERICKSBURG

OLD SALEM CHURCH

POHICK EPISCOPAL CHURCH

AQUIA EPISCOPAL CHURCH

LEE CHAPEL & MUSEUM
AT WASHINGTON & LEE
UNIVERSITY

BRUTON PARISH CHURCH

ST. PETER'S CHURCH

ST. MARY'S
WHITECHAPEL
EPISCOPAL CHURCH

Richmond

CHRIST CHURCH

MONUMENTAL CHURCH

ST. JOHN'S CHURCH

ST. JOHN'S CHURCH

Roanoke

BLANDFORD CHURCH

JAMESTOWN MEMORIAL CHURCH

ST. PAUL'S EPISCOPAL

OLD ST. LUKE'S

Middletown

Front Royal

Falls Church

Alexandria

Lorton

Warrenton

Stafford

Fredericksburg

Lexington

Lancaster

Irvington

New Kent

Petersburg

Williamsburg
Jamestown

Smithfield

Hampton

Randolph

Norfolk

0 100 Miles

0 100 KM

CHRIST CHURCH

118 North Washington Street, Alexandria, Virginia 22314

PHONE: 703-549-1450

HOURS: Daily

ADMISSION: No fee charged

WHEELCHAIR ACCESSIBLE: Limited access

WEBSITE: www.historicchristchurch.org

Built in 1767, Christ Church received the financial support of such parishioners as George Washington. Robert E. Lee also worshiped here; in fact, Lee attended services here the day before he traveled to Richmond to become Confederate commander. During the Civil War, the city of Alexandria was occupied by Union forces; unlike many of the other area churches that had been taken by the Union army and used as hospitals or stables, Christ Church was not damaged. Nonetheless, Christ Church's Confederate parishioners were forced out and the church was used for services by U. S. Army chaplains. After the war, Christ Church was returned to its congregation, and today the pews used by both Washington and Lee are marked by plaques. In honor of Christ Church's ties to the father of our country, tradition dictates that each president visit the church at least once during his administration. President Franklin Delano Roosevelt visited Christ Church on January 1, 1942, accompanied by British Prime Minister Winston Churchill, for the World Day of Prayer for Peace.

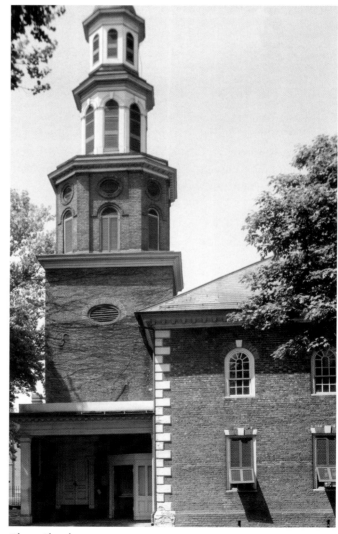

Christ Church

OLD PRESBYTERIAN MEETING HOUSE

521 South Fairfax Street, Alexandria, Virginia 22314

PHONE: 703-549-6670

HOURS: Daily

ADMISSION: No fee charged

WHEELCHAIR ACCESSIBLE: Full access

WEBSITE: www.opmh.org

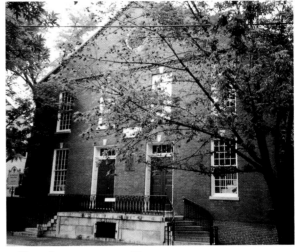

Old Presbyterian Meeting House

Many members of the Old Presbyterian Meeting House fought in both the Revolutionary War and the War of 1812, and forty members who fought in the American Revolution are buried in the graveyard adjacent to the church, along with one unknown veteran who has been recognized with the *Memorial to an Unknown Soldier of the American Revolution.* Four funeral services for George Washington were held at the Meeting House in 1799, although Washington was actually a member of Christ Church in Alexandria. Dr. James Muir, pastor of Old Presbyterian and personal friend of Washington, and Dr. James Craik, Washington's personal physician, attended Old Presbyterian. Craik and Muir are both buried in the church graveyard. Washington himself worshiped at Old Presbyterian in 1798 on the National Day of Solemn Humiliation, Fasting, and Prayer. With clear glass windows and box pews, the sanctuary today maintains an unadorned style that evokes life from the earliest days of the nation.

THE FALLS CHURCH

115 E. Fairfax Street, Falls Church, Virginia 22046

PHONE: 703-532-7600

HOURS: Monday through Friday

ADMISSION: No fee charged

WHEELCHAIR ACCESSIBLE: Full access

WEBSITE: www.thefallschurch.org

The Falls Church was established in 1732 by the Colonial General Assembly, and the congregation elected George Washington to be a vestryman, and another notable American figure, Francis Scott Key, served as a layreader. The church served as a recruiting station during the Revolution and a military hospital and stable during the Civil War. Today, the structure of Falls Church is the original 1769 construction. Visitors will want to see the baptismal font that was stolen by a soldier during the Civil War and hidden in Star Tavern, where local townspeople

recognized it and hid it until they returned it to the church in 1876. Other items of note include the silver markers on the fifth row of pews in memory of George Washington and Robert E. Lee. The south lawn of the churchyard includes the oldest tree on the grounds—a huge white oak tree that has been recorded as the largest specimen of *Quercus alba* in the state. The Falls Church cemetery includes the graves of Revolutionary War veterans, known and unknown Confederate and Union soldiers, and a Baptist minister named Mr. Read, who was hanged for being a Civil War spy. The oldest marked grave bears the year 1805; historians have surmised that the rounded indentations on this gravestone were caused by bullets fired by Civil War soldiers quartered here during the conflict.

THE PRESBYTERIAN CHURCH OF FREDERICKSBURG

810 Princess Anne Street, Fredericksburg, Virginia 22401
PHONE: 540-373-7057
HOURS: Monday through Friday; inquire at church office
ADMISSION: No fee charged
WHEELCHAIR ACCESSIBLE: Limited access
WEBSITE: www.fredericksburgpc.org

During the Civil War, the Presbyterian Church of Fredericksburg was heavily shelled in the 1862 Battle of Fredericksburg and the church bell was given to the Confederacy to be melted down for ammunition. The church soon became an emergency hospital, and it was here that Clara Barton, founder of the American Red Cross, first came to care for the Union wounded. A plaque inside the church pays tribute to Barton. The close of the war left the building in ruins, but by 1866 the sanctuary was rebuilt, largely through funds donated by friends in the North.

OLD SALEM CHURCH

4054 Plank Road, Fredericksburg and
Spotsylvania National Military Park,
Fredericksburg, Virginia 22405
PHONE: 540-373-6122
HOURS: Daily; guided tours available
ADMISSION: Nominal fee
WHEELCHAIR ACCESSIBLE: Limited access
WEBSITE: www.nps.gov/frsp/sc.htm

Although Old Salem Church today stands in the midst of commercial development, it was once surrounded by firing Federal soldiers during the Civil War. When war

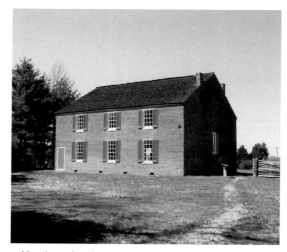

Old Salem Church

broke out in 1861, many men in Old Salem's congregation joined the Confederate army. During the Battle of Fredericksburg in December of 1862, local townspeople fled their homes and camped in the relative safety of Old Salem Church, where they stored what furniture they could salvage. In May of 1863, the church itself became part of the Battle of Chancellorsville. During the battle, gunmen fired from the church's upper gallery. Marks from the bullets of Federal soldiers returning fire can still be seen on the exterior of the church. Although the Confederates were able to drive back the Union soldiers, many lives were lost and many men were wounded, and the church became a field hospital immediately following the conflict. The church has since been donated to the National Park Service and stands today on an acre of land with two adjacent Civil War memorials.

ST. JOHN'S CHURCH

100 West Queen's Way, Hampton, Virginia 23669
PHONE: *757-722-2568*
HOURS: Monday through Saturday
ADMISSION: No fee charged
WHEELCHAIR ACCESSIBLE:
Limited access
WEBSITE: www.stjohnshampton.org

St. John's Church has stood amidst warring soldiers in the American Revolution, the War of 1812, and the Civil War. St. John's survived the Revolutionary War untouched by the British bombing of Hampton, and during the War of 1812, the town and the church were ransacked by British troops but the church walls were left standing, although damaged. St. John's did not fare so well when the Civil War came to Virginia. When Confederate soldiers fled Hampton, they burned the city down rather than allow it to fall into Union hands. Like most of Hampton, St. John's burned; but although the interior was destroyed, the church's brick walls again remained standing. St. John's has been restored to its former colonial appearance. The parish house today

St. John's Church

contains a museum, which displays photographs, artifacts of the orginal 1623–27 church, ancient Bibles and Prayer Books, and other items. The church cemetery includes graves that date back to 1701 and include a number of memorials and monuments, including the Hannah Nicholson Tunnel Memorial, which honors the woman who earned a citation during the Civil War for crossing Union lines to warn the Confederate forces of an advance. Visitors will also see the Virginia Laydon Memorial, which honors the first surviving child born of English parents in the New World.

CHRIST CHURCH

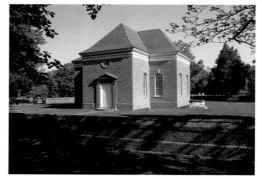

420 Christ Church Road, Irvington, Virginia 22480
PHONE: 804-438-6855
HOURS: Daily; closed Thanksgiving, Christmas, and New Year's Day; Carter Reception Center closed December through March
ADMISSION: No fee charged
WHEELCHAIR ACCESSIBLE: Full access
WEBSITE: www.christchurch1735.org

Completed in 1735, Christ Church is often hailed as one of the best-preserved of colonial

Christ Church

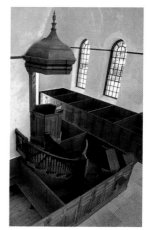

Virginia's Anglican parish churches. The building was begun in 1730 and financed by Robert "King" Carter, the most powerful planter in colonial Virginia, who died three years before its completion. Carter was the ancestor of eight Virginia governors, two presidents, three signers of the Declaration of Independence, a Chief Justice of the Supreme Court, and Confederate General Robert E. Lee. Inside the church are vaulted ceilings, large compass-headed windows, a three-tiered pulpit, and the only collection of high-backed pews remaining in Virginia. The Carter Reception Center on the grounds houses a museum with exhibits on the history of Christ Church and Robert Carter as well as a small gift shop. The museum gallery exhibits artifacts from the church including the original communion silver, some of which Robert Carter ordered from England in 1720. The tombs of Robert Carter and his two wives, Judith Armistead Carter and Betty Landon Carter, stand in the churchyard.

JAMESTOWN MEMORIAL CHURCH

Historic Jamestowne, 1365 Colonial Parkway, Jamestown, Virginia 23081
PHONE: 757-229-1733
HOURS: Daily; closed Christmas and New Year's Day
ADMISSION: Nominal fee
WHEELCHAIR ACCESSIBLE: Limited access
WEBSITE: www.historicjamestowne.org

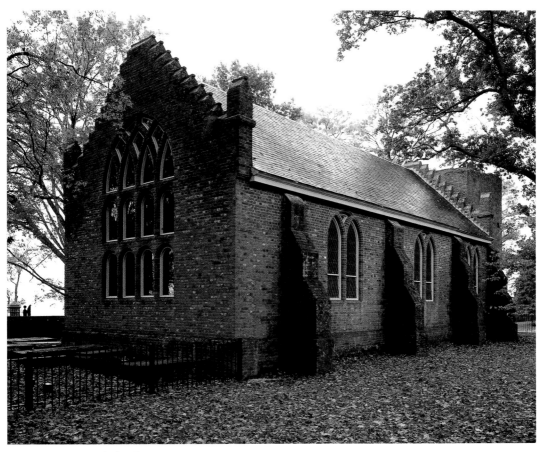

Jamestown Memorial Church

Jamestown Memorial Church is situated in the heart of Historic Jamestowne, the first permanent English settlement in North America, begun in 1607. Built in the early years of the twentieth century, Memorial Church marks the location of Jamestown's four previous churches, dating back to the very earliest days of colonial America. Jamestown's first church burned in January, 1608. It was replaced by a wooden church where Pocahontas and John Rolfe were later married. The tower of the fourth church, built in 1639 and burned during Bacon's Rebellion in 1676, remains standing today as the only intact seventeenth-century structure in Jamestown. A fifth church was built and used until the 1750s. Its bricks were used to build the wall around the present graveyard. Jamestown Memorial Church was built in 1907 just outside the foundations of the earlier churches. Visitors can take several tours, which include the Jamestown Memorial Church, the 1639 church tower, a burial ground, and the Dale House, which houses sixteenth- and seventeenth-century artifacts, including ceramics, glassware, weaponry, tools, furniture, and other objects used by Jamestown's early colonists. Visitors will also find a Museum Store and a Visitors Center.

St. Mary's Whitechapel Episcopal Church

5940 White Chapel Road,
Lancaster, Virginia 22502
PHONE: 804-462-5908
HOURS: Monday
through Friday
ADMISSION: No fee charged
WHEELCHAIR ACCESSIBLE:
Limited access
WEBSITE: None

George Washington's maternal
grandfather served St. Mary's
Whitechapel Episcopal Church
as a vestryman in its early
years, and several members of
Washington's mother's family,
the Balls, were parishioners.

St. Mary's Whitechapel Episcopal Church

The Ball family built the extant gallery within the church as their own personal seating in 1740; today the church cemetery includes the graves of many Ball family members. The interior of St. Mary's Whitechapel includes three altar tablets, inscribed with the Ten Commandments, the Lord's Prayer, and the Apostles' Creed, that are the oldest such artifacts in the Commonwealth of Virginia. The church also includes a 1718 baptismal font imported from England.

Lee Chapel and Museum at Washington and Lee University

Jefferson Street, Washington and Lee University, Lexington, Virginia 24450
PHONE: 540-458-8768
HOURS: Daily; closed
Thanksgiving and the day after,
Christmas Eve, Christmas, and
New Year's Day
ADMISSION: No fee charged
WHEELCHAIR ACCESSIBLE:
Full access
WEBSITE: http://leechapel.wlu.edu

Lee Chapel at Washington and
Lee University contains the family
crypt in which Robert E. Lee, his

Lee Chapel

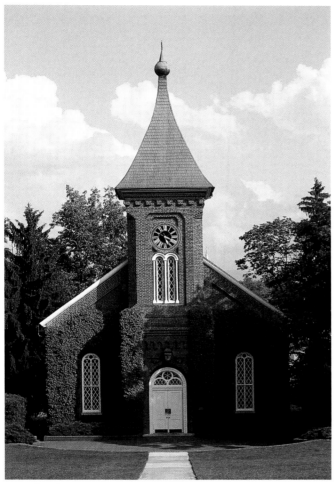

Lee Chapel

wife, mother, father, and children are interred. Lee's horse, Traveller, is buried just outside the chapel. After the Civil War, General Robert E. Lee became president of what was then called Washington College. Upon his recommendation, construction was begun on a new chapel, completed in 1868. Lee attended daily worship services with the students here. Upon Lee's death in 1870, the College's name was changed to Washington and Lee University in his honor, and the Chapel continues to be used, as in Lee's day, as the largest auditorium space on campus. The museum, renovated in 1998, contains exhibits of its two namesake generals, Washington and Lee. The museum's artifacts include an important collection of early American portraits of the Washington, Custis, and Lee families, including the 1772 portrait of "Washington as Colonel of the Virginia Regiment" by Charles Willson Peale. The museum exhibition also includes Robert E. Lee artifacts that date prior to and just after the Civil War, including insignia, binoculars, and spyglass used during the Mexican War. On display in the Chapel auditorium is the circa 1875 marble sculpture entitled "Recumbent Lee" by Richmond artist Edward Valentine.

POHICK EPISCOPAL CHURCH

9301 Richmond Highway, Lorton, Virginia 22079
PHONE: 703-339-6572
HOURS: Daily
ADMISSION: No fee charged
WHEELCHAIR ACCESSIBLE: Full access
WEBSITE: www.pohick.org

Pohick Episcopal Church

Pohick Church was built as the parish church for both George Washington's Mount Vernon estate and its neighbor, Gunston Hall, the home of George Mason. Washington himself is believed to have surveyed and chosen the site for the church while Mason oversaw its construction. The church today includes an original brick exterior and an interior reconstructed with box pews and hour-glass pulpit. The pews of all of the original vestrymen are marked with plaques, including those of Washington, Mason, and George Fairfax. Pohick's second rector, the Reverend Lee Massey, is buried underneath the pulpit, his tombstone marking the site. During the Civil War the church's interior was destroyed by Union troops, who used the building as a stable. Pohick was restored, although the carved initials of occupying soldiers can still be seen on the walls. Visitors will also want to see the twelfth-century baptismal font, which was sent to Pohick Church from England and had been originally used in a monastery to grind grain. The church cemetery contains the remains of William Brown, the first Surgeon General of the United States, and several members of the Alexander family, for which the city of Alexandria was named, are also buried here. In addition, several of the colonial vestrymen are buried near the church, including Daniel McCarty, Daniel French, Peter Wagener, and Hugh West.

St. Peter's Episcopal Church

8400 St. Peters Lane, New Kent, Virginia 23124

PHONE: 804-932-4846

HOURS: Monday through Friday

ADMISSION: No fee charged

WHEELCHAIR ACCESSIBLE: Limited access

WEBSITE: www.geocities.com/stpeterstc

St. Peter's parish was established by the General Court of Virginia in 1679, and the current church building was erected in 1703. In January of 1759, Col. George Washington and the widow Martha Dandridge Custis were married at St. Peter's, and church records indicate that another First Lady, Letitia Christian, wife of President John Tyler, was likely baptized here in 1790. During the Civil War, Union troops damaged St. Peter's while using the building for stables and storage. Visitors to the parish house will see a number of historic photographs by Matthew Brady of Union General "Bull" Sumner and his men, who camped here in May of 1862. Commander of the Union army General George B. McClellan visited St. Peter's during the encampment. On the church itself, the names and units of several of the Union soldiers from Sumner's division are carved into the bricks. After the war, Mary Ann Randolph Custis, Martha Washington's great-granddaughter and general Robert E. Lee's wife, spearheaded a movement to restore the church. The Lees' son, General William Henry Fitzhugh Lee, supervised work on the restoration beginning in 1869 and contributed needed lumber. In 1960, the Virginia General Assembly officially designated St. Peter's "The First Church of the First First Lady." St. Peter's churchyard contains a number of tombs that date back to colonial times.

St. Paul's Episcopal Church

201 St. Paul's Boulevard, Norfolk, Virginia 23510

PHONE: 757-627-4353

HOURS: Monday through Friday

ADMISSION: Donation requested

WHEELCHAIR ACCESSIBLE: Full access

WEBSITE: None

St. Paul's Episcopal Church, formed in 1641 and built in 1739, is the only building to survive the burning of Norfolk by British troops in 1776. On New Year's Day of that year, English ships opened fire on Norfolk; the attack set a series of blazes and many of the city's buildings burned to the ground. St. Paul's remained standing, although it stood a roofless ruin. Colonial troops then completed the city's destruction to prevent British occupation. The southeast corner of the church still holds a British cannon ball as a memorial of the event. In the years preceding the American Revolution, Rev. Thomas Davis of St. Paul's joined the Sons of

St. Paul's Church

Liberty and protested the Stamp Act, and during the Revolutionary years Rev. Davis served as chaplain to a Virginia regiment. During the Civil War, St. Paul's services halted and Union soldiers occupying Norfolk used the church instead. More than one hundred years later, General Douglas MacArthur's funeral was held at St. Paul's Episcopal Church in 1964. MacArthur and his wife Jean are buried at the MacArthur Memorial in Norfolk, a few blocks from St. Paul's. The interior of St. Paul's features a double-decker pulpit, enclosed box pews, and an elaborate altarpiece.

BLANDFORD CHURCH

319 South Crater Road, Petersburg, Virginia 23805

PHONE: 804-733-2396

HOURS: Daily; closed on all major holidays

ADMISSION: Nominal fee

WHEELCHAIR ACCESSIBLE: Full access

WEBSITE: www.petersburg-va.org/tourism/museums.htm

Originally erected between 1735 and 1737 through the efforts of Thomas Jefferson's father, Bladford Church and cemetery were damaged during the 1781 Battle of Petersburg during

the American Revolution. During the Civil War, the building served as a Confederate field hospital for men wounded during the Battle of the Crater at the Siege of Petersburg, 1864–1865. The church fell into disrepair after the war, but in 1901 a local women's group restored the church and transformed it into a Confederate Memorial Chapel. Each of the fifteen former Confederate states funded a Tiffany stained glass window, dedicated to their state's dead. The church also displays nine memorial plaques including those to Robert E. Lee and the soldiers of the American Revolution and the Civil War. Outside the church is Blandford Cemetery, the second largest cemetery in Virginia. Approximately thirty thousand Confederate soldiers are buried on Memorial Hill in the cemetary, which covers approximately 189 acres and also includes the grave of a British general from the Revolutionary War. Its oldest grave marker bears the date 1702.

Blandford Church

MONUMENTAL CHURCH

1224 E. Broad Street, Richmond, Virginia 23219

PHONE: 804-643-7407

HOURS: Open for special events; call for information

ADMISSION: Call for information

WHEELCHAIR ACCESSIBLE: No access

WEBSITE: www.historicrichmond.com

Monumental Church was erected in 1814 to memorialize the seventy-two people who lost their lives in a fire that engulfed a theater on this site in 1811. The city hired Robert Mills, the first native-born American architect and the only architectural student of Thomas Jefferson, to design a fitting memorial to those who lost their lives in the fire. A crypt below the church contains the remains of those who perished in the fire, and a memorial urn stands in the church's portico. Edgar Allan Poe attended worship services at Monumental Church with his foster parents, Mr. and Mrs. John Allan. Other members have included Justice John Marshall, Confederate Lt. Gen. Leonidas Polk, and Lewis Webb Chamberlayne, a founder of the Medical College of Virginia. When the Marquis de Lafayette returned to Virginia in 1824, he was honored during a service at Monumental Church. Today, Monumental Church is owned by the Historic Richmond Foundation, which opens the church for special events and tours and is currently undertaking a complete restoration of the building.

ST. JOHN'S CHURCH

Twenty-fourth and Broad Streets,
Richmond, Virginia 23223
PHONE: 804-648-5015
HOURS: Daily
ADMISSION: Nominal fee
WHEELCHAIR ACCESSIBLE:
Full access
WEBSITE:
www.historicstjohnschurch.org

Built 1741, St. John's Church forever became a part of American history in March of 1775, when delegates from the Virginia colony gathered here to discuss the future of the British colonies in America. Thomas Jefferson, George Washington, Benjamin Harrison, and Patrick Henry were among the 120 delegates who met here to debate the necessity of preparing for rebellion against King George III. On March 23, Henry rose and urged the delegates to join the rebellion, uttering his most famous words, "Give me liberty or give

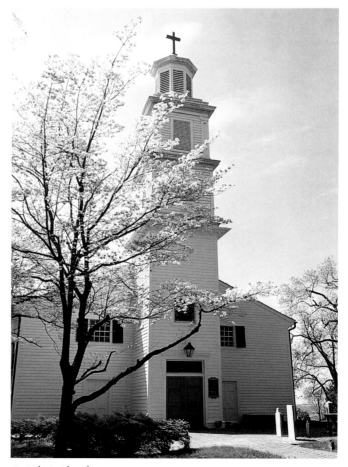

St. John's Church

me death!" The delegates voted by a margin of five to support Henry's call and to train and arm local militia units for potential war with England. On July 17, 1775, the Virginia delegates met again at St. John's to organize the war effort in Virginia. The following year, Henry became the first revolutionary governor of Virginia. In 1781 the traitorous Benedict Arnold, general in the British Army, quartered his troops at St. John's Church after occupying the city of Richmond. Reenactments of the Second Virginia Convention of March 1775 have been performed at St. John's since 1976. Presented by the Patrick Henry Committee of St. John's, the reenactments are held during the summer months and include living history interpreters and professional actors in 1770s attire. Ten of the founding fathers who participated in the convention debates are portrayed and the performance culminates with Mr. Henry's "Liberty or Death" speech.

OLD ST. LUKE'S

14477 Benn's Church Boulevard, Smithfield, Virginia 25430
PHONE: 757-357-3367
HOURS: Tuesday through Sunday; closed Thanksgiving, Christmas, and the month of January
ADMISSION: No fee charged
WHEELCHAIR ACCESSIBLE: Limited access
WEBSITE: www.historicstlukes.org

During the American Revolution, British Colonel Banastre Tarleton and his troops camped on the grounds of Old St. Luke's for a time but caused no damage. During the Civil War, a small contingent of Confederate soldiers encamped on the church's grounds. Local legend says the soldiers used the church building to stable their horses. Visitors can see a display in the church about Camp Ruffin, as the Civil War encampment was called. Old St. Luke's, founded in 1632 and also known as the Old Brick Church, is the oldest standing church in the original thirteen colonies and the oldest English church in America. Renovations to the church included the addition of several stained glass windows honoring prominent Virginians and one tribute window to Pocahontas, the first convert to the gospel. Old St. Luke's also acquired the oldest intact organ in America, a 1630 English chamber organ. The interior of Old St. Luke's is filled with both English and American seventeenth-century furnishings and appointments, and visitors can still see the brick incised with the year 1632 displayed. The church also has its original Bible, which is displayed at an annual service called the Pilgrimage.

AQUIA EPISCOPAL CHURCH

2938 Jefferson Davis Highway, Stafford, Virginia 22554
PHONE: 540-659-4007
HOURS: Monday through Friday
ADMISSION: No fee charged
WHEELCHAIR ACCESSIBLE: Full access if given advance notice
WEBSITE: www.aquiachurch.com

Aquia Episcopal Church was occupied by Union soldiers during the Civil War and some of their graffiti has been preserved on the walls. Aquia Episcopal Church was first established by the colonial government in 1667 as a parish in the Church of England. The present church building, constructed in 1751, features one of the last remaining three-tiered pulpits in Virginia. The

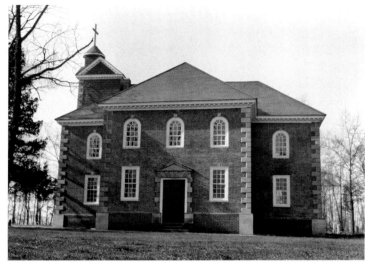

Aquia Episcopal Church

church's burial grounds include the graves of many early residents of Stafford County and date to the early eighteenth century.

BRUTON PARISH CHURCH

201 W. Duke of Gloucester Street, Williamsburg, Virginia 23187-3520

PHONE: 757-229-2891

HOURS: Daily

ADMISSION: Nominal fee

WHEELCHAIR ACCESSIBLE: Limited access

WEBSITE: www.brutonparish.org

In the years preceding the American Revolution, many members of the Virginia House of Burgesses, including such influential figures as George Washington, Thomas Jefferson, and Patrick Henry worshiped at Bruton Parish Church; memorial pews today bear these names and more. The members of the House of Burgesses gathered at Bruton Parish Church for a special service following the passage of the Stamp Act in 1765. After the port of Boston was closed in 1774, the burgesses formally marched together to the church for a Day of Fasting, Humiliation, and Prayer. The church's first rector was Rowland Jones (1674–1688), great-grandfather of Martha Washington; his gravestone can be seen at the church. The current church building was erected in 1715 while Williamsburg was the capital of the Virginia colony. The 1769 tower houses the Virginia Liberty Bell, and a rare *Book of Common Prayer* from Bruton is displayed at the College of William and Mary, which includes the pages where the prayer for the king was crossed out and a prayer for the president of the United States was substituted. During the Civil War, Bruton became a hospital for soldiers wounded at the Battle of Williamsburg in May of 1862, and the remains of many Confederate soldiers lie in

the churchyard. The rector of Bruton at that time, Thomas M. Ambler, eventually left to serve the Confederate army as a chaplain. At the turn of the twentieth century, restoration efforts included the donation of a bronze lectern given by President Theodore Roosevelt and the large Bible that rests upon it, given by King Edward VII. Today, not only the church but all of colonial Williamsburg has been restored to its colonial appearance, thanks in part to the financial support of John D. Rockefeller Jr.

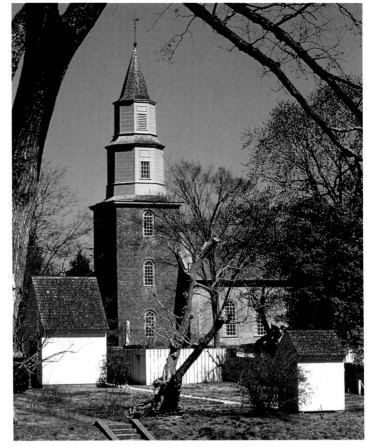

Bruton Parish Church

WEST VIRGINIA

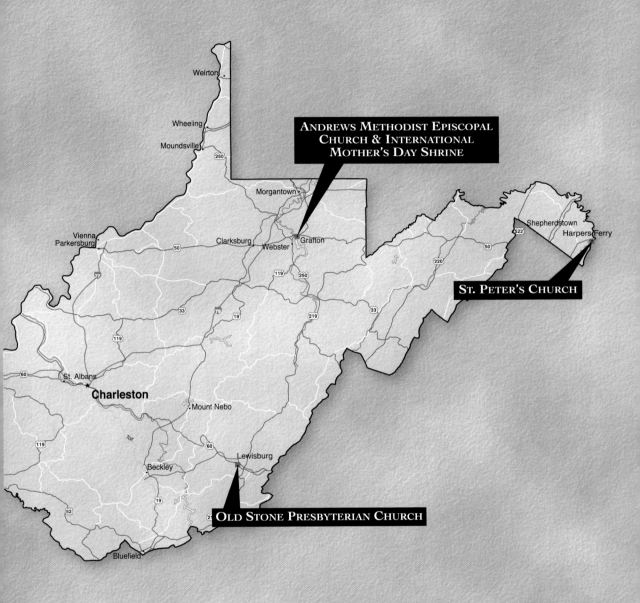

Weirton

Wheeling

Moundsville

250

Morgantown

**ANDREWS METHODIST EPISCOPAL
CHURCH & INTERNATIONAL
MOTHER'S DAY SHRINE**

Shepherdstown

522

Harpers Ferry

Vienna
Parkersburg

Clarksburg

Webster

Grafton

50

50

ST. PETER'S CHURCH

77

50

119

250

220

33

75

19

219

33

119

St. Albans

60

Charleston

Mount Nebo

119

60

Lewisburg

Beckley

OLD STONE PRESBYTERIAN CHURCH

52

19

Bluefield

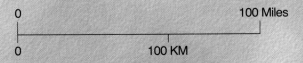

0 100 Miles

0 100 KM

ST. PETER'S CHURCH

Church Street, Harpers Ferry, West Virginia 25425

PHONE: 304-535-6298

HOURS: Daily

ADMISSION: No fee charged

WHEELCHAIR ACCESSIBLE: Limited access

WEBSITE: None

St. Peter's Catholic Church, built in the 1830s, was the only church in Harpers Ferry to survive the Civil War with little damage, a remarkable feat considering the town of Harpers Ferry changed hands between the Confederates and the Federalists fourteen times during the war. The sparing of the church building has been credited to Father Michael A. Costello, who was pastor at St. Peter's during the war. Father Costello continued to conduct Mass throughout the war and also administered last rites to dying soldiers. He reportedly flew a Union Jack flag over the church in hopes that Confederate soldiers would spare it, since the Confederacy considered Britain to be an ally to their cause. St. Peter's Church today sits amid the Harpers Ferry National Historical Park. No longer an active church, it is still open to the public.

ANDREWS METHODIST EPISCOPAL CHURCH AND INTERNATIONAL MOTHER'S DAY SHRINE

Grafton, West Virginia 26354

PHONE: 304-265-1589

HOURS: Monday through Friday, April 15 through October 31

ADMISSION: No fee charged

WHEELCHAIR ACCESSIBLE: No access

WEBSITE: www.mothersdayshrine.org

This Victorian-era church, with stained glass windows and pressed tin ceilings, has been known since 1962 as the International Mother's Day Shrine. Built in 1873 as the Andrews Methodist Episcopal Church, it officially became the Mother's Day Shrine in recognition of parishioner Anna Mae Jarvis. Miss Jarvis led the movement in the early years of the twentieth century to establish an official national holiday in honor of mothers. The first official Mother's Day service was held in Andrews Methodist Church on May 10, 1908. On May 14, 1914 Congress passed and President Wilson signed a joint resolution naming the second Sunday in May as National Mother's Day.

OLD STONE PRESBYTERIAN CHURCH

200 Church Street, Lewisburg, West Virginia 24901

PHONE: 304-645-2676

Hours: Daily
Admission: No fee charged
Wheelchair Accessible: Full access
Website: www.oldstone.us

During the Civil War, Old Stone Presbyterian Church served as a makeshift hospital for wounded and dying soldiers from the Battle of Lewisburg in 1862. The plain stone church was constructed in 1796, making it the oldest sanctuary in continuous use west of the Allegheny Mountains. Visitors today can see the original slave gallery, which stretches the length of three sides of the sanctuary.

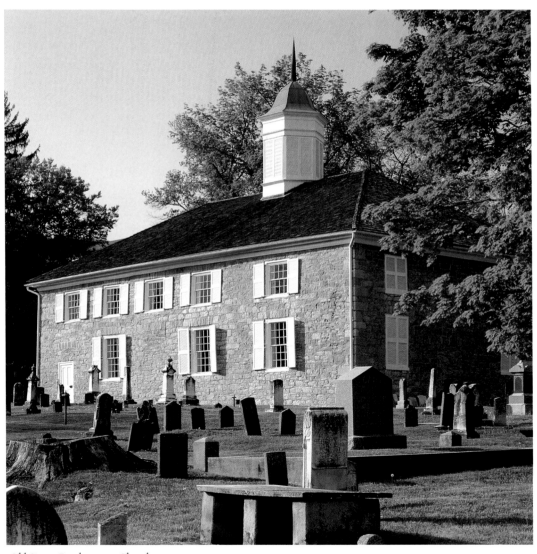

Old Stone Presbyterian Church

SOUTHEAST

Across the Southeast there are historic churches with stories to tell. During the Civil War, the churches of the American south saw their bells melted down for weapons and their walls scarred by battle; they saw their buildings become barracks, hospitals, and headquarters for generals; they saw their congregations scattered and divided and their burying grounds filled with fallen soldiers. In the twentieth century, many of the churches of the American South led the nation in the Civil Rights movement. They hosted meetings, launched marches, and offered inspiration. Add to these the many churches with ties to colonial days, the American Revolution, and to the days of the Spanish explorers and the result is a treasure trove of history and heritage awaiting discovery.

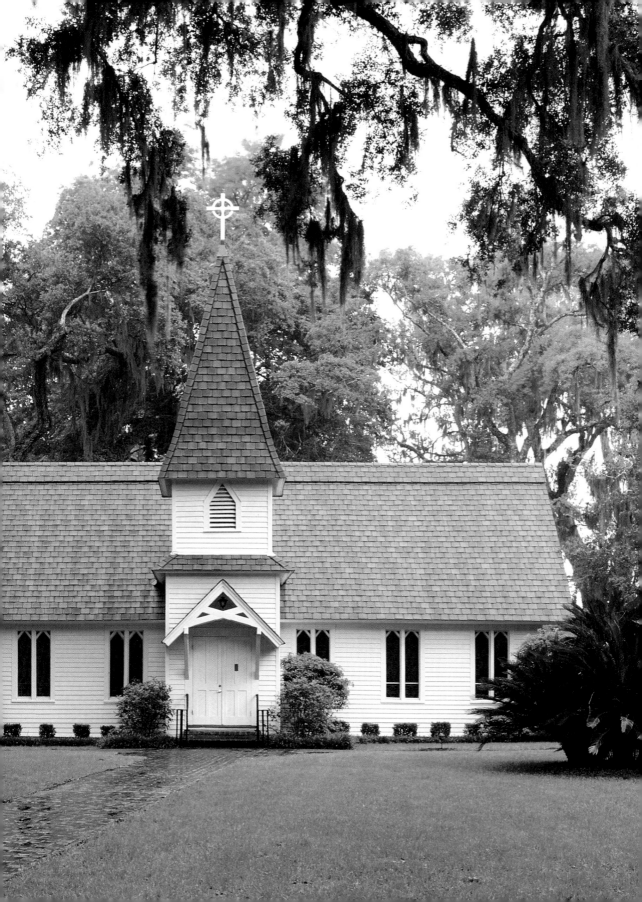

NORTH CAROLINA

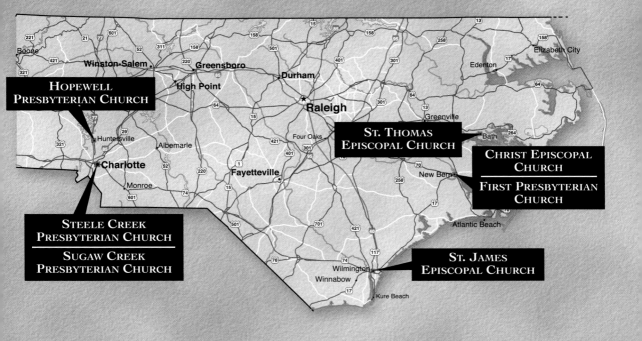

HOPEWELL PRESBYTERIAN CHURCH

ST. THOMAS EPISCOPAL CHURCH

CHRIST EPISCOPAL CHURCH

FIRST PRESBYTERIAN CHURCH

STEELE CREEK PRESBYTERIAN CHURCH

SUGAW CREEK PRESBYTERIAN CHURCH

ST. JAMES EPISCOPAL CHURCH

0 100 Miles

0 100 KM

ST. THOMAS EPISCOPAL CHURCH

Craven Street, Bath, North Carolina 27808

PHONE: 919-923-3971;
252-923-9141

HOURS: Monday
through Friday

ADMISSION: No fee charged

WHEELCHAIR ACCESSIBLE:
Full access

WEBSITE: None

St. Thomas Episcopal

Built in 1734, St. Thomas Episcopal is believed to be the oldest existing church building in North Carolina. Visitors to the church today can see the Queen Anne's Bell inside the belltower, which was cast in 1750 and recast in 1872. St. Thomas also owns one of North Carolina's oldest Bibles, which was printed in 1703 in England and given to the church by one of the parish families. The church is notable as the location of North Carolina's first public library, which included 1,050 books and pamphlets.

STEELE CREEK PRESBYTERIAN CHURCH

7407 Steele Creek Road, Charlotte, North Carolina 28217

PHONE: 704-588-1290

HOURS: Daily

ADMISSION: No fee charged

WHEELCHAIR ACCESSIBLE: Limited access

WEBSITE: www.scpconline.org

Buried in the cemetery of Steele Creek Presbyterian Church are the remains of General Robert Irwin and Zacceus Wilson, both elders in the church and signers of the Mecklenburg

Opposite: Steele Creek Presbyterian Church

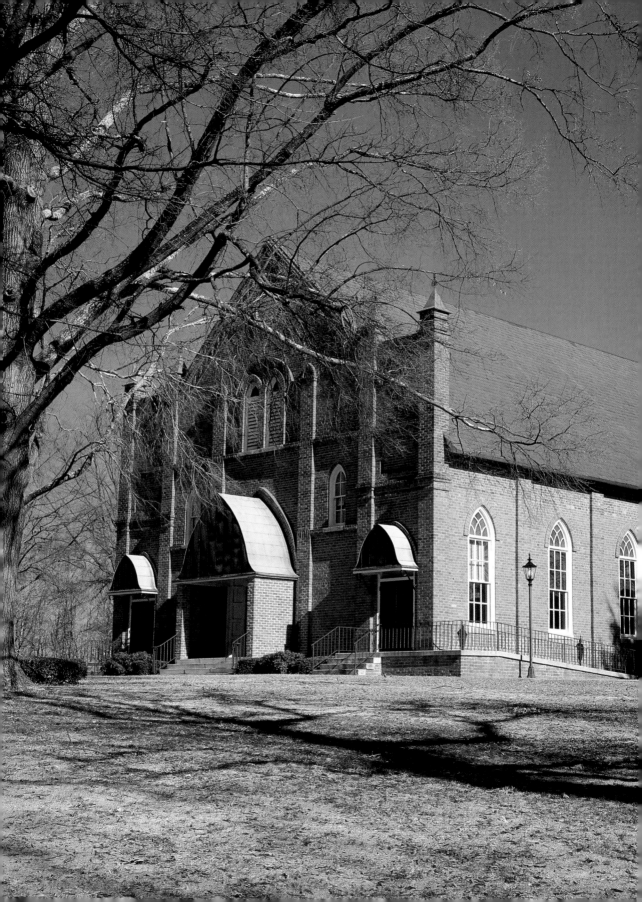

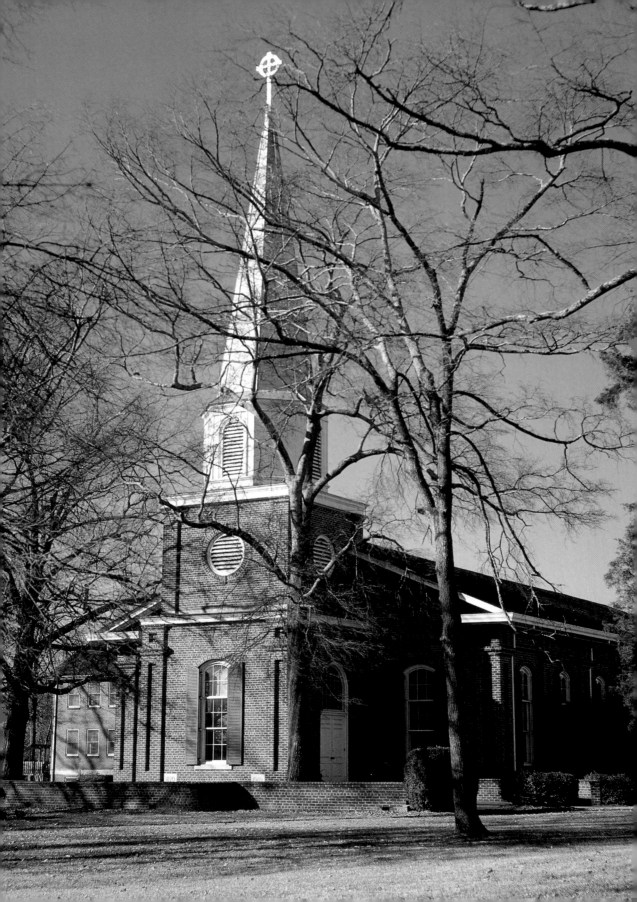

Declaration of Independence, in which the citizens of Mecklenburg County declared themselves free from Britain a full year before the Philadelphia delegates did in 1776. A marker in the cemetery lists the names of thirteen soldiers of the Revolution interred here as well as a number of heroines of the War. Visitors will also see 101 gravestones that mark the resting place of Civil War veterans. In addition, the parents of Rev. Billy Graham are buried in the cemetery. The church cemetery contains 2,958 headstones, some of which date as early as 1763.

Sugaw Creek Presbyterian Church

101 Sugar Creek Road West, Charlotte, North Carolina 28213

Phone: 704-596-4466
Hours: Monday through Friday
Admission: No fee charged
Wheelchair Accessible: Full access
Website: None

Organized in 1755, Sugaw Creek has three historic cemeteries, the first of which contains the grave of Rev. Alexander Craighead, who is credited with planting the seeds for the Mecklenburg Declaration of Independence, which was signed on May 20, 1775, and appears on the state flag and state seal. Two green sassafras poles were used to transport his coffin to the graveyard and were set into the ground to mark the head and foot of his grave. The poles took root and thrived for more than a century until they were blown down by a storm. Some of the sassafras wood was saved to craft a gavel for the Synod of North Carolina and also to construct a church pulpit, which is now on display in the church museum. In the second cemetery of the church lie two of the signers of the Mecklenburg Declaration of Independence: Hezekiah Alexander and Abraham Alexander. Another tombstone in the second cemetery honors General (then Captain) Joseph Graham, who led the stand against the British army in front of the church on North Tryon Street during the Battle of Charlotte in the Revolutionary War.

Hopewell Presbyterian Church

10500 Beatties Ford Road, Huntersville, North Carolina 28078

Phone: 704-875-2291
Hours: Monday through Friday
Admission: No fee charged
Wheelchair Accessible: Limited access
Website: www.hopewellpresbyterian.com

The cemetery of Hopewell Presbyterian Church contains the graves of four signers of the

Opposite: Sugaw Creek Presbyterian Church

Hopewell Presbyterian Church

1775 Mecklenburg Declaration of Independence as well as many Revolutionary War Patriots. Among these is General William Lee Davidson, who was killed at the Battle of Cowan's Ford. The original gravestone of the notorious Francis Bradley is preserved in the Heritage Room at Hopewell Presbyterian and an identical stone now marks his grave. Bradley was known throughout the state as a terrorizer of Tories and was killed when four Tories ambushed him at his plantation. Founded in the early 1750s, Hopewell's second building was erected in 1833; an 1859 addition included a slave balcony, which is still accessed by an outside entrance knows as the "servant entrance."

CHRIST EPISCOPAL CHURCH

320 Pollock Street, New Bern, North Carolina 28563
PHONE: 252-633-2109
HOURS: Monday through Friday
ADMISSION: No fee charged
WHEELCHAIR ACCESSIBLE: Limited access
WEBSITE: www.christchurchnewbern.com

President George Washington worshiped at Christ Episcopal's original 1750 building when he visited New Bern in 1791. The church was rebuilt in 1824, and it was here that Union

forces met for services when New Bern was occupied by the North during the Civil War. Today the church houses artifacts from the colonial period, including a silver communion service given to the church by King George II in 1752. Each piece bears the Royal Arms of England. Other gifts from King George II on display include a Bible and a *Book of Common Prayer.* In the church cemetery are graves from the colonial period, including that of church member and patriot John Wright Stanly, whose ship defeated the HMS *Lady Blessington* and captured its cannons during the Revolutionary War. A cannon from the *Lady Blessington* rests just outside the church fence.

Christ Episcopal Church

FIRST PRESBYTERIAN CHURCH

418 New Street, New Bern, North Carolina 28563

PHONE: 252-637-3270

HOURS: Monday through Friday

ADMISSION: No fee charged

WHEELCHAIR ACCESSIBLE: Limited access

WEBSITE: www.firstpresnewbern.org

During the Civil War, the First Presbyterian Church served as an emergency hospital for Union soldiers, who were laid on wooden planks placed on top of the pews. Tents were pitched on the church's grounds to house additional medical facilities, and the manse, located directly behind the church, became living quarters for the surgeons who worked in the hospital. The congregation of

the First Presbyterian Church was organized in 1817 under the guidance of Pastor John Witherspoon, who was named for his grandfather, the only member of the clergy to sign the Declaration of Independence. Plaques commemorating the founding members hang in the sanctuary and include the names of Eunice Edwards Hunt and Frances Pollock Devereux, daughter and granddaughter, respectively, of American preacher Jonathan Edwards.

St. James Episcopal Church

25 S. Third Street, Wilmington, North Carolina 28401
Phone: 910-763-1628
Hours: Daily
Admission: No fee charged
Wheelchair Accessible:
Limited access
Website: None

St. James Parish was first established in 1729 but its building was not completed until 1770 because of colonial animosity in Wilmington toward the Church of England. In 1781, during the American Revolution, pews and other furnishings were removed from St. James so the building could serve not only as a military hospital for the British army but also as a blockhouse for defense against the patriots and as a riding school for Tarlton's Dragoons. St. James was again transformed into a hospital during the Civil War when Federal troops moved into Wilmington in 1865 from Ft. Fisher. The colonial graveyard, which opened in 1745, contains the remains of Revolutionary War Patriot Cornelius Harnett and American playwright Thomas Godfrey. The church houses a painting, *Ecce Homo*, which depicts Christ with a crown of thorns, that has been estimated to be between four and six hundred years old. The painting was taken from a captured pirate ship and given to St. James Parish in 1754.

Opposite: St. James Episcopal Church

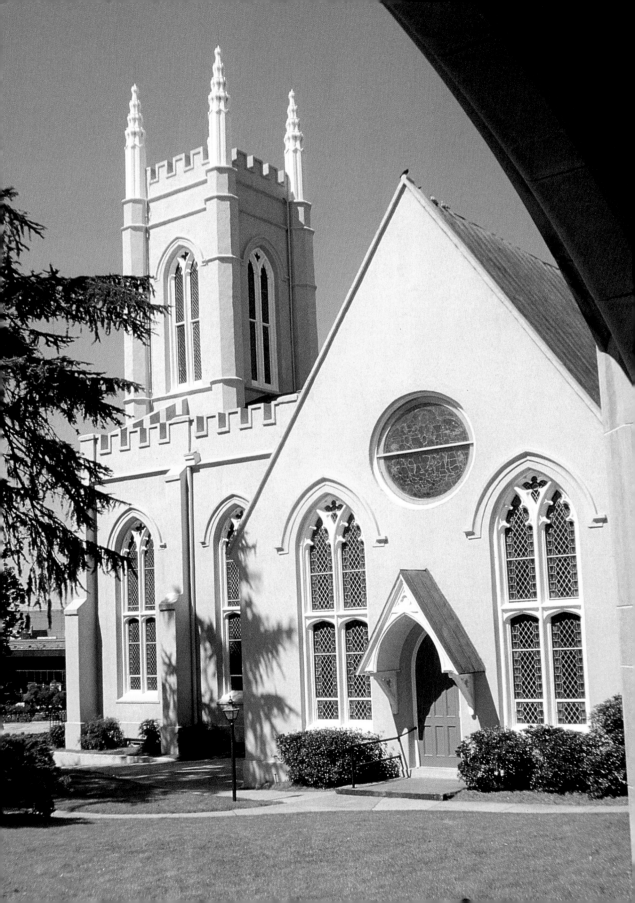

SOUTH CAROLINA

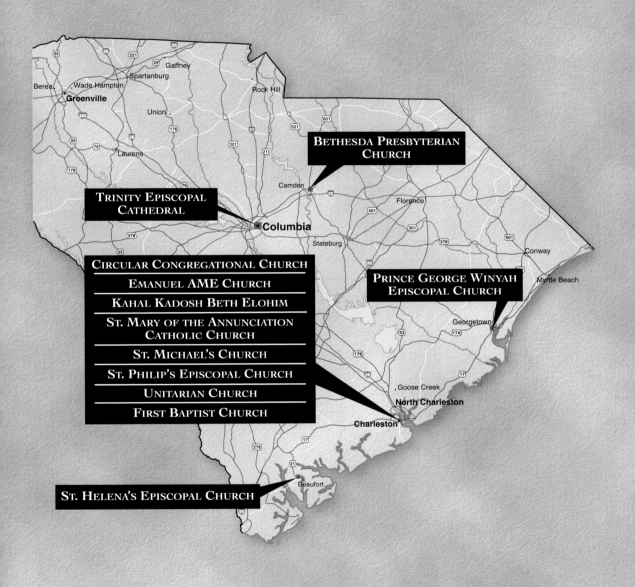

BETHESDA PRESBYTERIAN
CHURCH

TRINITY EPISCOPAL
CATHEDRAL

CIRCULAR CONGREGATIONAL CHURCH

EMANUEL AME CHURCH

KAHAL KADOSH BETH ELOHIM

ST. MARY OF THE ANNUNCIATION
CATHOLIC CHURCH

ST. MICHAEL'S CHURCH

ST. PHILIP'S EPISCOPAL CHURCH

UNITARIAN CHURCH

FIRST BAPTIST CHURCH

PRINCE GEORGE WINYAH
EPISCOPAL CHURCH

ST. HELENA'S EPISCOPAL CHURCH

0 100 Miles

0 100 KM

ST. HELENA'S EPISCOPAL CHURCH

505 Church Street, Beaufort, South Carolina 29901
PHONE: 843-522-1712
HOURS: Tuesday through Saturday
ADMISSION: No fee charged
WHEELCHAIR ACCESSIBLE: Full access
WEBSITE: www.sthelenas1712.org

During the Revolutionary War, St. Helena's Episcopal Church sent several men to fight, including parishioner Thomas Heyward Jr., a signer of the Declaration of Independence. Parishioner John Barnwell reached the rank of general in the military and had earned fame during the Yemassee Indian War; his remains are in the churchyard. St. Helena's churchyard includes the remains of two British officers killed during the American Revolution; their graves can be identified by the King's Colours flags honoring their memory. The churchyard also includes the graves of two Civil War Confederate generals, Lieutenant Richard Heron "Fightin' Dick" Anderson and Brigadier General Stephen Elliott Jr. By 1861, during the Civil War, Union troops occupied Beaufort and stripped the church to use it for a hospital. The only remaining furnishing that dates prior to the Civil War is a small marble baptismal font, which still stands in the nave today. The church has a rare 1728 King George II Prayer Book with Royal Binding that was confiscated during the Civil War and returned to St. Helena's in 1979 by a Connecticut family.

BETHESDA PRESBYTERIAN CHURCH

502 DeKalb Street, Camden, South Carolina 29020
PHONE: 803-432-4593
HOURS: Monday through Friday
ADMISSION: No fee charged
WHEELCHAIR ACCESSIBLE: Limited access
WEBSITE: None

The Bethesda Presbyterian Church was built in 1820, and in its burial ground is the grave of the Baron De Kalb. De Kalb, a French officer, joined the Contintental Army in 1777 along with his protégé, the Marquis de Lafayette. He led the American army to relieve the besieged Charleston, South Carolina. DeKalb died as a result of wounds received at the Battle of Camden, and his remains were reinterred at Bethesda Presbyterian in 1825. The Marquis de Lafayette officiated at the final burial ceremony. A monument marks the grave of the baron.

Opposite: St. Helena's Episcopal Church

CIRCULAR CONGREGATIONAL CHURCH

150 Meeting Street, Charleston, South Carolina 29401

PHONE: 843-577-6400

HOURS: Graveyard open Monday through Friday; graveyard tour following Sunday morning service

ADMISSION: No fee charged

WHEELCHAIR ACCESSIBLE: Full access

WEBSITE: www.circularchurch.org

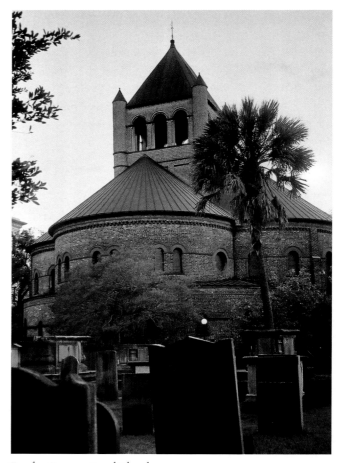

Circular Congregational Church

During a Sunday service in 1780, a British cannonball burst in the graveyard of Circular Congregational Church. British forces soon captured Charleston and used the meetinghouse as a British hospital. Many state leaders and revolutionaries, including thirty-eight heads of families of the Circular Congregational Church, were illegally exiled to St. Augustine, Florida, and then to Philadelphia. At the end of the War, remaining church members began to rebuild the meeting-house, which the British had left a ruin. Founded in the late seventeenth century, Circular Congregational derived its name from the shape of its 1804 building, designed by Robert Mills, architect of the Washington Monument in Washington, D.C. The circular church earned fame as the first major domed building in North America. The church's graveyard is the city's oldest burial grounds with monuments dating from 1695. More than fifty monuments of handcarved slate were transported from New England, mostly prior to the American Revolution. More of these unusual eighteenth-century slate stones have survived in this graveyard than anywhere else in the country. The graveyard also includes the remains of many local Revolutionary War heroes.

Emanuel AME Church

110 Calhoun Street, Charleston, South Carolina 29403

PHONE: 843-722-2561; 843-577-3400

HOURS: Daily

ADMISSION: No fee charged

WHEELCHAIR ACCESSIBLE: Limited access

WEBSITE: None

The history of Emanuel African Methodist Episcopal Church includes the imprisionment of its first pastor, Morris Brown, for meeting with slaves and free blacks without white supervision, and the execution of one of its founders, Denmark Vesey, for organizing a slave revolt in Charleston. Emanuel AME Church first formed in 1816, when the African-American members of Charleston's Methodist Episcopal church withdrew to form their own church. During the Vesey controversy, Emanuel's first building, erected in 1818, succumbed to arson. The congregation rebuilt the church and worship services resumed until 1834, when South Carolina banned all-black churches, at which time the congregation began to meet in secret. In 1865 at the end of the Civil War, the church formally reorganized and adopted the name Emanuel. Emanuel AME Church survives today as one of the oldest AME churches in the South and as the oldest congregation of African-Americans south of Baltimore, Maryland.

Kahal Kadosh Beth Elohim

90 Hasell Street,
Charleston, South Carolina 29401

PHONE: 843-723-1090

HOURS: Monday through Friday; closed all major holidays

ADMISSION: No fee charged

WHEELCHAIR ACCESSIBLE: Full access

WEBSITE: www.kkbe.org

Among Beth Elohim's important members have been Joseph Levy, veteran of the Cherokee War of 1760–61 and likely the first Jewish military officer in America, and Francis Salvador, who was

Kahal Kadosh Beth Elohim

the first Jew elected to an American legislative body. Salvador is also believed to be the first Jew to die in the Revolutionary War. Founded in 1749, Kahal Kadosh Beth Elohim is the fourth oldest Jewish congregation in the continental United States, and its burying ground, Coming Street Cemetery, is the oldest Jewish graveyard in the American South. Kahal Kadosh Beth Elohim is also known as the birthplace of Reform Judaism in the United States.

St. Mary of the Annunciation Catholic Church

89 Hasell Street, Charleston, South Carolina 29401-1417
Phone: 843-722-7696
Hours: Monday through Friday
Admission: No fee charged
Wheelchair Accessible: Limited access
Website: www.catholic-doc.org/saintmarys/

Established in 1788, St. Mary's is the oldest Catholic church in the Carolinas and Georgia. Among St. Mary's notable members was the Marquis de Grasse, who came to Charleston and joined the church in 1793 after escaping an insurrection in Santa Domingo in the West Indies. The Marquis de Grasse played a noteworthy role in the American Revolution when he commanded naval forces of the Marquis de LaFayette at the decisive British surrender at Yorktown on October 19, 1791. Two daughters of Admiral de Grasse are interred in St. Mary's churchyard. St. Mary's was also caught up in the American Civil War when the Charleston peninsula was bombarded in 1864. One Union shell destroyed the Henry Urban organ in the rear balcony section of St. Mary's while another damaged the left front of the church's exterior, and numerous other shells obliterated gravestones and caused other interior damage.

St. Michael's Church

Meeting at Broad Street, Charleston, South Carolina 29410
Phone: 843-723-0603
Hours: Monday through Saturday
Admission: No fee charged
Wheelchair Accessible: Full access
Website: www.stmichaelschurch.net

Visitors to St. Michael's Church can see pew number forty-three, the long double-pew in the center of the church known as "The Governor's Pew." It is here that President George Washington worshiped on Sunday afternoon, May 8, 1791, and where General Robert E. Lee worshiped seventy years later. Careful observation will reveal a scar at the base of the

pulpit, left by a bursting shell in 1865 during the Federal bombardment of the city at the end of the Civil War. Completed in 1761, St. Michael's Episcopal Church is the oldest church building in Charleston. St. Michael's steeple houses a set of bells that were stolen by retreating British soldiers during the Revolutionary War. The eight bells were later discovered in London and shipped back to St. Michael's. During the Civil War, fearful that the bells would be confiscated and melted down for weapons, St. Michael's elders shipped the bells to Columbia, South Carolina, where they escaped transformation into weapons, but did not escape the fire that devastated the city. The bells were recast in London, but then were hung incorrectly in St. Michael's steeple. After a 1989 hurricane hit Charleston, the bells were returned to London again, and today chime out over the city of Charleston.

St. Michael's Church

ST. PHILIP'S EPISCOPAL CHURCH

146 Church Street, Charleston, South Carolina 29401
PHONE: 843-722-7734
HOURS: Monday through Friday; guided tours available twice a day
ADMISSION: No fee charged
WHEELCHAIR ACCESSIBLE: Full access
WEBSITE: www.stphilipschurchsc.org

The congregation of St. Philip's Episcopal Church is the oldest in South Carolina and the church

St. Philip's Episcopal Church

was the first Anglican church established south of Virginia. The lighted steeple of St. Philip's Episcopal Church served for many years as a landmark to ships at sea, but during the Civil War, the steeple served the Union Army for sighting. As a result, St. Philip's was heavily damaged by Union fire. Like so many other Southern churches, St. Philip's gave up its bells to the war. Melted down for weapons, the bells of St. Philip's were not replaced until 1976. Several colonial governors and five Episcopal bishops are buried in St. Philip's graveyard as are Vice President John C. Calhoun and author and playwright Dubose Heyward.

UNITARIAN CHURCH

4 Archdale Street, Charleston, South Carolina 29401
PHONE: 843-723-4617
HOURS: Friday and Saturday
ADMISSION: No fee charged

WHEELCHAIR ACCESSIBLE:
Limited access
WEBSITE:
www.charlestonuu.org

The Unitarian Church on Archdale Street is the second oldest church in Charleston and first began in 1772 as a second building for the growing Circular Congregational Church. Construction was nearing completion in 1776 when British troops invaded Charleston and used the new church building to stable their horses and house their soldiers. The British troops destroyed the pews and caused significant damage to the interior. Following the war, local citizens repaired the Archdale Street church, which was formally dedicated in 1787.

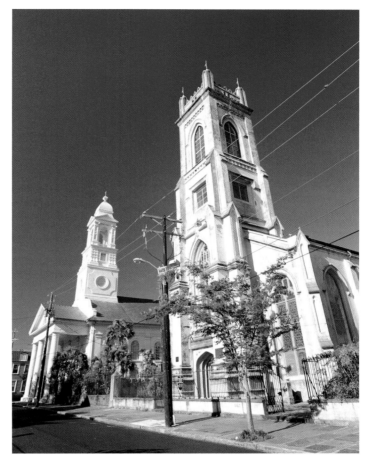

Unitarian Church

FIRST BAPTIST CHURCH

1306 Hampton Street,
Columbia, South Carolina 29201
PHONE: 803-256-4251
HOURS: Monday through Friday
ADMISSION: No fee charged
WHEELCHAIR ACCESSIBLE: Full access
WEBSITE: www.fbccola.com

The congregation of First Baptist Church first organized in 1809 and built the church sanctuary, now called Boyce Chapel, in 1859. One year later the church was selected, at the request of the

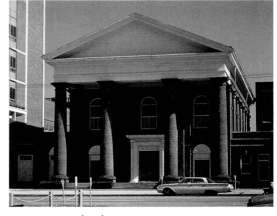

First Baptist Church

state legislature, as the site for the Secession Convention. South Carolina then voted to become the first state to secede from the Union. Tours detail the church's role in the Secession Convention, as well as the post Civil War meeting where delegates voted to repeal the Articles of Secession and come back into conformance with federal law. The tour also details the balcony where slave members sat, the original pulpit furnishings, and the hand-made brick-pillared portico. First Baptist Church was the site of the funeral for Senator Strom Thurmond on July 1, 2003, held in the new sanctuary that opened in 1992.

TRINITY EPISCOPAL CATHEDRAL

1100 Sumter Street, Columbia, South Carolina 29201

PHONE: 803-771-7300

HOURS: Monday through Friday

ADMISSION: No fee charged

WHEELCHAIR ACCESSIBLE:
Full access

WEBSITE:
www.trinityepiscopalcathedral.org

On February 17, 1865, when General William Tecumseh Sherman marched through Columbia, Trinity Cathedral was one of the few buildings to survive the ensuing fires. Trinity Episcopal Cathedral dates to 1846 and is a replica of York Minster Cathedral in England. Visitors today can see Trinity's original box pews, choir stalls with hand carving, and a marble baptismal font. Trinity's churchyard is the final resting place of many distinguished South Carolinians, including General Wade Hampton, General Peter Horry, and Private Robert Stark, all of whom served in the Revolutionary War;

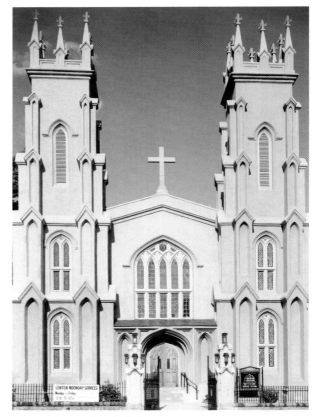

Trinity Episcopal Cathedral

General Wade Hampton of the Civil War; and six governors, including the first Wade Hampton, Richard Irvine Manning, John Lawrence Manning, Hugh Smith Thompson, and James F. Byrnes.

The congregation of Ebenezer Baptist Church first formed in 1886 and erected their first church building in 1894. Ebenezer's second pastor, Rev. Adam Daniel Williams, was Rev. Dr. Martin Luther King Jr.'s grandfather. Rev. Williams served from 1894 until 1931 and despite the Jim Crow segregation laws, encouraged his congregation to promote black businesses, become home owners, and demand adequate public accommodations. Rev. Martin Luther King Sr. served as pastor of Ebenezer Baptist Church from 1931 until 1975. His son, Rev. Dr. Martin Luther King Jr., served as co-pastor with him at Ebenezer in 1960. Upon the assassination of Dr. King Jr. in 1968, his younger brother, Rev. Alfred Daniel Williams King, became co-pastor at Ebenezer. The present church building dates to 1922 and 1999.

MIDWAY CHURCH AND MUSEUM

State Highway 17, Midway, Georgia 31320
PHONE: 912-884-5837
HOURS: Saturday and Sunday; closed all holidays
ADMISSION: Nominal fee
WHEELCHAIR ACCESSIBLE: Limited access
WEBSITE: None

In 1775, when the Continental Congress called for representatives from each colony, Georgia failed to respond. The town of Midway became outraged and sent two men of its own. The present church building was built in 1792 after British soldiers burned the original 1754 building in 1772. Midway Church was also used by General Sherman's troops during the Civil War. James Screven and Daniel Stewart, both American generals of the Revolution, are buried in the Midway cemetary, as are Senator John Elliott, Governor Nathan Brownson, and Commodore John McIntosh. Also buried here is Louis LeConte, famous for his botanical

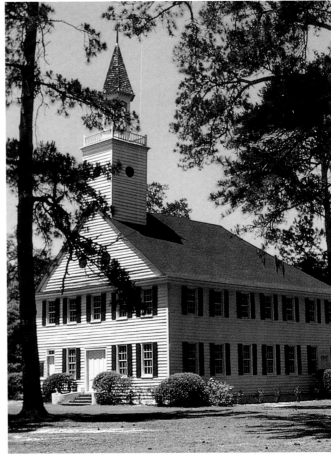

Midway Church

gardens and father of John LeConte, first president of the University of California. The museum showcases exhibits, documents, and furnishings used in coastal Georgia homes from colonial days until the Civil War.

CHRIST CHURCH

6329 Frederica Road, St. Simons Island, Georgia 31522
PHONE: 912-638-8683
HOURS: Daily
ADMISSION: No fee charged
WHEELCHAIR ACCESSIBLE: Limited access
WEBSITE: www.christchurchfrederica.org

The congregation of Christ Church officially formed in 1808 although its history goes back to 1736 when Charles Wesley began his ministry at Frederica on St. Simons Island, along with John Wesley, George Whitfield, and other clergy appointed by the Society for the Propagation of the Gospel. After the original 1820 church building was decimated during the Civil War, Rector Anson Greene Phelps Dodge, of the Dodge Lumber Mills family, built the present-day Christ Church in the 1870s as a memorial to his wife. Her body was originally

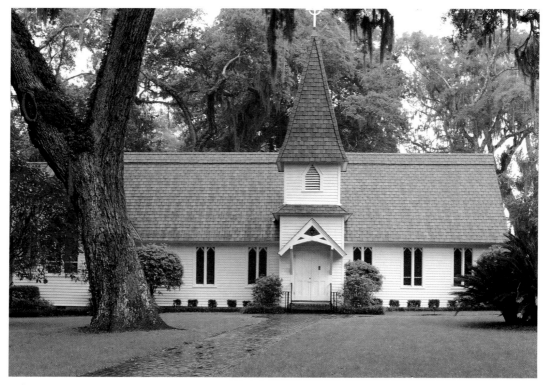

Christ Church

entombed beneath the chancel of the church but, upon her husband's death, was moved next to his grave in the cemetery, which also includes the remains of former rectors of Christ Church and the families of early settlers. Also buried in the cemetery is the first Georgia State Historian, Lucian Lamar Knight. The baptismal font dates back to 1884 when it was donated to the church by the Sunday school of St. Thomas Church in New Haven, Connecticut. The needlepoint adornments on the altar were created by church member Mrs. William Chisholm, who also designed and executed much of the needlework for the National Cathedral in Washington, D.C. Queen Wilhelmina, Calvin Coolidge, Jimmy Carter, and George Bush have all visited Christ Church.

FLORIDA

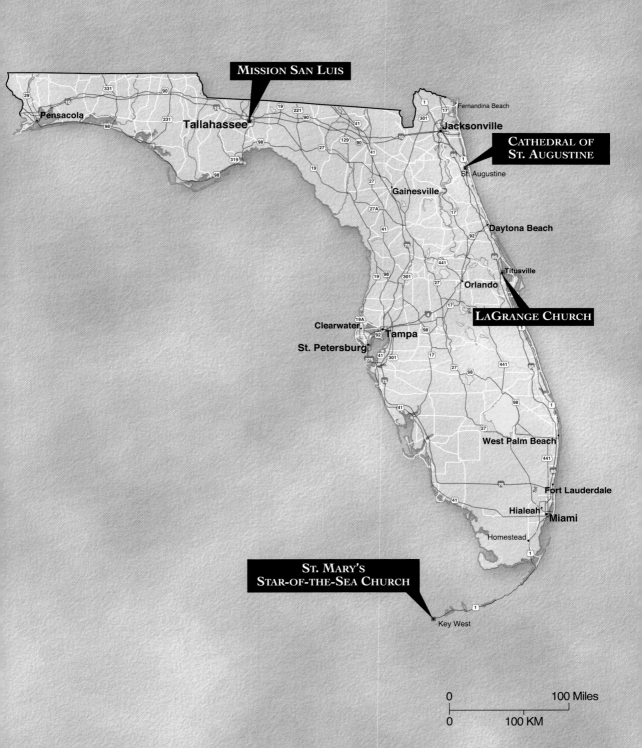

MISSION SAN LUIS

CATHEDRAL OF
ST. AUGUSTINE

LaGRANGE CHURCH

ST. MARY'S
STAR-OF-THE-SEA CHURCH

Pensacola

Tallahassee

Fernandina Beach

Jacksonville

St. Augustine

Gainesville

Daytona Beach

Titusville

Orlando

Clearwater

Tampa

St. Petersburg

West Palm Beach

Fort Lauderdale

Hialeah

Miami

Homestead

Key West

0 100 Miles

0 100 KM

ST. MARY'S STAR-OF-THE-SEA CHURCH

1010 Windsor Lane, Key West, Florida 33040

PHONE: 305-294-1018

HOURS: Daily

ADMISSION: No fee charged

WHEELCHAIR ACCESSIBLE:
Limited access

WEBSITE:
www.keywestcatholicparish.org

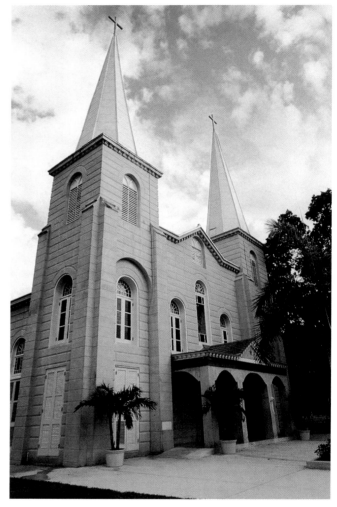

St. Mary's Star-of-the-Sea Church

Founded in 1819 in the recently annexed U. S. territory of Florida, the parish of St. Mary's Star-of-the-Sea Church volunteered its aid to the nation when, on February 15, 1898, the Spanish American War started with the sinking of the Battleship *Maine* in Havana Harbor, Cuba. As wounded and dead soldiers from the *Maine* began to fill the Navy Marine Hospital and the Barracks Hospital on Key West, Mother Mary Florentine, Superior of the Convent of Mary Immaculate at St. Mary's Star-of-the-Sea Church, went to Commander James M. Forsyth and volunteered the Sisters to serve as nurses and placed the convent at the Navy's disposal. The Convent of Mary Immaculate, founded in 1868, was first housed in an abandoned Civil War barracks. A small chapel behind the present St. Mary's Star-of-the-Sea Church now houses the parish gift shop.

LAGRANGE COMMUNITY CHURCH

1575 Old Dixie Highway, Titusville, Florida 32796

PHONE: 321-267-4480

HOURS: Open house the third Saturday of each month

ADMISSION: No fee charged

WHEELCHAIR ACCESSIBLE:
Limited access
WEBSITE:
www.nbbd.com/godo/history/lagrange

The cemetery adjacent to LaGrange Community Church is the final resting place for many of the area's first pioneer families and their descendants, including Colonel Henry T. Titus, founder of the city of Titusville. The oldest marked grave is that of Andrew Fesster, who served as a soldier in the War of 1812 and was buried in the cemetery in 1869. The cemetery also includes the remains of twenty Civil War soldiers, several from the Spanish American War, and soldiers from almost every war that the United States has been engaged in, up to and including Desert Storm. Built in 1869, LaGrange Church survives today as the oldest Protestant church on the Atlantic seaboard between St. Augustine and Key West.

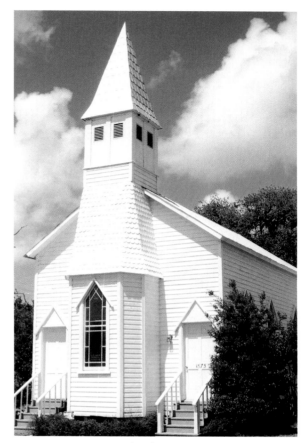

LaGrange Community Church

CATHEDRAL-BASILICA OF ST. AUGUSTINE

38 Cathedral Place, St. Augustine, Florida 32084
PHONE: 904-824-2806
HOURS: Daily
ADMISSION: No fee charged
WHEELCHAIR ACCESSIBLE: Limited access
WEBSITE: www.thefirstparish.org

The Spanish explorer Ponce de Leon landed at what would become St. Augustine in 1513 and became the first European to set foot on Florida soil. Don Pedro Menendez de Aviles first sighted the Florida coast on August 28, 1561, the feast day of St. Augustine of Hippo, and named the place St. Augustine, claiming Florida for Spain. The Parish of St. Augustine was established by the Spanish in 1565. The Church of England used the old Spanish parish church in St. Augustine during British occupation of the city, and the church was left in ruins. The present

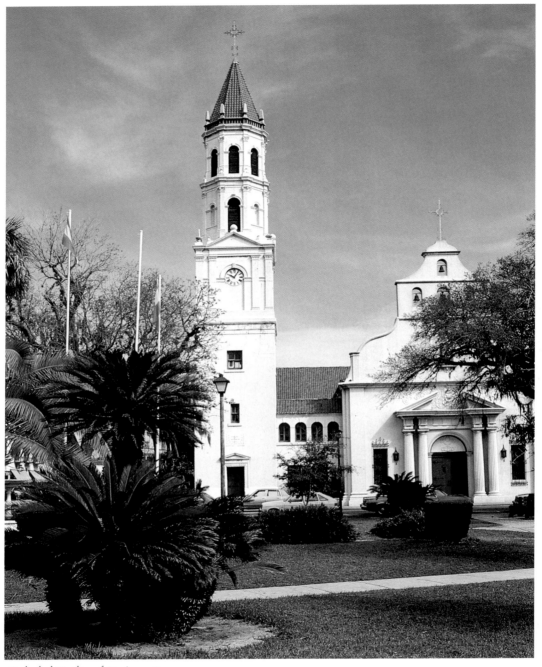

Cathedral-Basilica of St. Augustine

cathedral dates to 1797. In 1827, Pedro Benét was elected to the "Board of Wardens of the Catholic Congregation of St. Augustine." Benét was the father of Stephen Vincent Benét, future chief of Ordinance of the United States Army, and great-grandfather of Stephen Vincent Benét, the poet and novelist.

MISSION SAN LUIS

2020 Mission Road, Tallahassee, Florida 32304

PHONE: 850-487-3711

HOURS: Tuesday through Sunday

ADMISSION: No fee charged

WHEELCHAIR ACCESSIBLE:
Limited access

WEBSITE:
http://dhr.dos.state.fl.us/bar/san_luis

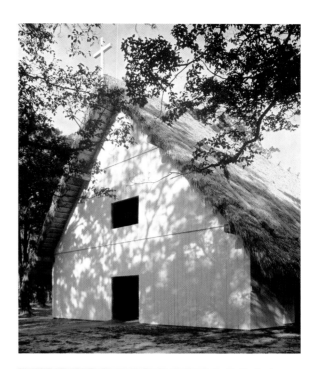

From 1656 to 1704, Mission San Luis de Apalachee served as the western capital of the Spanish mission system in Florida. More than fourteen hundred Apalachee Indians lived in and around the mission, as did a large community of Spanish settlers. The mission was burned and abandoned in 1704, just two days before a strike force of British soldiers and their Creek Indian allies arrived at the site. Although there were more than one hundred mission settlements in Spanish Florida during the sixteenth and seventeenth centuries, Mission San Luis and Nombre de Dios (in St. Augustine) are the only missions whose locations were never lost. Today, Mission San Luis is the only reconstructed Franciscan mission in Florida, and in 2000, more than six hundred people attended the first formal mass held at the mission since 1704.

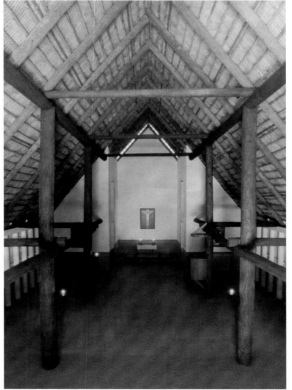

Mission San Luis

TENNESSEE

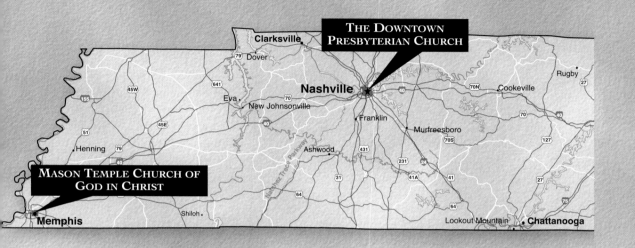

THE DOWNTOWN
PRESBYTERIAN CHURCH

Clarksville

Dover

Rugby

Nashville

Cookeville

Eva
New Johnsonville

Franklin

Murfreesboro

Henning

Ashwood

MASON TEMPLE CHURCH OF
GOD IN CHRIST

Shiloh

Lookout Mountain

Chattanooga

Memphis

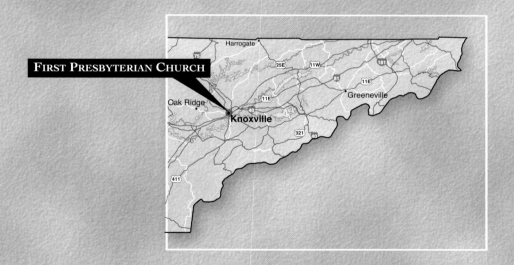

Harrogate

FIRST PRESBYTERIAN CHURCH

Greeneville

Oak Ridge

Knoxville

0 100 Miles

0 100 KM

FIRST PRESBYTERIAN CHURCH

620 State Street, Knoxville, Tennessee 37902
PHONE: 865-546-2531
HOURS: Monday through Friday
ADMISSION: No fee charged
WHEELCHAIR ACCESSIBLE: Limited access
WEBSITE: www.fpcknox.org

During the Civil War, Confederate soldiers occupied First Presbyterian and kept their horses in the church's graveyard. In 1863, Union troops removed the Confederate soldiers and used the church as a hospital and a barracks. During Reconstruction the church was used as a school for the Freedmen's Bureau, the organization established by Congress to help newly freed slaves transition to freedom. First Presbyterian's congregation got their church back in 1866, but both the building and the grounds were heavily damaged. During restoration work, one member painted the words "Jehovah Jireh," or, "The Lord will provide" over the chancel. This testament of faith remains to this day. Organized in 1792, First Presbyterian Church was Knoxville's first church. Its site was chosen by the city's founder, James White, who directed that plans for the layout of Knoxville "reserve my turnip patch for a church and a burying ground." In 1816 a brick meeting-house was dedicated on the site of James White's turnip patch; a second church building was erected in 1853. First Presbyterian stands on its original site today, although it has expanded to cover an entire city block. Buried in the church's graveyard are founder James White as well as other early settlers, including territorial governor William Blount, congressional representative John Williams, and Hugh Lawson White, a judge and 1836 candidate for U. S. President.

MASON TEMPLE CHURCH OF GOD IN CHRIST

958 Mason Street, Memphis, Tennessee 38105
PHONE: 901-947-9332
HOURS: Monday through Friday
ADMISSION: No fee charged
WHEELCHAIR ACCESSIBLE: Full access
WEBSITE: None

On April 3, 1968, three thousand people gathered inside Mason Temple to hear the scheduled speaker, Rev. Ralph Abernathy of the Southern Christian Leadership Conference. Abernathy had come to Memphis with Rev. Martin Luther King Jr. to support the striking sanitation workers, and on this night, the crowd made it clear that it was Rev. King that they wanted to hear. Heeding the crowd's wishes, Abernathy called King at his hotel and asked him to come and speak at Mason Temple. The "mountaintop" speech that Rev. King gave that night was to be his last, for on the following day, King was assassinated.

THE DOWNTOWN PRESBYTERIAN CHURCH

154 Fifth Avenue N., Nashville, Tennessee 37219
PHONE: 615-254-7584
HOURS: Monday through Friday
ADMISSION: No fee charged
WHEELCHAIR ACCESSIBLE: Full access
WEBSITE: www.dpchurch.com

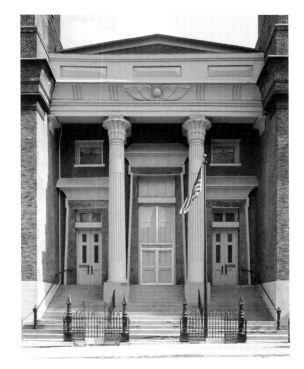

Built in 1849, the Downtown Presbyterian Church that stands today once served as a Union hospital during the Civil War. On the front steps of the congregation's first building, the state of Tennessee presented General Andrew Jackson with a ceremonial sword following the Battle of New Orleans, and the church's minister preached at the Hermitage, Andrew and Rachel Jackson's plantation. Another minister preached at the funerals of both Jacksons and also presided over the wedding of Sam Houston and his first wife. The church's second building, on the same site, hosted the inauguration of James K. Polk as governor of Tennessee. Mrs. James K. (Sarah) Polk was a member of the Downtown Presbyterian Church. After the second church burned down in 1848, the congregation built the current structure, which housed victims of the great floods of 1927 and 1937, and during World War II, thousands of soldiers on leave in Nashville found shelter within the church's walls. Visitors to the church today can peruse the History Room to the right front of the sanctuary, in which is displayed historic photographs of the church, historic artifacts that include gas-lit torches, and Civil War floor plans that show how the church was used as a hospital.

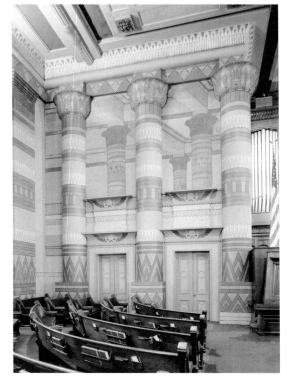

The Downtown Presbyterian Church

ALABAMA

& MISSISSIPPI

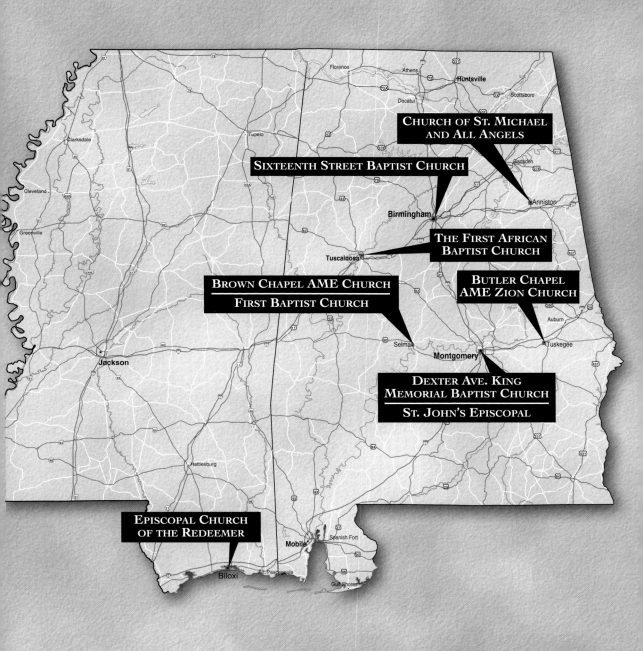

CHURCH OF ST. MICHAEL
AND ALL ANGELS

SIXTEENTH STREET BAPTIST CHURCH

THE FIRST AFRICAN
BAPTIST CHURCH

BUTLER CHAPEL
AME ZION CHURCH

BROWN CHAPEL AME CHURCH

FIRST BAPTIST CHURCH

DEXTER AVE. KING
MEMORIAL BAPTIST CHURCH

ST. JOHN'S EPISCOPAL

EPISCOPAL CHURCH
OF THE REDEEMER

0 100 Miles

0 100 KM

THE CHURCH OF
ST. MICHAEL AND ALL ANGELS

1000 W. Eighteenth Street, Anniston, Alabama 36202-1884

PHONE: 256-237-4011
HOURS: Daily
ADMISSION: No fee charged
WHEELCHAIR ACCESSIBLE: Full access
WEBSITE: www.brasenhill.com/stmikesaa

At the start of the Civil War, Confederate President Jefferson Davis ordered the Noble brothers of Noble Iron Works not to enlist as soldiers and to instead make cannons, caissons, and other munitions for the Confederacy. John Ward Noble and his family provided the funds for the Church of St. Michael and All Angels, and his portrait hangs in the narthex of the church. The church has a two-hundred-year-old plaque crafted by Indian and Spanish artisans that was secured in Ecuador for the church by General Robert E. Noble, brother of John Ward Noble. Another item of note is the Coptic cross presented to a former rector by the Ethiopian Emperor Haile Selassie. The graves of John Ward Noble, his wife, and his parents are in the churchyard.

SIXTEENTH STREET BAPTIST CHURCH

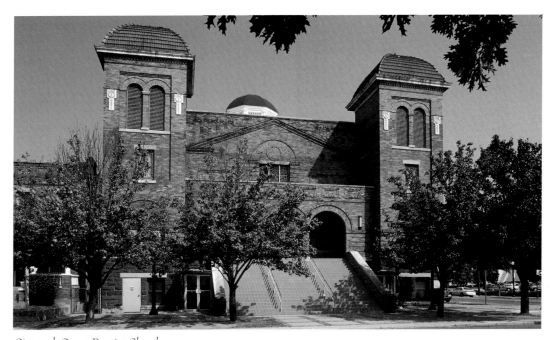

Sixteenth Street Baptist Church

1530 Sixth Avenue N., Birmingham, Alabama 35203
PHONE: 205-251-9402
HOURS: Tuesday through Friday; Saturday by appointment only
ADMISSION: No fee charged
WHEELCHAIR ACCESSIBLE: Full access
WEBSITE: None

The Ku Klux Klan bombed the Sixteenth Street Baptist Church church on Sunday, September 15, 1963, and killed four young girls who were inside waiting to lead the 11 A.M. Youth Sunday service. Martin Luther King Jr. spoke at a funeral for three of the girls, which was attended by more than eight thousand mourners. Sixteenth Street Baptist Church had functioned as the center of the African-American community in Birmingham during the Civil Rights era. The pipe organ, which was installed in 1912 and had once accompanied the acclaimed contralto Marian Anderson, was severely damaged during the bombing. Restoration of the instrument was completed in 1998.

DEXTER AVENUE KING MEMORIAL BAPTIST CHURCH

454 Dexter Avenue, Montgomery, Alabama 36104
PHONE: 334-263-3970
HOURS: Monday through Saturday
ADMISSION: Nominal fee
WHEELCHAIR ACCESSIBLE: Full access
WEBSITE: www.dexterkingmemorial.org

The Montgomery bus boycott began at Dexter Avenue Baptist Church on December 2, 1955, when a group of Montgomery's black citizens met to launch a boycott of the city's segregated public buses. On the day before the meeting, Rosa Parks had refused to give up her seat on a city bus. For the next eleven months, Dexter Avenue Church served as the headquarters for the boycott's organizers, and the church's pastor, Martin Luther King Jr., emerged as a national leader. The Montgomery bus boycott lasted until November of 1956, when the United States Supreme Court ruled that Alabama's segregated buses were unconstitutional.

ST. JOHN'S EPISCOPAL CHURCH

113 Madison Avenue, Montgomery, Alabama 36104
PHONE: 334-262-1937
HOURS: Call for hours
ADMISSION: No fee charged
WHEELCHAIR ACCESSIBLE: Limited access
WEBSITE: www.stjohnsmontgomery.org

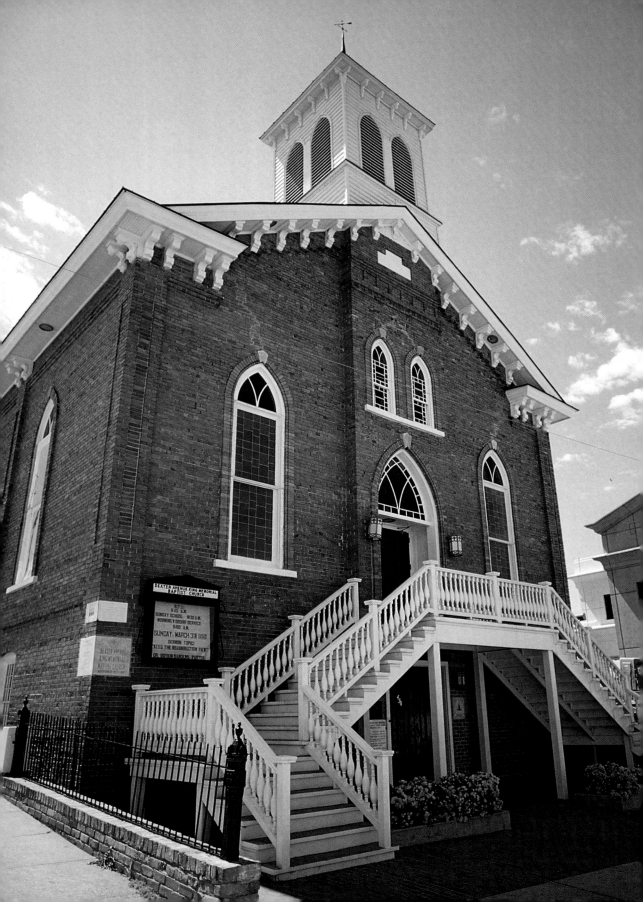

In 1861, St. John's Episcopal Church hosted the Secession Convention of Southern Churches. Later, Confederate President Jefferson Davis attended services at St. John's. In 1865, the Union army closed the doors of St. John's along with every other Episcopal church in Alabama. St. John's parishioners gathered for worship in private homes until 1866, when the churches were allowed to reopen. Inside St. John's today is a display of church memorabilia plus stained glass windows by Charles Connick and Louis Comfort Tiffany, as well as four hundred prayer kneelers decorated in needlepoint by parishioners.

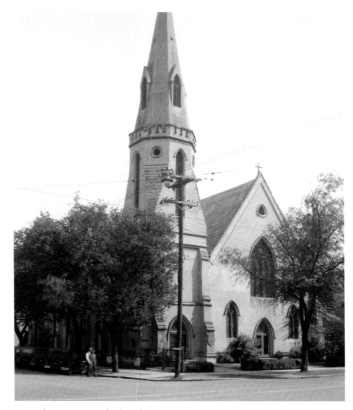

St. John's Episcopal Church

BROWN CHAPEL AME CHURCH

410 Martin Luther King Jr. Street, Selma, Alabama 36701
PHONE: 334-874-7897
HOURS: Open by appointment only
ADMISSION: No fee charged
WHEELCHAIR ACCESSIBLE: Limited access
WEBSITE: None

In March of 1965, even though Alabama governor George Wallace had issued a ban on all protest marches, six hundred African-American citizens gathered at Brown Chapel AME Church and began a march toward the capital city of Montgomery to protest discriminatory voting practices in Alabama. Only six blocks from the church, at the Edmund Pettus Bridge, state troopers ordered the marchers to disperse, using violence when the protestors refused. On March 9, Martin Luther King Jr. led a march to the Edmund Pettus Bridge, and on March 21, King led a five-day march to Montgomery. By late summer of the same year, President Johnson signed the Voting Rights Act. Today, a monument to Dr. Martin Luther King Jr. stands in front of Brown Chapel.

Opposite: Dexter Avenue King Memorial Baptist Church

FIRST BAPTIST CHURCH ────────────

709 Martin Luther King Jr. Street, Selma, Alabama 36703

PHONE: 334-874-7331

HOURS: Monday through Friday

ADMISSION: No fee charged

WHEELCHAIR ACCESSIBLE: Limited access

WEBSITE: None

First Baptist Church, like its close neighbor Brown Chapel AME Church, played an important role in the organization of the protest marches that culminated in the Voting Rights Act in 1965. The Student Nonviolent Coordinating Committee (SNCC), one of the two main organizations that planned and led the marches, had their headquarters inside First Baptist with the full support of the church's congregation. First Baptist Church also stands out for its Gothic revival style and is included on every list of architecturally significant churches in Alabama.

THE FIRST AFRICAN BAPTIST CHURCH ────────

2621 Stillman Boulevard, Tuscaloosa, Alabama 35401

PHONE: 205-758-2833

HOURS: Tours available by appointment

ADMISSION: No fee charged

WHEELCHAIR ACCESSIBLE: Full access

WEBSITE: None

In the spring of 1964, Tuscaloosa's new county courthouse posted signs outside its restrooms reading, "Whites Only." Rev. T. Y. Rogers Jr., pastor of the city's First African Baptist Church, responded by organizing and leading a series of protest rallies. On June 9, a violent confrontation erupted outside First African between protesters and police, and Rev. Rogers was eventually arrested. Partly as a result of this day of violence, and largely as a result of Rev. Rogers's activism, the federal court moved quickly on the question of the discriminatory signs. On June 26, the federal court ruled that Tuscaloosa County's segregation of its bathrooms was unconstitutional.

BUTLER CHAPEL AME ZION CHURCH ────────

1002 N. Church Street, Tuskegee, Alabama 36083

PHONE: 334-727-3550; 334-727-3601

HOURS: Tours available by appointment

ADMISSION: No fee charged

WHEELCHAIR ACCESSIBLE: Full access

WEBSITE: None

Butler Chapel AME Zion Church played an important role in the battle for equal rights for African-Americans in the 1950s and 60s, particularly in the struggle for the right to vote. Following a 1957 redistricting plan that excluded black voters from municipal elections, Butler Chapel became the central meeting place for a group of African-American Alabamans and their "Crusade for Citizenship." Thousands gathered at Butler Chapel weekly, and their leaders urged African-American residents to boycott white-run businesses until their right to vote was restored. The boycott lasted until 1961 when city districts were restored following a Supreme Court ruling that called the redistricting plan discriminatory. Butler Chapel AME Zion Church now houses a museum.

EPISCOPAL CHURCH OF THE REDEEMER

610 Water Street, Biloxi, Mississippi 39530
PHONE: 228-436-3123
HOURS: Daily
ADMISSION: No fee charged
WHEELCHAIR ACCESSIBLE: Full access
WEBSITE: www.redeemer-biloxi.org

Founded in 1851, Episcopal Church of the Redeemer has become a Confederate shrine, containing within its walls more than fifty memorials to Jefferson Davis and other Confederate veterans. Former president of the Confederacy Jefferson Davis worshiped at Episcopal Church of the Redeemer and served as a member of its vestry during the latter years of his life.

Episcopal Church of the Redeemer

The walls of the present church are hung with many plaques in memory of Confederates who at one time worshiped at the church, including Lt. General Alexander P. Stewart, Brigadier General Joseph Davis, and Brigadier General Samuel W. Ferguson.

ARKANSAS

& LOUISIANA

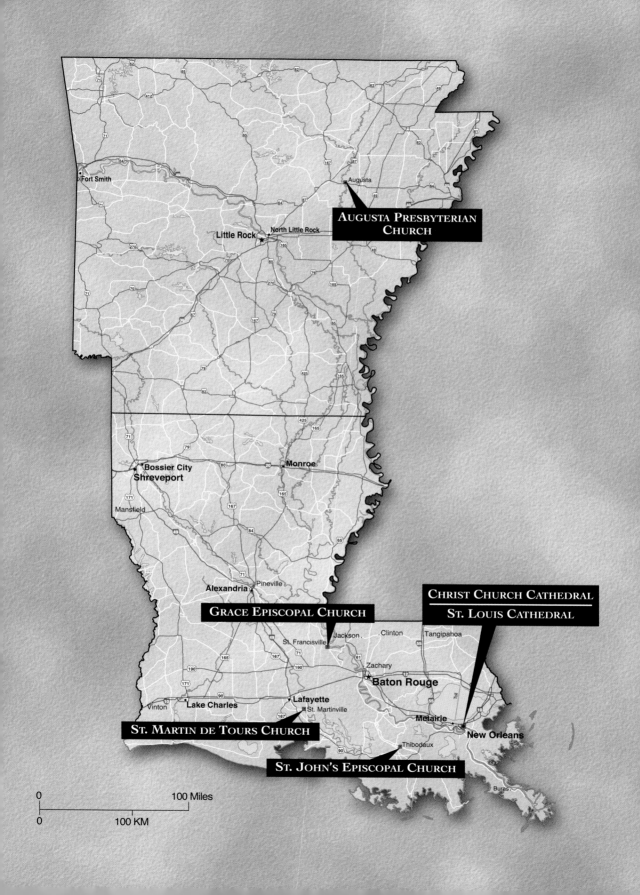

AUGUSTA PRESBYTERIAN CHURCH

CHRIST CHURCH CATHEDRAL

ST. LOUIS CATHEDRAL

GRACE EPISCOPAL CHURCH

ST. MARTIN DE TOURS CHURCH

ST. JOHN'S EPISCOPAL CHURCH

0 100 Miles

0 100 KM

AUGUSTA PRESBYTERIAN CHURCH

211 S. Third Street, Augusta, Arkansas 72006

PHONE: 870-347-2735; 870-347-5656

HOURS: By appointment

ADMISSION: No fee charged

WHEELCHAIR ACCESSIBLE: Limited access

WEBSITE: None

In his youth, former U. S. President Woodrow Wilson worshiped at Augusta Presbyterian Church between 1877 and 1881, while his brother-in-law, Rev. A. R. Kennedy, served as pastor. A marker in front of the church describes the church's connection to President Wilson. Augusta Presbyterian Church was also the first non-segregated church in Arkansas. The church began when Thomas Hough, who ran a trading post during Augusta's pioneer days, donated the land, designed the church, and paid for its construction in 1871. Hough is buried, along with his wife, in the rear churchyard. Visitors to the church today will see the original pulpit, pews, bell, and 1872 organ.

CHRIST CHURCH CATHEDRAL

2919 St. Charles Avenue, New Orleans, Louisiana 70115

PHONE: 504-895-6602

HOURS: Monday through Friday

ADMISSION: No fee charged

WHEELCHAIR ACCESSIBLE: Limited access

WEBSITE: www.cccnola.org

Founded in 1805 as the first non-Roman Catholic congregation in the entire Louisiana Purchase territory, Christ Church Cathedral contains the grave of the "Fighting Bishop," Leonidas Polk. The West Point-educated Polk became an Episcopal minister and eventually was named the first Bishop of Louisiana in 1841. In 1861 his friend and former classmate Jefferson Davis urged Polk to accept a commission in the Confederate army. Polk was killed in 1864 during the Atlanta Campaign.

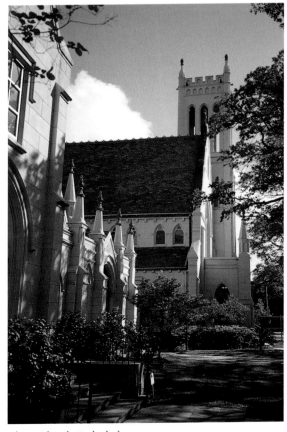

Christ Church Cathedral

Opposite: St. Louis Cathedral

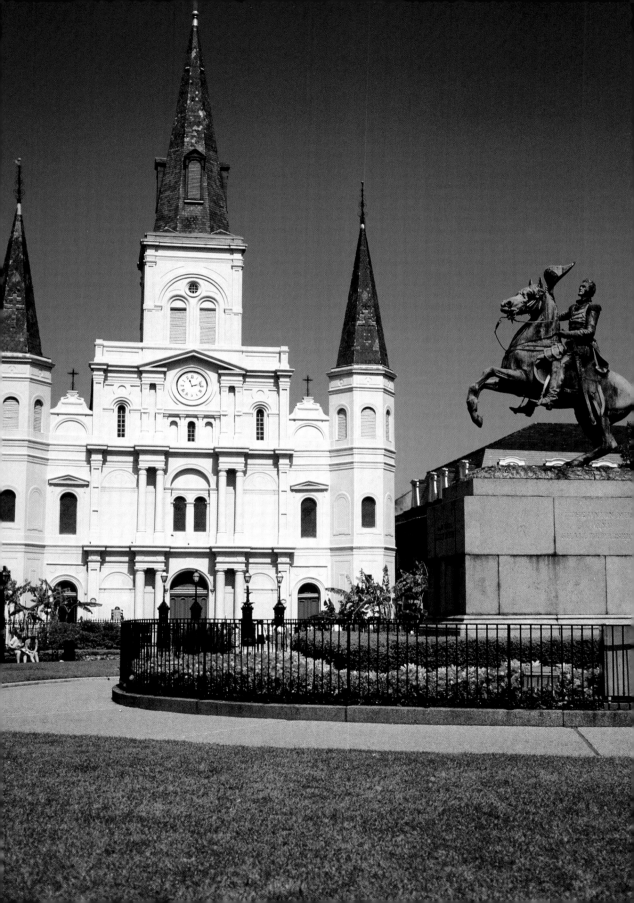

ST. LOUIS CATHEDRAL

615 Pere Antoine Alley, New Orleans, Louisiana

PHONE: 504-525-9585

HOURS: Daily

ADMISSION: No fee charged

WHEELCHAIR ACCESSIBLE: Limited access

WEBSITE: www.stlouiscathedral.org

Built in 1793, St. Louis Cathedral is the oldest continuously active cathedral in the United States. In December of 1847, Mexican War hero and future president Zachary Taylor attended services at St. Louis Cathedral. After leaving the church Taylor rode through the streets of New Orleans on his battle horse Old Whitey to the cheers of great crowds. The cathedral faces Jackson Square, where a bronze statue of General Andrew Jackson on horseback has stood since 1856. St. Louis Cathedral was also honored with a visit by Pope John Paul II when he attended services in 1987.

GRACE EPISCOPAL CHURCH

494 Ferdinand Street, St. Francisville, Louisiana 70775

PHONE: 225-635-4065

HOURS: Monday through Friday

ADMISSION: No fee charged

WHEELCHAIR ACCESSIBLE: Limited access

WEBSITE: None

In 1863, the third year after the church's dedication, Grace suffered serious shelling by Federal gunboats and sustained much damage. During this devastating battle, when the commander of one of the Federal gunboats, a Mason, was killed, his comrade raised a white flag and asked permission to bring the body ashore for a Masonic burial. Local Masons granted the request. The battle suspended, the burial service was conducted, and the Federal commander Lieutenant John E. Hart was laid to rest in Grace's churchyard. His grave remains at Grace Church, covered by a flat granite slab bearing the Masonic emblem.

ST. MARTIN DE TOURS CHURCH

133 South Main Street, St. Martinville, Louisiana 70582

PHONE: 337-394-6021

HOURS: Daily

ADMISSION: No fee charged

WHEELCHAIR ACCESSIBLE: Limited access

WEBSITE: None

Founded in 1765, St. Martin de Tours Church is called the "Mother Church of the Acadians." During the mid-1700s, thousands of French settlers from Acadia, on the Atlantic coast of Canada, were driven from their homes by the invading British. In exile, these Acadians sailed southward and settled in southern Louisiana, becoming the forebears of Cajun culture. Behind the church on the site of the original cemetery stand monuments to the participation of Acadians in the American Revolution. The grave of Emmeline Labiche can be found behind the left wing of the church. Legend has it that Labiche was the inspiration for Henry Wadsworth Longfellow's poem "Evangeline."

ST. JOHN'S EPISCOPAL CHURCH

718 Jackson Street, Thibodaux, Louisiana 70302
PHONE: 985-447-2910
HOURS: Monday through Friday
ADMISSION: No fee charged
WHEELCHAIR ACCESSIBLE: Limited access
WEBSITE: None

Leonidas Polk, Bishop of Louisiana and a future Civil War general, organized St. John's Church in 1843, and went on to lay the church's cornerstone the following year. St. John's is the oldest Episcopal church building west of the Mississippi River. Visitors to St. John's can see a monument to Bishop and General Polk, who was killed in Georgia at Pine Mountain on June 14, 1864, and who is remembered as the "Fighting Bishop of the Confederacy." The church burial grounds include the remains of Francis Redding Tillou Nicholls, Brigadier General of the Confederate Army and later governor of Louisiana.

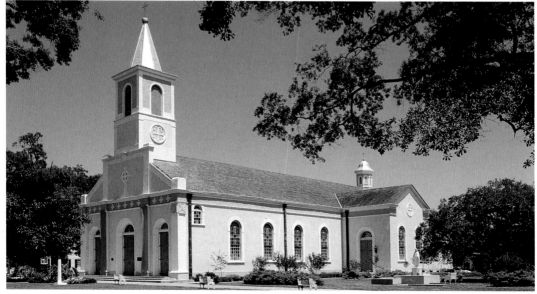

St. Martin de Tours Church

GREAT LAKES

The historic churches of the Great Lakes region offer a range of historical perspectives. The Great Lakes themselves figure into these stories in the maritime details and special services at a Detroit church as well as the Jesuit chapel in Sault Ste. Marie of the Upper Peninsula. The region also includes a fifteenth century French chapel transplanted to a Wisconsin university and a city church in Chicago famous for its gospel music. Each of these historic churches has its own unique story to tell of a time, a place, and a page in the history of America.

ILLINOIS, MICHIGAN,

& WISCONSIN

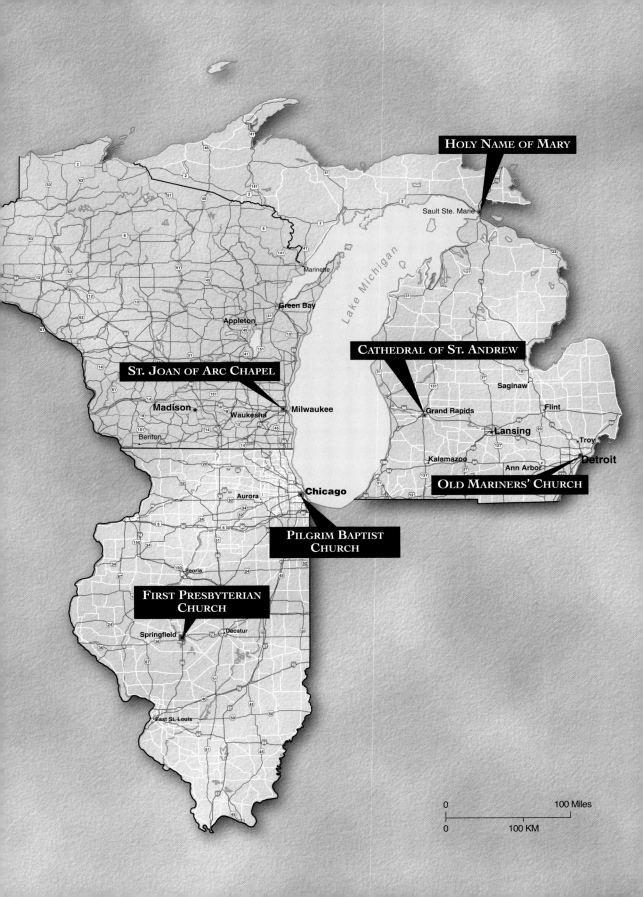

PILGRIM BAPTIST CHURCH ━━━━━━━━

3301 S. Indiana Avenue, Chicago, Illinois 60616
PHONE: 312-842-4417
HOURS: Daily
ADMISSION: No fee charged
WHEELCHAIR ACCESSIBLE: Limited access
WEBSITE: None

Chicago's Pilgrim Baptist Church has been called the birthplace of American gospel music primarily because its musical director from 1932 until 1983 was Thomas A. Dorsey, the "father of gospel music." Dorsey wrote more than one thousand gospel songs during his lifetime, including the hymns "Precious Lord, Take My Hand" and "Peace in the Valley." Many great gospel singers, among them Mahalia Jackson, Sallie Martin, and James Cleveland, sang at Pilgrim, and Aretha Franklin's father once taught vocalists at the church.

FIRST PRESBYTERIAN CHURCH ━━━━━━━━

321 S. Seventh Street, Springfield, Illinois 62701
PHONE: 217-528-4311
HOURS: Daily; guided tours available June through September
ADMISSION: No fee charged
WHEELCHAIR ACCESSIBLE: Limited access
WEBSITE: www.first-pres-church.org

Founded in 1828, First Presbyterian was the church of President Abraham Lincoln, who worshiped here with his family from 1850 until 1861. The church maintains the Lincoln pew as a memorial. The church's first building was erected in 1830, but a larger church was built in 1843, and it was at this building that Abraham Lincoln joined his family for worship. First Presbyterian moved to the current church building, which dates to 1871, in the 1870s.

OLD MARINERS' CHURCH ━━━━━━━━

170 E. Jefferson Avenue, Detroit, Michigan 48226
PHONE: 313-259-2206
HOURS: Daily
ADMISSION: No fee charged
WHEELCHAIR ACCESSIBLE: Limited access
WEBSITE: www.oldmarinerschurch.org

Nicknamed the Maritime Sailor's Cathedral, Old Mariners' Church holds a special service each November in memory of the victims of the ship *Edmund Fitzgerald*, which sank in 1975 in Lake

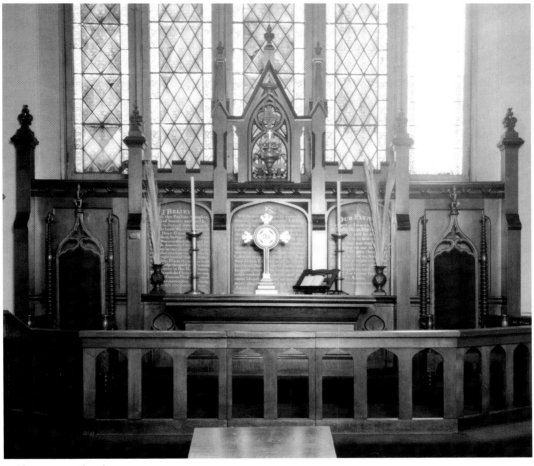

Old Mariners' Church

Superior. Gordon Lightfoot's ballad "The Wreck of the *Edmund Fitzgerald,*" includes a reference to Old Mariners' and the rector in its lyrics. Built in 1849, Old Mariners' Church is the oldest stone church in Michigan. It includes many maritime details, including a distinctive facade with a central rose window that depicts a mariner's compass and wheel, and inside the church, marine prints and paintings, civic flags, ship models, and historic photographs of two giant ship bells adorn the walls and beams. In addition to the special November service, other annual civic services include the Great Lakes Memorial and Blessing of the Fleet and the United States Navy League Sunday with the Sea Cadets.

HOLY NAME OF MARY

377 Maple Street, Sault Ste. Marie, Michigan 49783
PHONE: 906-632-3381
HOURS: Daily

ADMISSION: No fee charged

WHEELCHAIR ACCESSIBLE: Limited access

WEBSITE: None

Jesuit missionaries arrived at the eastern tip of the Upper Peninsula, now the city of Sault Ste. Marie, in 1641 and for many years celebrated Mass within the protection of a fort. Father Frederic Baraga, who was consecrated as the "Bishop of the Sault," created the first known grammar and dictionary of the Chippewa language, a book that is still revered by scholars today. Another of the Jesuits ministering to the Indians of the Upper Peninsula was Father Jacques Marquette, the French explorer who named Sault St. Marie and who was on the expedition that led to the discovery of the Mississippi River. The current church building was built in 1881.

ST. JOAN OF ARC CHAPEL

Fourteenth Street and Wisconsin Avenue, Marquette University, Milwaukee, Wisconsin 53201

PHONE: 414-288-6873

HOURS: Daily; closed when university is closed

ADMISSION: No fee charged

WHEELCHAIR ACCESSIBLE: Full access

WEBSITE: www.mu.edu/um

St. Joan of Arc Chapel

Marquette University is a most unlikely place to find a fifteenth-century French chapel, but the St. Joan of Arc Chapel stands here nonetheless as a survivor of five centuries, a trans-Atlantic journey, and two stone-by-stone reconstructions. In a niche inside the chapel lies a stone connected by legend to Joan of Arc, who is said to have kissed this stone as she knelt on it to pray. In its first life in Chasse, France, this chapel was known as Chappelle de St. Martin. In 1927 a wealthy American woman purchased Chappelle de St. Martin and had it dismantled, shipped, and reassembled at her estate on Long Island, New York. It was during this reconstruction that the Joan of Arc stone was added to the chapel's interior. After the Long Island owner passed away the new owners donated the chapel to Marquette University. Once again the chapel was dismantled, shipped, and reassembled. On May 26, 1966, the chapel was rededicated, this time on the Marquette campus, with a new name, the St. Joan of Arc Chapel.

GREAT PLAINS

The historic churches of the Great Plains were founded by pioneers, abolitionists, fur trappers—a diverse group of true individuals who settled the plains and brought their faith and religion with them. There is no unifying theme to their architecture or to their denominations. From the grand old cathedrals of St. Louis to a simple stone church built by the hands of pioneering abolitionists, what these places of worship have in common is their testimony to the determination of Americans to keep faith part of their lives as they moved westward and expanded the nation.

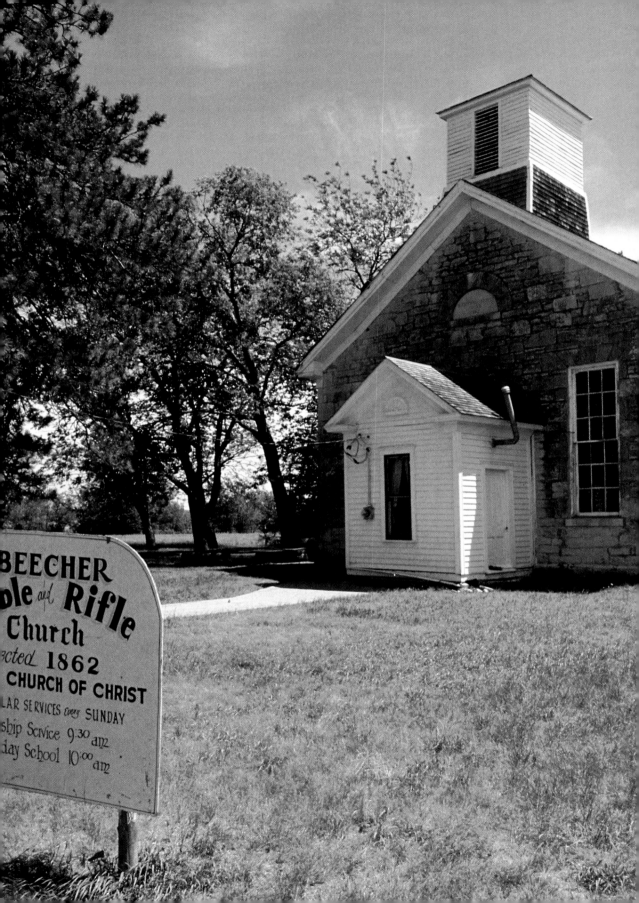

Iowa, Missouri, Kansas, Nebraska, South Dakota, & North Dakota

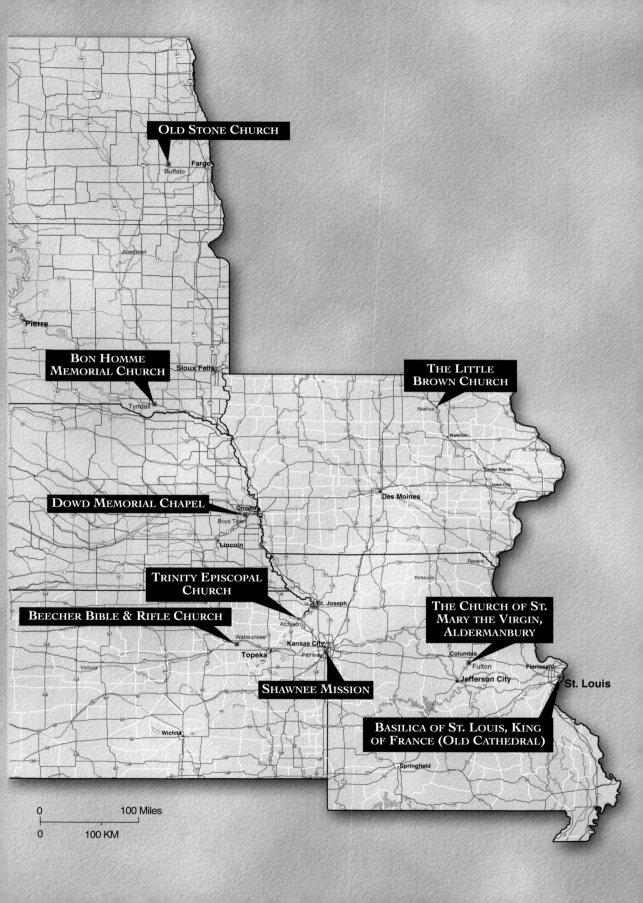

OLD STONE CHURCH

Buffalo • Fargo

Aberdeen

Pierre

BON HOMME
MEMORIAL CHURCH

Sioux Falls

Tyndall

THE LITTLE
BROWN CHURCH

Nashua

Waterloo

St. Donatus

Cedar Rapids

Iowa City

DOWD MEMORIAL CHAPEL

Omaha

Boys Town

Des Moines

Lincoln

Revere

Kirksville

TRINITY EPISCOPAL
CHURCH

St. Joseph

THE CHURCH OF ST.
MARY THE VIRGIN,
ALDERMANBURY

BEECHER BIBLE & RIFLE CHURCH

Wabaunsee

Atchison

Kansas City

Fairway

Columbia

Fulton

Florissant

Victoria

Topeka

Jefferson City

St. Louis

SHAWNEE MISSION

Wichita

BASILICA OF ST. LOUIS, KING
OF FRANCE (OLD CATHEDRAL)

Springfield

0 100 Miles

0 100 KM

THE LITTLE BROWN CHURCH

2730 Cheyenne Avenue, Nashua, Iowa 50658
PHONE: 641-435-2027
HOURS: Daily
ADMISSION: No fee charged
WHEELCHAIR ACCESSIBLE: Full access
WEBSITE: www.littlebrownchurch.org

This is the church made famous by the song "The Church in the Wildwood" by William S. Pitts, published in 1865. Legend has it that when Pitts was traveling to Iowa to visit his future wife, his stagecoach stopped in the frontier town of Bradford for the horses to be changed. Pitts wandered down Cedar Street and spotted a wooded lot that he thought would be ideal for a church. He subsequently wrote "The Church in the Wildwood" and described "the little brown church in the vale" before the church had even been built. Later,

when the members of the Congregational Church finished the church building, they painted it brown because the white, lead-based paint of the day was too expensive. In the meantime, Pitts published his song, which was sung in the church at the dedication service in 1864. A photograph of Pitts is displayed in the church. The bell tower of the Little Brown Church still has its original 1862 bell, and the tower also includes a hand-sewn quilt. The church also includes its original 1870 pump organ, original floors, original oil lamps, and pews that date back to 1872.

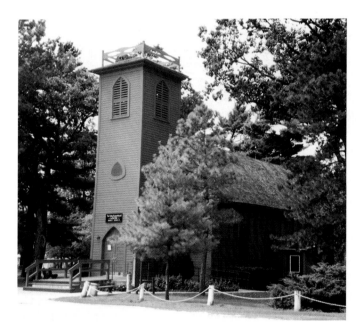

The Little Brown Church

THE CHURCH OF ST. MARY THE VIRGIN, ALDERMANBURY

Westminster College, 501 Westminster Avenue, Fulton, Missouri 65251
PHONE: 573-592-5232

Hours: Daily; closed Thanksgiving, Christmas, and New Year's Day
Admission: Nominal fee
Wheelchair Accessible: Full access
Website: www.churchillmemorial.org/westminstermo.edu

The Church of St. Mary the Virgin, Aldermanbury, once stood in London, England. William Shakespeare attended weekly worship at the church and the poet John Milton was married here. But today, more than three hundred years later, the church stands in Fulton, Missouri,

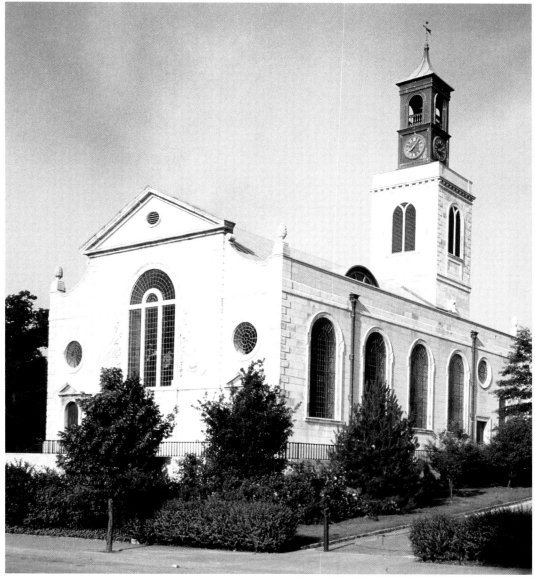

The Church of St. Mary the Virgin, Aldermanbury

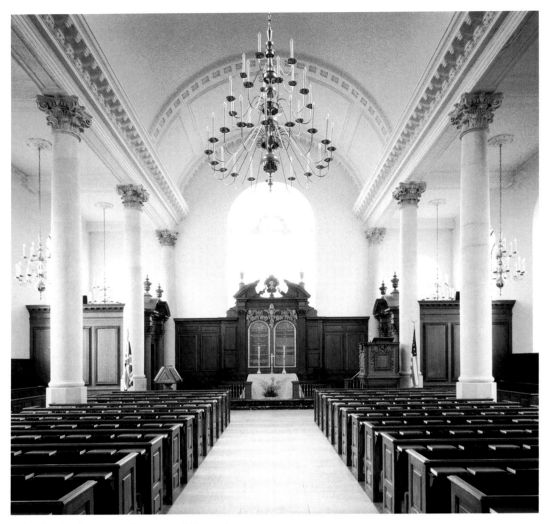

The Church of St. Mary the Virgin, Aldermanbury

on the campus of Westminster College, as a tribute to British Prime Minister Winston Churchill and his visit to the town. The Church of St. Mary dates from the twelfth century, but its current appearance is the work of seventeenth-century English architect Sir Christopher Wren, who redesigned the church after it was destroyed by the Great Fire of London in 1677. During World War II, a German bomb fell on St. Mary's and caused near complete destruction. St. Mary's survived and was bought by Westminster College as part of a Churchill memorial. The church was dismantled, shipped, and reconstructed. St. Mary's, Aldermanbury is now part of Westminster College's Winston Churchill Memorial and Library. In addition to the church, the memorial includes a museum with exhibits on the life and achievements of Sir Winston Churchill, the Clementine Spencer Churchill Reading Room, the Harris Research Library for Microfilm, and gift shops.

BASILICA OF ST. LOUIS, KING OF FRANCE/OLD CATHEDRAL

209 Walnut Street, St. Louis, Missouri 63102

PHONE: 314-231-3250

HOURS: Daily

ADMISSION: No fee charged

WHEELCHAIR ACCESSIBLE: Limited access

WEBSITE: www.catholic-forum.com/churches/140stlouis

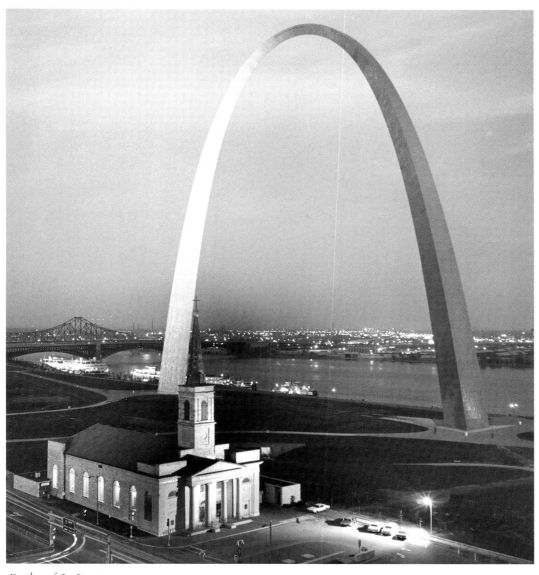

Basilica of St. Louis

St. Louis' Old Cathedral stands on ground that has been dedicated to religious purposes since the 1670s, when founder of the city Pierre Laclede selected a plot of land along the Mississippi River bank for a church. The Old Cathedral that stands today was completed in 1834 and is the oldest cathedral west of the Mississippi River. Visitors today can tour the inside and see a copy of Velazquez' painting *The Crucifixion* hanging above the altar. Another painting, a portrait of St. Louis IX, King of France, hangs at the rear of the cathedral. This portrait was given to the cathedral by the King of France in 1818. Visitors to Old Cathedral can also tour a small museum. Among the items on display are a bell from the first church and a portion of a cross bearing a bullet hole from the year 1854, when anti-Catholics attacked Old Cathedral and tried to burn it in protest of immigration laws. A brave protector of the church brought a brass cannon to Old Cathedral's front door and frightened off the protesters before they could burn the church. The only damage to the church that day was a few stray bullets, one of which hit the cross.

OLD STONE CHURCH

204 Wilcox Avenue, Buffalo, North Dakota
PHONE: 701-633-8586; 701-633-5259
HOURS: Tuesday, Friday, Saturday; other times by appointment
ADMISSION: No fee charged
WHEELCHAIR ACCESSIBLE: Full access
WEBSITE: www.geocities.com/Athens/Forum/2253

The early membership of Old Stone Church included Socrates Squire, a stockholder in the Northern Pacific Railway; his daughter, who named the town "New Buffalo" after her birthplace, Buffalo, New York; and her son, Frank Talcott, who was a North Dakota state senator from 1900–1913. Built in 1885 during the westward immigration boom, Old Stone Church, originally known as the Calvary Episcopal Chapel, was the first stone church in North Dakota to be built with a stone tower.

Old Stone Church

The church today stands in its original condition, including the original organ, altar, candlesticks, and other furniture. The Buffalo Heritage Center today includes the Old Stone Church as well as the 1887 Episcopal Rectory (now the town library) and Barn.

BON HOMME MEMORIAL CHURCH

Pearl at Lawler Street, Tyndall, South Dakota 57066

PHONE: 605-589-3394

HOURS: Call for hours

ADMISSION: No fee charged

WHEELCHAIR ACCESSIBLE: No access to church; full access to museum

WEBSITE: None

The Bon Homme Cemetery predates the Bon Homme Memorial Church and includes the remains of some of General Custer's soldiers. In 1873, General Custer and his army camped in the Bon Homme area on their way to the Battle of the Little Big Horn. Founded in 1867 and completed in 1885, Bone Homme Memorial Church was dedicated as a museum in 1989 and no longer serves an active congregation. Visitors can see a number of artifacts, including the original box, containing local newspapers, a Chicago newspaper, and other memorabilia, that had been placed in the church's cornerstone in 1885.

DOWD MEMORIAL CHAPEL OF THE IMMACULATE CONCEPTION

13945 Dowd Drive, Boys Town, Nebraska 68010

PHONE: 402-498-1030

HOURS: Daily

ADMISSION:
No fee charged

WHEELCHAIR ACCESSIBLE:
Full access

WEBSITE:
www.girlsandboystown.org

Father Flanagan and his Boys Town will always be a part of American history since it was immortalized in the early days of Hollywood cinema. The place of worship at Boys Town, the Dowd Memorial Chapel of the Immaculate Conception, built in 1941,

Dowd Memorial Chapel of the Immaculate Conception

includes stained glass windows that depict child saints or saints who assisted children. When Father Flanagan passed away, President Harry Truman visited Dowd Memorial Chapel to lay a wreath at the Boys Town founder's tomb.

TRINITY EPISCOPAL CHURCH

300 S. Fifth Street, Atchison, Kansas 66002

PHONE: 913-367-3171

HOURS: Daily

ADMISSION: No fee charged

WHEELCHAIR ACCESSIBLE: Limited access

WEBSITE: None

On October 10, 1897, the parents of young Amelia Earhart brought her to Trinity Episcopal Church to be baptized. Her parents had been wed in the church, and as a child Amelia spent the winter months with her grandparents in Atchison. Her grandfather, Alfred Otis, was a retired U. S. District Court Judge and minister at the nearby Lutheran church. Visitors can see photographs of Amelia Earhart and her grandparents displayed in the church. Founded in the spring of 1857, Trinity's history includes struggles from the beginning over the issue of slavery. Strong feelings on both sides eventually saw the congregation's minister leave Kansas for Florida and a number of the church's membership also moved to the South. When war was declared between the states in 1861, the congregation had no minister and construction on a building was delayed until 1866.

SHAWNEE MISSION

5403 W. Fifty-third, Fairway, Kansas 66205

PHONE: 913-262-0867

HOURS: Call for hours when renovations are complete in 2004

ADMISSION: Call for current fee information

WHEELCHAIR ACCESSIBLE: Limited access

WEBSITE: www.kshs.org/places/shawnee

The twelve-acre Shawnee Mission served as an early territorial capitol and a supply point on both the Oregon Trail and the Sante Fe Trail. During the Civil War, the mission functioned as a camp for Union soldiers. But its main role in the early days of our country's history was as a manual training school for Shawnee, Delaware, and other Native American nations from 1839 to 1862. Visitors to the mission today can see a number of historic buildings, including the building that served as the mission's place of worship. When the Kansas Territory was established in 1854, the new territorial governor kept offices at Shawnee Mission and the first territorial legislature met at the mission. The mission closed in 1862 during the Civil War. When the Civil War began, Rev. Johnson, who had always been pro-slavery, swore an oath of allegiance to the Union. In 1865, Rev. Johnson was murdered at his home; he and several members of his family are buried in the Shawnee Methodist Mission cemetery.

BEECHER BIBLE AND RIFLE CHURCH/ WABAUNSEE CONGREGATIONAL CHURCH ———————

Chapel and Elm Streets, Wabaunsee, Kansas
PHONE: 785-456-2485; 785-456-9446
HOURS: Call for visiting hours and to arrange tours
ADMISSION: No fee charged
WHEELCHAIR ACCESSIBLE: Limited access
WEBSITE: www.wamego.org/beecher.htm

Beecher Bible and Rifle Church grew out of the Kansas-Nebraska Act of 1854, which declared that the question of slavery in the territory of Kansas would be settled by the vote of its residents. In response, both pro- and anti-slavery settlers rushed to the Kansas territory to try and turn the vote in their favor. One group of sixty abolitionists came from New Haven, Connecticut, and Henry Ward Beecher, abolitionist preacher of Plymouth Church of the Pilgrims in Brooklyn, New York, led his own congregation in a successful effort to raise money for rifles to arm the settlers for potential conflict with local Native Americans. The New Haven settlers arrived in Wabaunsee in late April of 1856 and by June of 1857 they began building a church. Beecher Bible and Rifle Church, named to honor the contributions of Henry Ward Beecher, was dedicated in May, 1862, and still stands today. In a nearby park a monument placed by the Kansas State Historical Society pays tribute to the founders of the church. It reads: "In memory of the Beecher Bible and Rifle Colony, which settled this area in 1856 and helped make Kansas a free state. May future generations forever pay them tribute."

Beecher Bible and Rifle Church/Wabaunsee Congregational Church

ROCKIES

In this region are missions and churches, including the Temple of the Church of Jesus Christ of Latter-day Saints in Salt Lake City, that served the needs of pioneers moving West in search of a better life—whether searching for religious freedom, as were the Mormon pioneers, or searching for riches in the forms of furs, precious metals, or ranching. While the churches provided a place of worship for those bringing their faith with them, the missions served the Native American tribes in the area. All tell the varied stories of the settling of this vast and wild region.

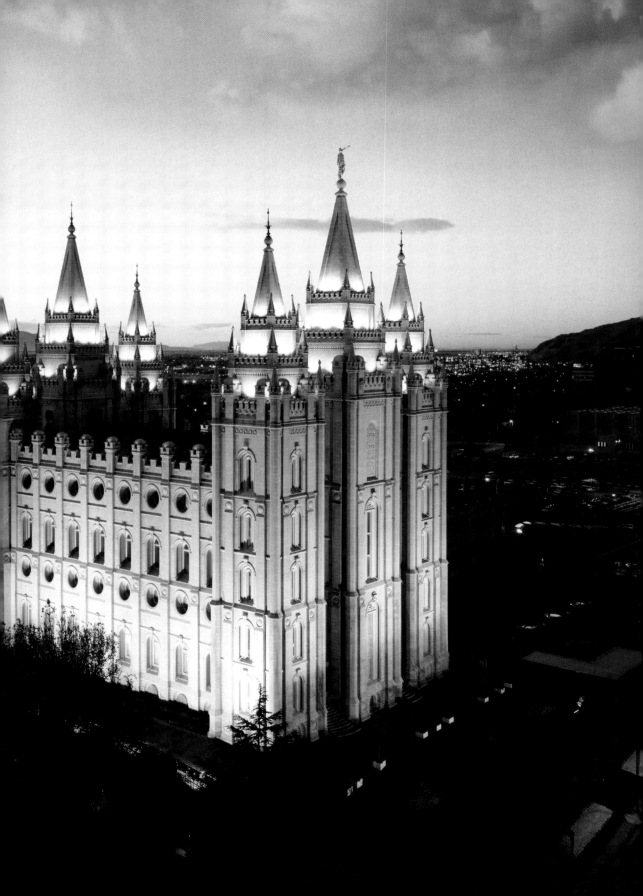

MONTANA,
IDAHO,
WYOMING,
COLORADO,
& UTAH

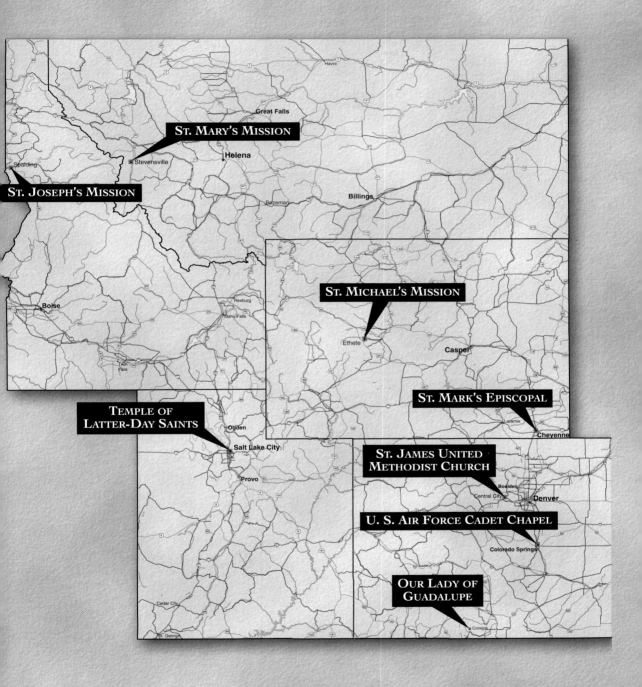

ST. MARY'S MISSION

ST. JOSEPH'S MISSION

ST. MICHAEL'S MISSION

ST. MARK'S EPISCOPAL

TEMPLE OF LATTER-DAY SAINTS

ST. JAMES UNITED METHODIST CHURCH

U. S. AIR FORCE CADET CHAPEL

OUR LADY OF GUADALUPE

Great Falls

Helena

Stevensville

Spalding

Boise

Billings

Bozeman

Rexburg

Idaho Falls

Twin Falls

Ethete

Casper

Ogden

Salt Lake City

Provo

Laramie

Cheyenne

Boulder

Central City

Denver

Colorado Springs

Cedar City

St. George

Conejos

Havre

0 100 Miles

0 100 KM

HISTORIC ST. MARY'S MISSION

West End of Fourth Street,
Stevensville, Montana

PHONE: 406-777-5734

HOURS: Daily, mid-April
through mid-October

ADMISSION: Nominal fee

WHEELCHAIR ACCESSIBLE:
Full access to Visitor Center;
Limited access to DeSmet Park

WEBSITE:
www.stmarysmission.homestead.com

Established in 1841 by Pierre Jean DeSmet, St. Mary's Mission was Montana's first permanent settlement and the first church established in the Northwest. It has been called the place where Montana began. The mission complex today has been

St. Mary's Mission

restored to its 1879 appearance, the peak of its beauty. The complex includes the chapel with attached residence, a log house and pharmacy, Chief Victor's cabin, Indian Burial Grounds, DeSmet Park, and Visitor Center. Chief Victor's cabin now houses a Salish museum, which displays artifacts and photographs that depict life in the 1800s as well as Native American chiefs. Most chapel and residence furnishings today are the original hand-carved work of Father Ravalli, Montana's first physician as well as a surgeon, pharmacist, architect, artist, and sculptor. Living quarters include Father Ravalli's handmade bed, desks, and chairs.

St. Joseph's Mission

Spalding Visitor Center, Nez Perce National Historical Park, U. S. Highway 95, Spalding, Idaho 83540

Phone: 208-843-2261 (Spalding Visitor Center)

Hours: Daily; closed Thanksgiving, Christmas, and New Year's

Admission: No fee is charged

Wheelchair Accessible: Limited access

Website: www.nps.gov/nepe

St. Joseph's Mission

Also called Slickpoo Mission, St. Joseph's Mission was the first Catholic mission among the Nez Perce people. It was founded by Father J. M. Cataldo, a Jesuit Priest, during the 1870s. In 1874, the mission was erected on the land of a Nez Perce headman, Eagle Shirt, who had converted his entire Presbyterian following to Catholicism. St. Joseph's Mission closed in 1958, although the mission school continued for another ten years. Today, the mission church is owned by the St. Joseph's Mission Historical Society and has its original furnishings, including the altarpiece. A museum exhibit in the Visitor Center at the Nez Perce National Historical Park tells the story of the early missionaries in Nez Perce country, and an annual mass is held on the first Sunday of June.

St. Mark's Episcopal, Cheyenne

1908 Central Avenue, Cheyenne, Wyoming 82001

Phone: 307-634-7709

Hours: Daily

Admission: No fee charged

Wheelchair Accessible: Limited access

Website: None

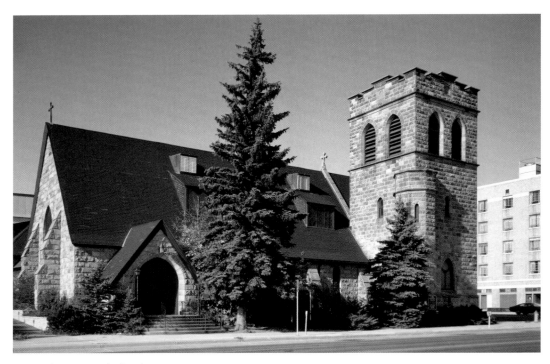

St. Mark's Episcopal Church

In 1936, President Franklin D. Roosevelt and his wife Eleanor worshiped at St. Mark's while he was in Cheyenne campaigning for his second term as President. The inspiration for St. Mark's Episcopal Church came from the London church where Thomas Gray wrote "Elegy in a Country Church Yard." Built in 1868, the church's interior today contains the original altar, wooden fixtures, pews, and open beams. The funeral of the wife and three small daughters of General John J. Pershing took place at St. Mark's in 1915. Mrs. Pershing, daughter of Wyoming's U. S. Senator Francis E. Warren, along with three of her four children had died in a fire at the Presidio army post in California.

OUR FATHER'S HOUSE/ST. MICHAEL'S MISSION

5 St. Michael's Circle, Ethete, Wyoming 82520
PHONE: 307-332-2660
HOURS: Daily
ADMISSION: No fee charged
WHEELCHAIR ACCESSIBLE: Limited access
WEBSITE: None

St. Michael's, founded in 1887 as a small mission to serve the Arapaho tribe, sits on the Wind River Reservation, one of the largest Indian reservations in the country, encompassing more than 2.2 million acres. Both the Catholic Church and the Episcopal Church made provisions to

serve both the Shoshone and the Arapaho tribes in the latter part of the nineteenth century. St. Michael's in Ethete, which means "good" in the Arapaho language, is laid out in a circle like an Arapaho encampment. Between 1910 and 1917, the buildings around the oval were built and in 1920 the old church was moved to its present site. Although the mission is called St. Michael's, the church building itself is known as Our Father's House, the English translation of the Arapaho name for a place of worship. The buildings are intact, although the mission is no longer active, and today features the Northern Arapaho Cultural Museum, which contains a collection of traditional Arapaho clothing, implements, and ceremonial objects as well as a collection of photographs and portraits. Visitors may also want to see the gravesite of Sacajawea, the Shoshone guide for the Lewis and Clark expedition, in nearby Ft. Washakie.

OUR LADY OF GUADALUPE

Conejos, Colorado
PHONE: 719-376-5985
HOURS: Daily
ADMISSION: No fee is charged
WHEELCHAIR ACCESSIBLE: Limited Access
WEBSITE: None

Our Lady of Guadalupe is the oldest Catholic parish in Colorado and was originally part of the New Mexico territory and the Diocese Sante Fe. Originally built in 1856, the present church was rebuilt in 1928 on the original site of the first church. Our Lady of Guadalupe includes Spanish and Mexican influences, including adobe walls in the typical Spanish mission style.

ST. JAMES UNITED METHODIST CHURCH

125 Eureka, Central City, Colorado 80427
PHONE: 303-582-5882
HOURS: Daily
ADMISSION: No fee charged
WHEELCHAIR ACCESSIBLE: Limited Access
WEBSITE: None

When St. James was first organized in 1859, services were held in the home of Clara Brown, a former slave. The congregation has included a diverse combination of black and white members throughout the years since its founding. With the church building dating back to 1872, St. James is now the oldest Protestant church in continuous use in Colorado. The Steere Pipe Organ was added to the church in 1899 and ran on water power until it was converted to electricity in 1933. St. James is still heated with the coal-burning furnace that was installed in 1897 and the original piano is still played. St. James's worshipers have included Senator Henry Teller.

U. S. AIR FORCE CADET CHAPEL

U. S. Air Force Academy, Colorado Springs, Colorado 80840

PHONE: 719-333-2025

HOURS: Daily; visitors must enter through the North Gate

ADMISSION: No fee charged

WHEELCHAIR ACCESSIBLE: Limited access

WEBSITE: www.usafa.af.mil/hc/

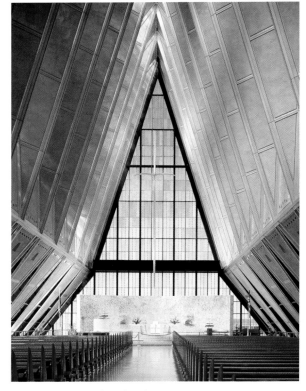

U. S. Air Force Cadet Chapel

With its Protestant, Catholic, and Jewish chapels, the U. S. Air Force Cadet Chapel embodies the religious freedom central to American ideals. The Protestant Chapel includes a forty-six-inch aluminum cross that appears to float above the communion table. The Catholic Chapel includes an abstract marble sculpture which represents the firmament. The Jewish Chapel includes a foyer floor of Jerusalem brownstone, which was donated by the Israeli Defense Forces. World-wide members of the U. S. Air Force's Officer's Wives Club hand-stitched the kneelers in the chapels.

TEMPLE OF THE CHURCH OF JESUS CHRIST OF LATTER-DAY SAINTS AND MORMON TABERNACLE

50 West North Temple, Salt Lake City, Utah 84150

PHONE: 800-537-9703 or 801-240-4872

HOURS: Tabernacle, daily; Temple, closed to the public

ADMISSION: No fee charged to Temple Square

WHEELCHAIR ACCESSIBLE: Full access

WEBSITE: www.mormon.org

The Salt Lake Temple of The Church of Jesus Christ of Latter-day Saints, one of 120 similar temples worldwide, stands in the heart of downtown Salt Lake City, world headquarters of the church. Mormon colonizer Brigham Young chose the site for this temple just days after arriving in Utah, and construction began in 1853 but was not completed until 1893, long

after Brigham Young's death. On the day before the temple's April 6, 1893, dedication, its doors were opened to the public, but following the dedication the building has only been open to members of the faith in good standing. Next to the great temple stands the Tabernacle, which is open to the public. Completed in 1867, this building served for decades as the home of the Mormon Tabernacle Choir, and for the church's semi-annual world conferences. A dome-shaped structure that houses a 11,623 pipe organ, the Tabernacle now serves as venue for many regional events and concerts. In April of 2000, the Tabernacle Choir moved into the Conference Center, its new home across North Temple Street. With rooftop gardens that cover more than four acres, the twenty-one-thousand-seat Conference Center is the world's largest acoustically finished concert hall. Guided tours of the Conference Center are offered daily.

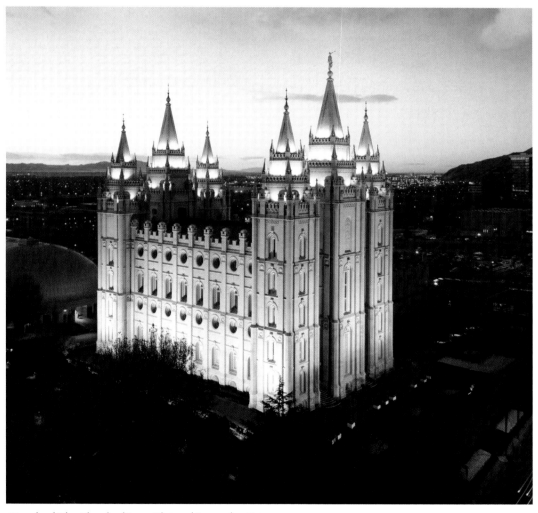

Temple of The Church of Jesus Christ of Latter-day Saints

NORTHWEST

No single theme unites the historic churches of this region; the houses of worship here are as diverse as the geography and culture of these states. The churches of the continental northwest tell stories of pioneers, missionaries, and Native Americans. Together, this diverse group of churches adds flavor and dimension to the story of how the region was transformed from wild frontier to part of the American nation.

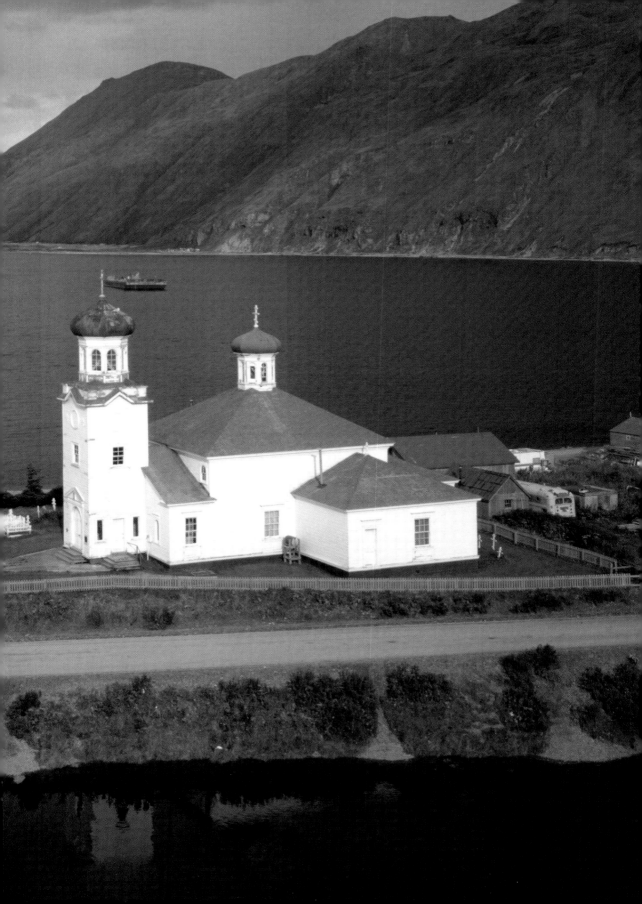

ALASKA, WASHINGTON,

& OREGON

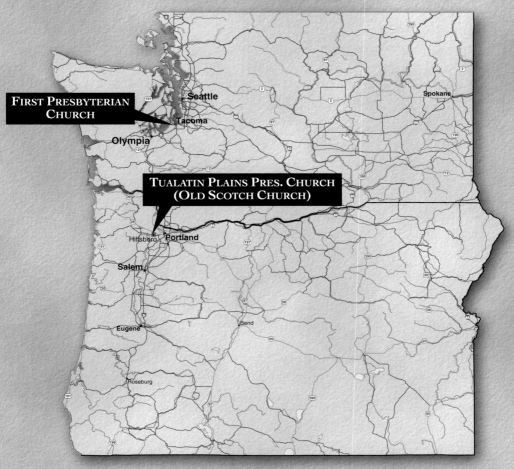

FIRST PRESBYTERIAN CHURCH

Seattle

Tacoma

Olympia

TUALATIN PLAINS PRES. CHURCH (OLD SCOTCH CHURCH)

Hillsboro Portland

Salem

Eugene Bend

Roseburg

Spokane

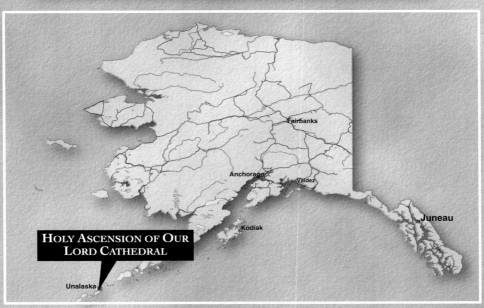

Fairbanks

Anchorage Valdez

Kodiak

Juneau

HOLY ASCENSION OF OUR LORD CATHEDRAL

Unalaska

0		100 Miles
0		100 KM

FIRST PRESBYTERIAN CHURCH, TACOMA

20 Tacoma Avenue S., Tacoma, Washington 98402
PHONE: 253-272-3286
HOURS: Daily
ADMISSION: No fee charged
WHEELCHAIR ACCESSIBLE: Limited access
WEBSITE: www.fpctacoma.com

First Presbyterian was established in 1873 to serve the growing number of settlers who came to Tacoma, the western terminus of the Northern Pacific Railroad in the 1870s. A few months after the church's founding, the great financial crash of September 1873 occurred, and most of the founding members left town. The church restarted in 1877. The current church building features choir windows produced by Colonial Stained Glass Works of Boston; they depict Christ with the Thistle of Scotland and the Rose of England in honor of the congregation's heritage. The auditorium includes a high vaulted ceiling, rose windows of stained glass, candle chandeliers, solid oak pews, and carved altar furnishings.

TUALATIN PLAINS PRESBYTERIAN CHURCH/ OLD SCOTCH CHURCH

50685 Scotch Church Road, Hillsboro, Oregon 97124
PHONE: 503-648-9573
HOURS: Daily
ADMISSION: No fee charged
WHEELCHAIR ACCESSIBLE: Limited Access
WEBSITE: None

On November 16, 1873, twelve settlers from Aberdeenshire, Scotland, founded the Tualatin Plains Presbyterian Church, later to be known as Old Scotch Church. Visitors to the church today can see some of the original items given to the church by its founding members, including a large pulpit Bible and a sterling communion service. The cemetery holds the graves of many of the original pioneer members as well

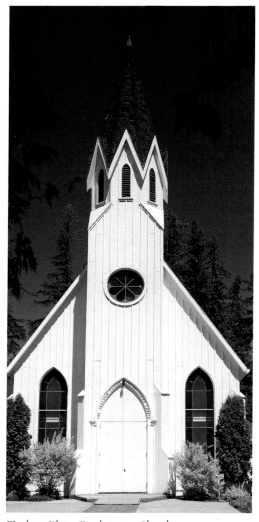

Tualatin Plains Presbyterian Church

as many settlers who came after them. Among them is Joe Meek, a legendary local mountain man who was also the first U. S. Marshall of the Oregon Territory. Meek died June 20, 1875. Old Scotch looks much as it did in the time of Oregon's pioneers and is one of the oldest, continuously used churches in Oregon.

HOLY ASCENSION OF OUR LORD CATHEDRAL ————

Unalaska, Alaska 99685
PHONE: 907-581-6404
HOURS: Daily
ADMISSION: No fee charged
WHEELCHAIR ACCESSIBLE: Limited access
WEBSITE: None

The Holy Ascension of Our Lord Cathedral is the oldest Russian Orthodox Cathedral in Alaska, founded in 1824 by Ivan Veniaminov. Father Veniaminov is credited with translating much of the Orthodox Catechism into the Aleut language of the local people. Since the native Aleut people had no written alphabet, Father Veniaminov used the Russian Cyrillic alphabet, which he taught the Aleut people. The Cathedral still possesses a copy of his 1828 translation of the Gospel of St. Matthew. Trouble came to Unalaska during World War II when on June 3, 1942, Japanese forces attacked the island; shortly after, nearly all of Unalaska's Aleuts were sent to internment camps in southeast Alaska, where they remained for the duration of the War. The church was closed during the evacuation of the local residents, who took all the contents of the Cathedral with them to the internment camp and brought them back after the war. The Cathedral was restored in 1996.

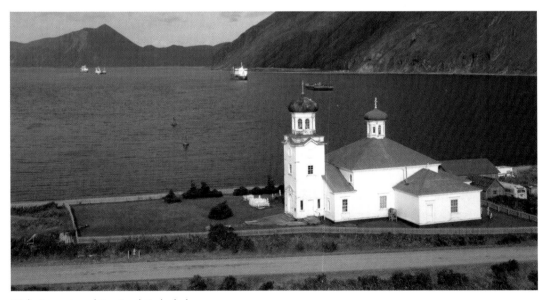

Holy Ascension of Our Lord Cathedral

SOUTHWEST

It is impossible to think about the churches of the Southwest without immediately thinking about the Spanish missions. These missions gave the cities and towns of the Southwest their names, defined their architecture, and shaped their culture. There are other houses of worship in the Southwest and many have wonderful histories to share with visitors, but the beautifully preserved mission churches give the Southwest its unique flavor. Their serene beauty is one of America's great historical treasures.

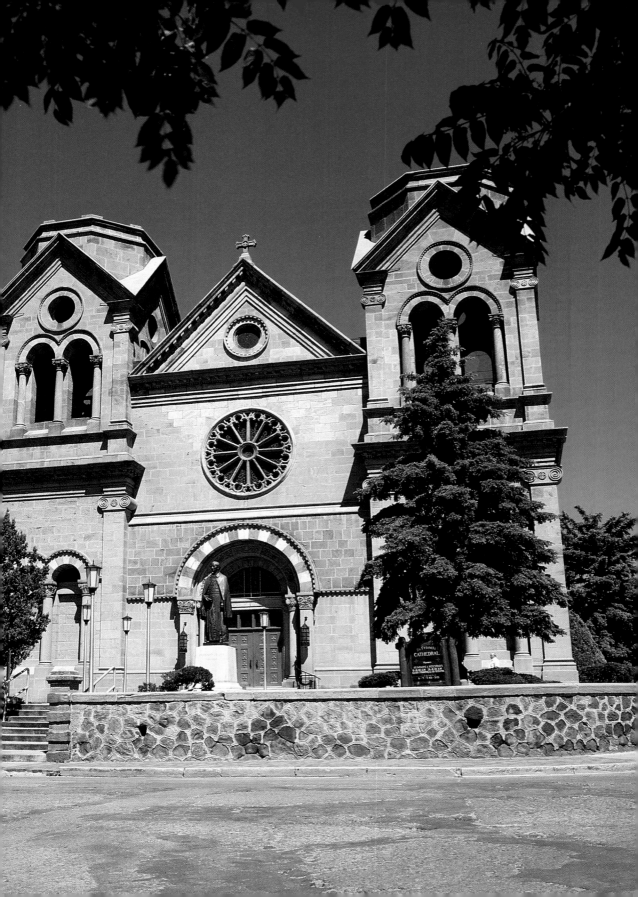

TEXAS

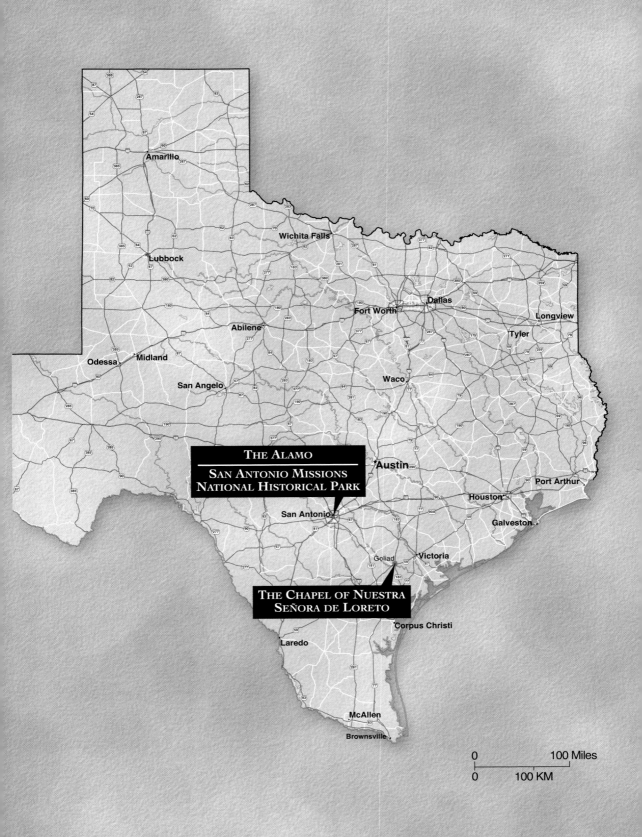

THE ALAMO

SAN ANTONIO MISSIONS
NATIONAL HISTORICAL PARK

THE CHAPEL OF NUESTRA
SEÑORA DE LORETO

THE CHAPEL OF NUESTRA SEÑORA DE LORETO ———

Presidio la Bahía, U. S. Highway 183, Goliad, Texas 77963

PHONE: 361-645-3752

HOURS: Daily

ADMISSION: No fee charged

WHEELCHAIR ACCESSIBLE: Limited access

WEBSITE: www.presidiolabahia.org

In 1721 Spain established a military post in the ruins of LaSalle's Fort St. Louis on the Lavaca Bay of the Gulf of Mexico. By the time of the American Revolution, soldiers from this fort joined the Spanish Army in fighting the British. The fort's chapel was named Nuestra Señora de Loreto in honor of the European shrine of the Virgin Mary that was the most often visited shrine in Europe until Lourdes became the most popular in the mid-1800s. The design of the chapel varies little from that of the fort itself, but the chapel does include pinnacles on the bell tower and a niche in the arched front. Standing in the niche is the statue of the Virgin of Loreto as sculpted by Lincoln Borglum, the son of the sculptor of Mount Rushmore. In 1835, the chapel served as the signing place of the first Declaration of Texas Independence. Several months later, Colonel James W. Fannin and 352 of his troops were killed at the fort by Mexican forces in what became known as the Goliad Massacre.

THE ALAMO ———

300 Alamo Plaza, San Antonio, Texas 78299

PHONE: 210-225-1391

HOURS: Daily; closed Christmas Eve and Christmas

ADMISSION: No fee charged

WHEELCHAIR ACCESSIBLE: Limited access

WEBSITE: www.thealamo.org

The little church that every American knows as the Alamo began its life under the name Mission San Antonio de Valero in 1724. In 1793, San Antonio's missions were secularized and Mission San Antonio de Valero ceased operating as a church; in the beginning of the nineteenth century, the mission became Spanish military barracks and eventually the compound became known as the Village of the Alamo Company, later shortened to "the Alamo." It continued operating as a Mexican military barracks after Mexico declared its independence from Spain in 1821. San Antonio was twice fought over in the Texas Revolution (1835–1836), with the Alamo playing an important role in the town's defense. In December of 1835, Texan forces captured the town, and General Antonio Lopez de Santa Anna's army laid siege to the Alamo, determined to flush out the rebels. The Texans held out until the predawn hours of March 6, 1836, when Mexican soldiers overwhelmed their defenses and entered the church. By sunrise, the battle was over and more than two hundred soldiers were

Opposite: The Alamo

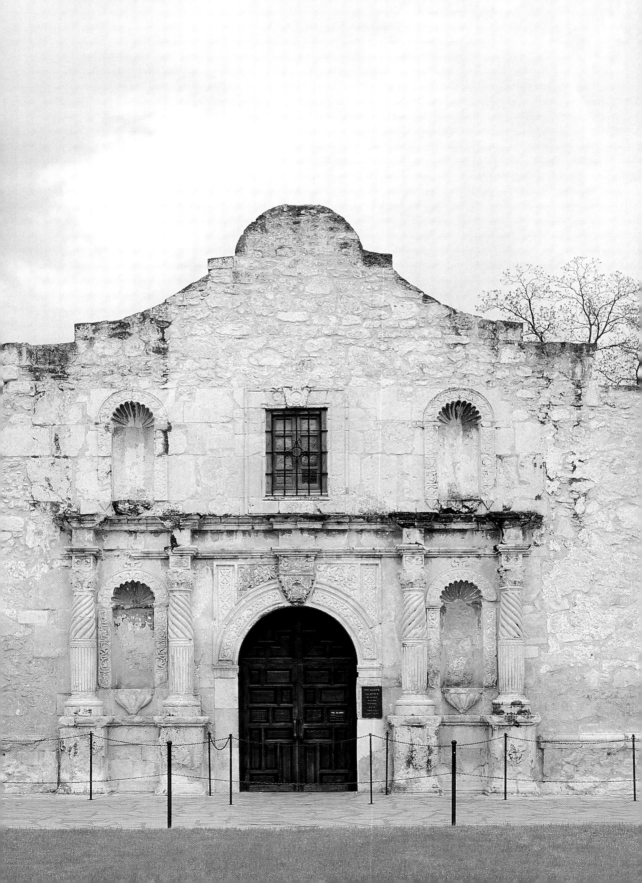

dead, including Jim Bowie, renowned knife fighter, and David Crockett, frontiersman and former congressional representative from Tennessee. Visitors today can tour the old mission and view exhibits on the Texas Revolution. An outdoor exhibit called The Wall of History takes visitors through the Alamo's nearly three-hundred-year-long history. The church and the Long Barrack remain from the original fort. In the church, visitors can view the faded frescoes that were painted on the sacristy walls when the mission was still active. The Long Barrack Museum and Library contains artifacts from the Republic of Texas and exhibits on the Battle of the Alamo.

SAN ANTONIO MISSIONS NATIONAL HISTORICAL PARK

2202 Roosevelt Avenue, San Antonio, Texas 78210
PHONE: 210-932-1001
HOURS: Daily; closed Thanksgiving, Christmas, and New Year's Day
ADMISSION: No fee charged
WHEELCHAIR ACCESSIBLE: Full access
WEBSITE: www.nps.gov/saan

Between 1718 and 1731 a chain of missions was built by the Spanish along the San Antonio River. Four of these missions—Mission Concepcion, Mission San Juan, Mission Espada, and Mission San Jose—are preserved within what is now called San Antonio Missions National Historical Park. These missions not only remain active as houses of worship but also serve as educational monuments to a

San Antonio Missions National Historic Park

significant time in Texas history. In the eighteenth century, these missions formed the greatest concentration of missions in all of North America. The Spanish missions in Texas were built with the dual objective of spreading the Catholic faith and expanding the Spanish claim north of Mexico. Of the many sites worth noting are Mission San Jose's "Rose Window," a distinctive example of Spanish Colonial architectural art in America. Also at Mission San Jose is the park's main Visitor Center, which includes a museum where visitors can peruse the artifacts and exhibits that tell about the native people and the founding of the mission by

the Spanish. At Mission Espada are remnants of the Spanish irrigation system that brought large scale agriculture to the area. The main ditch, or the *acequia madre,* continues to carry water to the mission. The Visitor Information Station at Mission Espada includes an exhibit on ranching in the missions.

San Antonio Missions National Historic Park, detail

NEW MEXICO

& ARIZONA

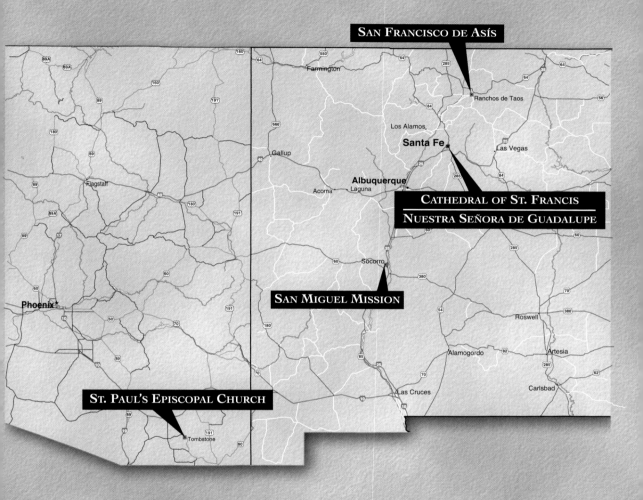

San Francisco de Asís

Cathedral of St. Francis
Nuestra Señora de Guadalupe

San Miguel Mission

St. Paul's Episcopal Church

0 100 Miles

0 100 KM

San Francisco de Asís Church

60 St. Francis Plaza, Highway 68, Ranchos de Taos, New Mexico

PHONE: 505-758-2754

HOURS: Daily; please call ahead

ADMISSION: Donation requested

WHEELCHAIR ACCESSIBLE: Full access

WEBSITE: None

San Francisco de Asís Church in Ranchos de Taos is an adobe church that resembles a work of sculpture rather than a church building. Built in the early years of the nineteenth century, the church is recognized the world over thanks to the many artists, particularly Georgia O'Keeffe as well as members of the Taos artists colony, who have tried to capture the unique beauty of its adobe exterior. Visitors will want to see the unusual painting by Henri Alut, done in the early 1900s. Depicting Jesus on the shore of the Sea of Galilee, the painting becomes luminescent in the dark and a cross appears over Jesus' shoulder. The church has also been a frequent subject of photographer Ansel Adams. The church also maintains a gift shop.

Cathedral Church of St. Francis of Assisi

131 Cathedral Place, Sante Fe, New Mexico 87504

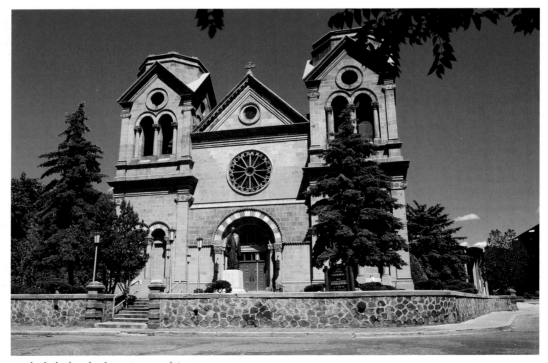

Cathedral Church of St. Francis of Assisi

Opposite: San Francisco de Asís Church

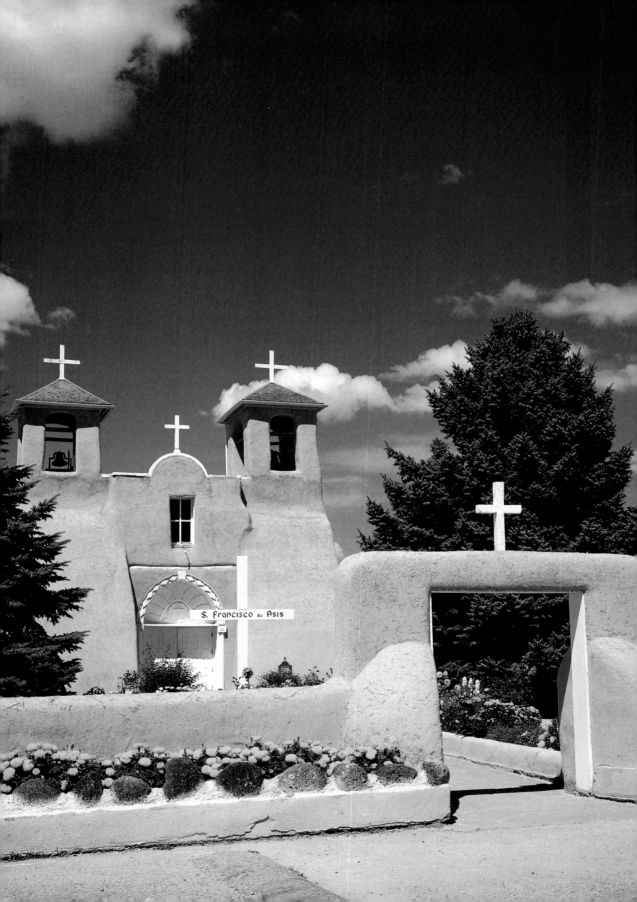

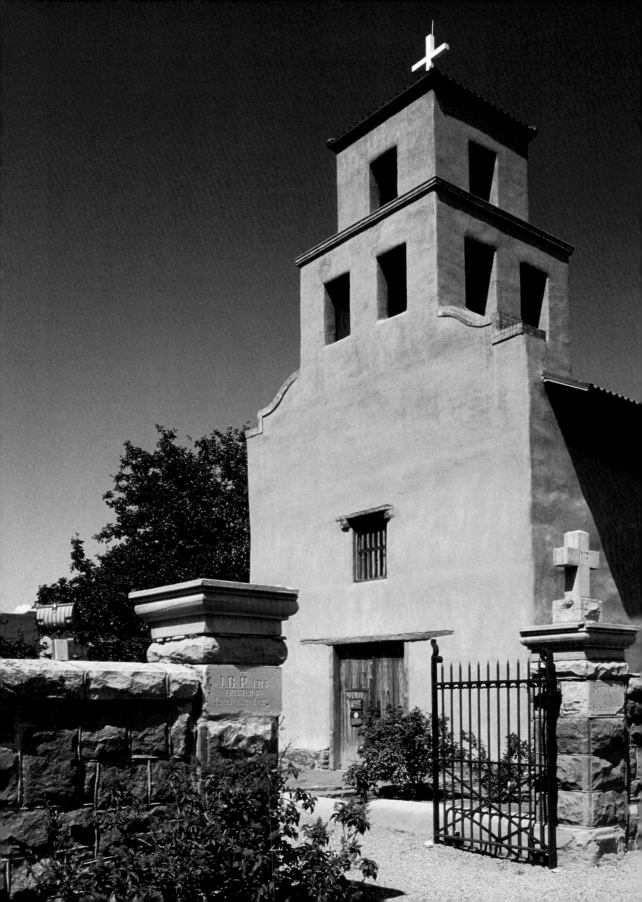

PHONE: 505-982-5619

HOURS: Daily

ADMISSION: No fee charged

WHEELCHAIR ACCESSIBLE: Limited access

WEBSITE: None

Novelist Willa Cather wrote about the Cathedral of St. Francis and Archbishop Lamy's life and work in her book *Death Comes for the Archbishop*. The first church that stood on the site of the present-day Cathedral Church of St. Francis of Assisi was Our Lady of the Assumption, built in 1610 by Spanish colonists. A larger one was built in 1631, which was then destroyed during the Pueblo Rebellion of 1680. The fourth church, built in 1717, was named the Church of St. Francis of Assisi. Bishop Jean Baptist Lamy came to the Church of St. Francis of Assisi in 1851 after New Mexico had been annexed to the United States, and his remains are interred beneath the altar of the new cathedral. A small wooden statue of the Virgin Mary stands in a small chapel of the cathedral and survives as the oldest representation of the Madonna in the country. Visitors can also see memorial statues of Archbishop Lamy, St. Francis, and Kateri Tekakwitha as well as artwork that dates to 1710 by Pasqual Perez. The cathedral also includes a stone labyrinth in the Chartres style.

Nuestra Señora de Guadalupe

100 Guadalupe Street, Sante Fe, New Mexico 87501

PHONE: 505-988-2027

HOURS: Monday through Saturday; closed weekends November through April

ADMISSION: No fee charged

WHEELCHAIR ACCESSIBLE: No access

WEBSITE: None

Nuestra Señora de Guadalupe church was built in 1781 and is the oldest shrine to Our Lady of Guadalupe in the United States. The church serves today as an art and history museum, which includes Mexican baroque paintings, Italian Renaissance paintings, and the Archdiocese of Sante Fe's collection of New Mexican *santos* (carvings of the saints). The shining jewel of this museum is *Our Lady of Guadalupe*, a 1783 oil painting by José de Alzibar, one of Mexico's most renowned artists. The site also includes a meditation chapel, pictorial history room, and a botanical garden that includes plants of the Holy Land.

San Miguel Mission

403 El Camino Real, Socorro, New Mexico 87801

PHONE: 505-835-1620

HOURS: Daily

Opposite: Nuestra Señora de Guadalupe

ADMISSION: No fee charged
WHEELCHAIR ACCESSIBLE: Full access
WEBSITE: www.sdc.org/~smiguel/

San Miguel Mission was built on the old Sante Fe Trail in 1598. The original mission was almost completely destroyed during the Pueblo Rebellion of 1680, but one wall remains from the 1598 building. The rebuilt mission with its twin steeples dates to 1821 and includes a number of artifacts from the earlier missions. No longer hanging in the tower but displayed on the mission grounds is an ancient bell from Spain that was cast in 1356 and includes the inscription, "St. Joseph, pray for us." The legend of the bell relates the story that it rang out the birth of Christianity in the lands above and below the Rio Grande.

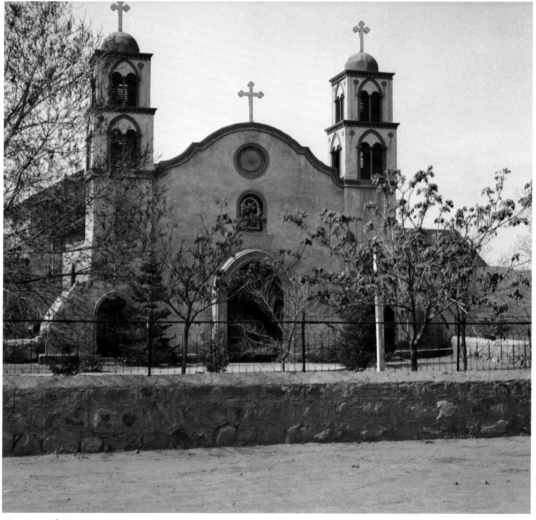

San Miguel Mission

ST. PAUL'S EPISCOPAL CHURCH

19 N. Third Street, Tombstone, Arizona 85638

PHONE: None

HOURS: Daily; inquire at the rectory, next to the church

ADMISSION: No fee charged

WHEELCHAIR ACCESSIBLE: Limited access

WEBSITE: None

The oldest Protestant church in Arizona, the congregation of St. Paul's began in 1881 during the instability of the Wild West and survived in a town with a legendary reputation of drinking, gambling, and fighting. Worship services were first held in a storeroom and then in the old courthouse before a church building was erected. Rev. Endicott Peabody served as the one of the earliest pastors of St. Paul's Episcopal and later went on to become headmaster at Massachusett's Groton School and officiate at the wedding of Franklin D. and Eleanor Roosevelt. Sheriff Wyatt Earp also attended services at St. Paul's. The church boasts eight original stained glass windows that were installed during the initial construction in 1882.

WEST

As is true of the Southwest, it is the Spanish missions, the first permanent European settlements in California, that leap to mind when considering the churches of the West. Twenty-one missions were established in California, nine of those by Father Junipero Serra, a pivotal figure in the Spanish colonization of the area. Responsible for the conversion to Christianity of hundreds of thousands of Native Americans, the missions survived Spanish rule, Mexican independence, and the establishment of statehood for California. An ocean away in Hawaii, the church buildings speak of European influence in their design, but their materials, such as coral and lava rock, echo the islands they occupy. From the missions of California to the cathedral of the Hawaiian royal line, the churches of this region tell an intriguing story of expansion and influence.

CALIFORNIA

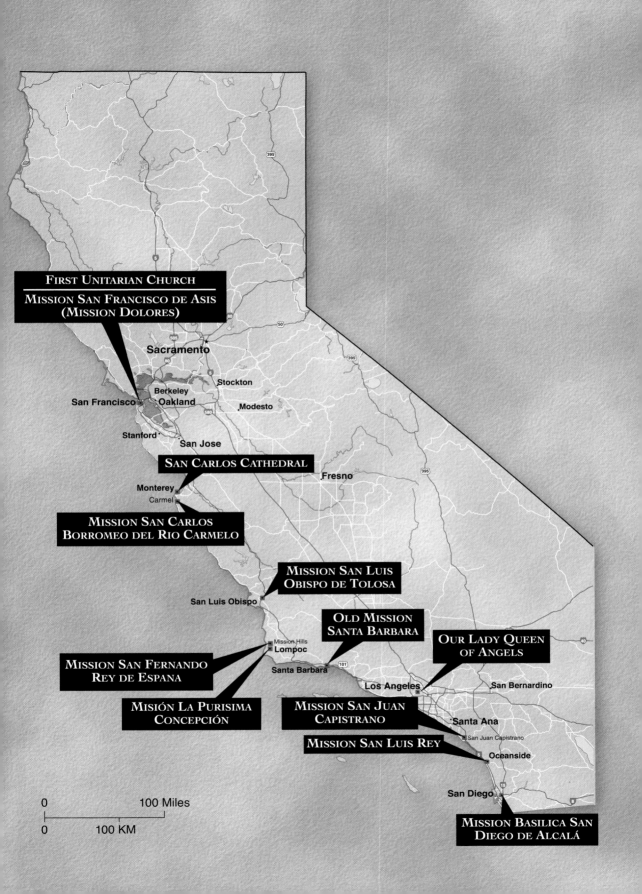

FIRST UNITARIAN CHURCH
MISSION SAN FRANCISCO DE ASIS
(MISSION DOLORES)

Sacramento

Stockton

Berkeley
San Francisco Oakland

Modesto

Stanford
San Jose

SAN CARLOS CATHEDRAL

Fresno

Monterey
Carmel

MISSION SAN CARLOS
BORROMEO DEL RIO CARMELO

MISSION SAN LUIS
OBISPO DE TOLOSA

San Luis Obispo

OLD MISSION
SANTA BARBARA

OUR LADY QUEEN
OF ANGELS

Mission Hills
Lompoc

MISSION SAN FERNANDO
REY DE ESPANA

Santa Barbara

Los Angeles San Bernardino

MISIÓN LA PURISIMA
CONCEPCIÓN

MISSION SAN JUAN
CAPISTRANO

Santa Ana

San Juan Capistrano

MISSION SAN LUIS REY

Oceanside

0 100 Miles

0 100 KM

San Diego

MISSION BASILICA SAN
DIEGO DE ALCALÁ

MISSION SAN CARLOS BORROMEO DEL RIO CARMELO

3080 Rio Road, Carmel, California
PHONE: 408-624-1271
HOURS: Daily; closed Christmas
ADMISSION: No fee charged
WHEELCHAIR ACCESSIBLE: Limited access
WEBSITE: None

It is said that this mission, known as Mission Carmel, was the favorite of Father Junipero Serra, the Father President of the California mission system. Father Serra, who was beatified by the Catholic Church in 1988, is buried here on the mission grounds. Built in 1797, Carmel is one of only a handful of missions built in stone. The Carmel mission is distinctive for its Moorish design, its stone ceiling arches, and a star window. Like so many of the missions, Carmel began to fall into disrepair after secularization, but was saved by a restoration movement begun by poet Robert Louis Stevenson. Eventually the church and quadrangle were restored. A side chapel includes a statue of Mary brought from Spain by Father Serra. Serra's rustic room is recreated as is the mission's library—the first in the state of California.

MISIÓN LA PURISIMA CONCEPCIÓN (LA PURISIMA MISSION STATE HISTORIC PARK)

2295 Purisima Road, Lompoc, California 93426
PHONE: 805-733-3713
HOURS: Daily
ADMISSION: Nominal fee
WHEELCHAIR ACCESSIBLE: Limited access
WEBSITE: www.lapurisimamission.org

The eleventh of California's twenty-one missions, Misión La Purisima was founded in 1787 and served as a frontier colony for a handful of Spanish and Mexican settlers and a new home for more than one thousand Native Americans. For a quarter of a century the mission grew and prospered, until the great earthquake and drenching rains of 1812, which destroyed the mission. After rebuilding, La Purisima Mission struggled to survive without support and supplies during the Mexican Revolution, and in 1824, the Chumash Indians rebelled against the abuses of the Mexican soldiers. Ten years later, the missions were removed from the control of the Catholic Church when Mexico enacted secularization. Today, La Purisima Mission is a State Historic Park and the most fully reconstructed California mission. Costumed docents and park staff recreate mission life with living history displays on special days.

Opposite: Mission San Carlos Borromeo del Rio Carmelo

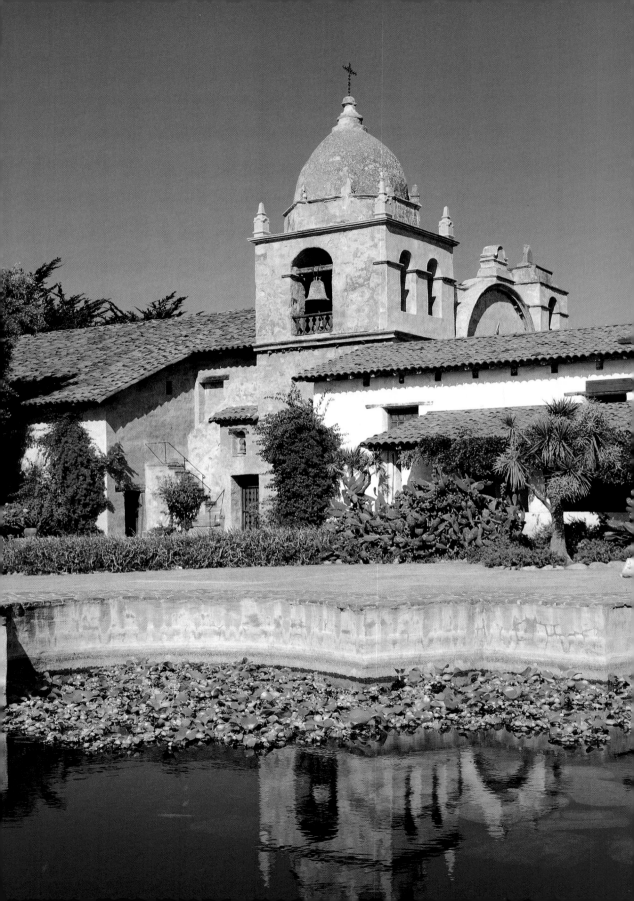

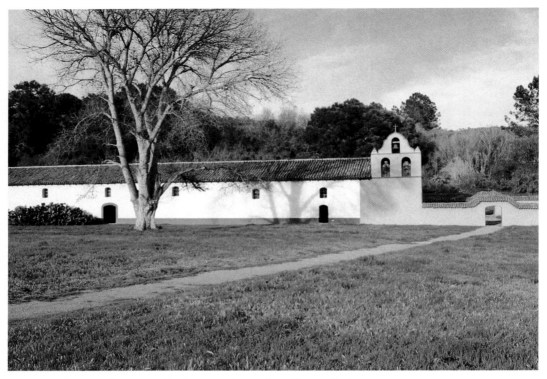

Misión La Purisima Concepción (La Purisima Mission State Historic Park)

OUR LADY QUEEN OF ANGELS CATHOLIC CHURCH

535 N. Main Street, Los Angeles, California 90012
PHONE: 213-629-3101
HOURS: Daily
ADMISSION: No fee charged
WHEELCHAIR ACCESSIBLE: Limited access
WEBSITE: www.laplacita.org

Also known as Old Plaza Church, Our Lady Queen of Angels Catholic Church began as part of *El Pueblo de Los Angeles,* a pueblo founded by Spain to serve the Spanish soldiers guarding the territory. El Pueblo is now a Historic Monument and encompasses a number of historic buildings. Built in 1784, the church survives as the oldest Catholic church in the city and continues to serve as an active church. The interior of Our Lady Queen of Angels Catholic Church includes a number of religious paintings as well as murals that cover the ceiling. The Spanish origins of the church can be viewed in the interior decorations of wrought iron and gold leaf.

MISSION SAN FERNANDO REY DE ESPANA

15151 San Fernando Mission Boulevard, Mission Hills, California 91345

PHONE: 818-361-0186

HOURS: Daily

ADMISSION: Nominal fee

WHEELCHAIR ACCESSIBLE: Full access

WEBSITE: None

Mission San Fernando Rey de Espana has survived Spanish rule, Mexican independence, the ensuing secularization of the missions, and finally, California statehood. At its most successful time during the early 1800s, the mission housed more than one thousand converts. During secularization, the mission served as a stagecoach station, warehouse, stable, and a hog farm. Returned to the Catholic church in 1863 by President Abraham Lincoln, the mission became an active church in 1923 and many of its buildings were restored. Explorer John C. Frémont stopped at Mission San Fernando on his way north, as did pioneer John Sutter, whose later discovery of gold on his land precipi-

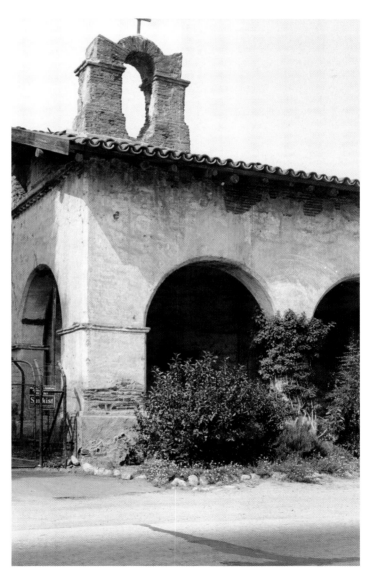

Mission San Fernando Rey de Espana

tated the California Gold Rush. The chapel, built in 1797, includes a four-hundred-year-old mahogany altar from Spain. The nineteen-room *convento* building of the mission survives as the oldest two-story adobe structure in California and includes a number of artifacts that date back to the 1800s.

SAN CARLOS CATHEDRAL/ THE ROYAL PRESIDIO CHAPEL OF SAN CARLOS BORROMEO DE MONTEREY

500 Church Street, Monterey, California 93940

PHONE: 831-373-2628

HOURS: Daily

ADMISSION: Nominal fee

WHEELCHAIR ACCESSIBLE:
Access to most places

WEBSITE:
www.sancarloscathedral.com

Founded in 1770 by Fr. Junipero Serra, San Carlos Cathedral stands as the oldest church in continuous use in California. The present building was completed in 1794. In its original function as the Royal Presidio Chapel, San Carlos Cathedral served as the place of worship for the Spanish governors and representatives from the King of Spain. When San Carlos was designated a cathedral in 1968, it became the smallest cathedral in the country.

San Carlos Cathedral

MISSION SAN LUIS REY

4050 Mission Avenue, Oceanside, California 92057

PHONE: 760-757-3651

HOURS: Daily; closed Good Friday, Easter, Thanksgiving Day,
Christmas Day, and New Year's Day

ADMISSION: Nominal fee; no fee charged for children under age seven

WHEELCHAIR ACCESSIBLE: Limited access

WEBSITE: www.sanluisrey.org

Mission San Luis Rey was founded by Father Fermin Francisco de Lasuen, President of the California Missions following Father Serra, and earned the nickname "King of the Missions." The mission church was constructed by the Luiseño Indians from 1811 until its completion in 1815, and the mission cemetery has been in continuous use since the mission was first founded in 1798. An Indian Memorial in the cemetery pays homage to the Luiseño Indians who were the mission's first converts. Nearly three thousand Native Americans are buried here as well as many mission priests. The museum on site displays exhibits of early mission life and displays artifacts from several periods, including Native American, Spanish Mission, Mexican Secularization, and American Military. Visitors can stop by the Quadrangle Patio to see the first pepper tree grown California, planted from seeds brought from Peru in 1830, which continues to thrive today.

MISSION BASILICA
SAN DIEGO DE ALCALÁ

10818 San Diego Mission Road, San Diego, California 92108-2429

PHONE: 619-283-7319

HOURS: Daily; tours by reservation only; for tour reservations,
call 858-565-9077 between noon and 2 P.M. on Monday or Thursday

ADMISSION: Nominal donation requested

WHEELCHAIR ACCESSIBLE: Limited access

WEBSITE: www.missionsandiego.com

In 1769, Spanish Father Junipero Serra founded Mission San Diego, the first of the Spanish missions in upper California, sometimes called the "Plymouth Rock" of the West Coast. In 1775, hundreds of Native Americans from the east, angry about the presence of the Spanish, burned the mission buildings and killed Father Luis Jáyme. Father Jáyme is considered California's first Christian martyr and is buried inside the present mission church. After the Mexican-American War, the mission church was used as barracks by the U. S. Army. Visitors to the mission today can see parts of the original church structure and can tour the Father Luis Jáyme Museum, which includes Native American art as well as documents and artifacts from mission

life. Pope Paul VI designated the Mission Basilica San Diego de Alcalá as a Minor Basilica in 1976. The mission church serves an active parish church today.

FIRST UNITARIAN CHURCH

1187 Franklin Street, San Francisco, California 94102
PHONE: 415- 776-4580
HOURS: Daily
ADMISSION: No fee charged
WHEELCHAIR ACCESSIBLE: Limited access
WEBSITE: www.uusf.org

Organized in 1850, the First Unitarian Universalist Church of San Francisco dedicated the present church sanctuary in 1889. In the churchyard lies the white marble sarcophagus of Thomas Starr King, who was pastor of First Unitarian during the Civil War. King was an abolitionist who appealed to Californians to devote money and energies to the fight against slavery. King has been honored by having two American mountains named after him, one in Yosemite National Park and another near his birthplace in New Hampshire's White Mountains. One statue of King stands in San Francisco's Golden Gate Park; another can be seen in the Statuary Hall of the United States Capitol.

MISSION DOLORES/MISSION SAN FRANCISCO DE ASIS

3321 Sixteenth Street, San Francisco, California 94114
PHONE: 415-621-8203
HOURS: Daily
ADMISSION: Nominal fee
WHEELCHAIR ACCESSIBLE:
Access to most places
WEBSITE: www.missiondolores.citysearch.com;
www.graphicmode.com/missiondolores

Mission Dolores was founded in 1776 by Mexican soldiers and colonists on the site of the Ohlone Indian Village of Chutchui. The soldiers soon moved on to the Presidio of San Francisco while the missionaries guided the local Indians in building a church, erected in 1782, which today stands as the oldest existing church nave in the state. Mission Dolores forms the core of the city of San Francisco, which grew up around the mission. Mission

Mission Dolores

Dolores includes significant baroque art pieces from Mexico, including *The Great Retablos*, which spans the entire front wall behind the altar.

MISSION SAN JUAN CAPISTRANO

Junction of Ortega Highway and Camino Capistrano,
San Juan Capistrano, California 92693
PHONE: 949-234-1300
HOURS: Daily; closed Thanksgiving, Christmas, and Good Friday afternoon
ADMISSION: Nominal fee
WHEELCHAIR ACCESSIBLE: Limited access
WEBSITE: www.missionsjc.com

Mission San Juan Capistrano

In 1777, Mission San Juan Capistrano was built—a small adobe building that is still used today and is considered the oldest church in California. This church is often called "Father Serra's Church" because it is the only remaining building where Serra is known for certain to have said Mass. In 1910, Father St. John O'Sullivan came to San Juan Capistrano and worked to restore its buildings and gardens. He invited both established and novice artists to San Juan Capistrano, among whom were the Belgian portraitist Joseph Kleitsch; Gutzon Borglum, best known for his Mount Rushmore sculpture, and his wife, Elizabeth; Charles Percy Austin, who painted the first wedding of silent screen star Mary Pickford; Colin Campbell Cooper, Fannie Duval, Franz Bischoff, Alson Clark, and William Wendt. Visitors today can listen to the tolling of mission bells as they tour the ten-acre grounds surrounded by adobe walls. Tours include the Serra Chapel, the Padres Quarters, a Soldiers Barracks, the Cemetery, and the remains of the Great Stone Church.

SAN LUIS OBISPO DE TOLOSA

782 Monterey Street, San Luis Obispo, California 93401
PHONE: 805-543-6850
HOURS: Daily
ADMISSION: No fee charged
WHEELCHAIR ACCESSIBLE: Limited access
WEBSITE: www.missionsanluisobispo.org

Founded by Father Junipero Serra in 1772, the San Luis Obispo de Tolosa mission survived the Mexican revolt against Spanish rule between 1810 and 1822 but very nearly crumbled after Mexico decreed the missions secular and used the buildings as a jail and courthouse. When California joined the United States in 1848, the mission returned to the Catholic diocese and has functioned as a parish church ever since. The original mission church dates back to 1794. A museum on-site includes historical photographs and other artifacts.

OLD MISSION SANTA BARBARA

2201 Laguna Street, Santa Barbara, California 93105
PHONE: 805-682-4149
HOURS: Daily; closed Easter, Thanksgiving, and Christmas Day
ADMISSION: Nominal fee
WHEELCHAIR ACCESSIBLE: Limited access
WEBSITE: www.sbmission.org

Old Mission Santa Barbara has been called one of the best preserved missions in the state and one of the most beautiful, hence its popular nickname "Queen of the Missions." The 1820s mission includes extensive water works with two reservoirs, remains of aqueducts, a

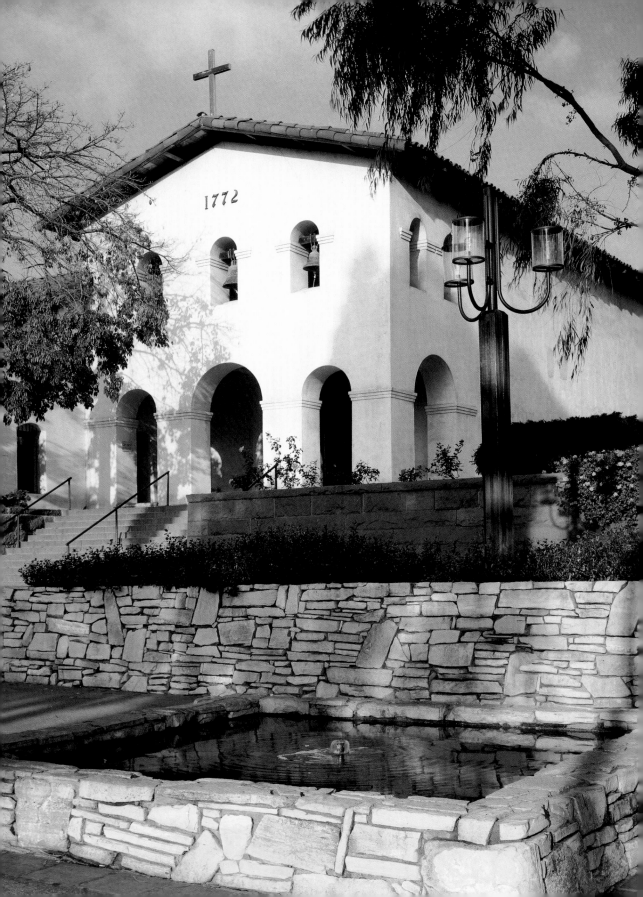

filter house, and a grist mill, all of which were built by the local Chumash Indians. The mission also includes an archive-library that houses three thousand original documents gathered from all twenty-one of the California Franciscan missions and includes maps, paintings, and sketches. The museum on the grounds includes exhibits of old mission artifacts, Chumash Indian artifacts, and oil paintings.

Old Mission Santa Barbara

Opposite: San Luis Obispo de Tolosa

HAWAII

OAHU

ST. PHILOMENA CATHOLIC CHURCH

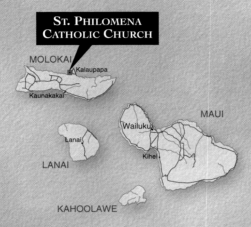

MOLOKAI

Kalaupapa

Honolulu

Kaunakakai

CATHEDRAL OF ST. ANDREW

KAWAIAHAO CHURCH

MAUI

Wailuku

Lanai

Kihei

LANAI

KAHOOLAWE

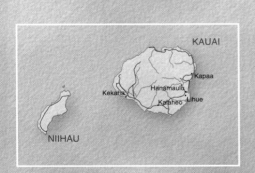

KAUAI

Kapaa

Kekaha

Hanamaulu

Kalaheo Lihue

NIIHAU

HAWAII

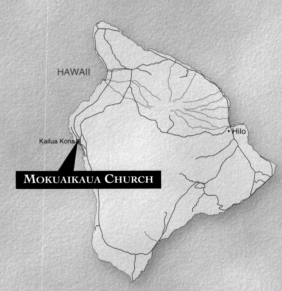

Kailua Kona

Hilo

MOKUAIKAUA CHURCH

0 100 Miles

0 100 KM

THE CATHEDRAL CHURCH OF ST. ANDREW ————

Queen Emma Square, Honolulu, Hawaii 96813

PHONE: 808-524-2822
HOURS: Daily
ADMISSION: No fee charged
WHEELCHAIR ACCESSIBLE: Limited access
WEBSITE: www.standrewscathedral.net

When King Kamehameha IV and Queen Emma invited the Episcopal Church to come to Hawaii in 1861, the Episcopal Church became the only religion expressly invited by Hawaiian royalty to the islands. Services were first conducted in a Protestant church building no longer in use. The church was named St. Andrew's Cathedral by King Kamehameha V in 1863, when his brother King Kamehameha IV died on St. Andrew's Day of that year. Even though the corner-stone for the present building was laid in 1867, the cathedral was not finished until 1958. Stained glass windows in the church memorialize King Kamehameha IV and Queen Emma, Queen Emma's baptism, and several of the church's first bishops. The cathedral today offers a Sunday Mass in native Hawaiian language and Hawaiian church music.

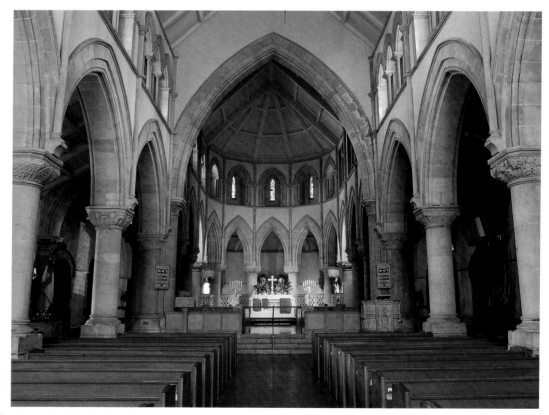

The Cathedral Church of St. Andrew

Opposite: Kawaiahao Church

KAWAIAHAO CHURCH

957 Punchbowl Street, Honolulu, Hawaii 96813

PHONE: 808-522-1333

HOURS: Monday through Friday

ADMISSION: No fee charged

WHEELCHAIR ACCESSIBLE: Limited access

WEBSITE: None

Kawaiahao Church was built between 1836 and 1842 and was the first Christian church in Hawaii. It is often referred to as the "Westminster Abbey of Hawaii," and while its architecture speaks of New England and Old England as well, Kawaiahao's construction and materials are distinctly Hawaiian: the building is made from fourteen thousand slabs of coral quarried by hand from underwater reefs. From the time of its dedication, Kawaiahao Church was the location for Hawaii's royal coronations, christenings, and other ceremonies. In a tomb inside the church lie King Lunalilo, the first elected monarch of Hawaii, and his father, Charles Kanaina. In the church's graveyard are buried many early missionaries. Next door to the church is the Mission House Museum, a living museum. The museum buildings were built by the first Christian missionaries to come to Honolulu and are the oldest structures in the city.

MOKUAIKAUA CHURCH

75-5713 Alii Drive, Kailua-Kona, Hawaii 96740

PHONE: 808-329-0655

HOURS: Daily

ADMISSION: No fee charged

WHEELCHAIR ACCESSIBLE: Full access

WEBSITE: www.mokuaikaua.org

Mokuaikaua was the first Christian missionary church built in the state of Hawaii. King Kamehameha II donated the land to the missionaries for the initial church, which was one of the king's thatched homes. The current structure was built by Governor Kuakini in 1835 and included lava rock from a fifteenth-century temple that once stood on the adjacent parcel of land. The church's first missionaries included Asa and Lucy Thurston of New England; portions of Lucy's diary can be viewed in the sanctuary of the church. The interior of Mokuaikaua Church includes native koa and ohia woods. The church includes a small exhibit, which displays artifacts and memorabilia from the early 1800s, including a photograph of the church when it was surrounded by hundreds of thatched homes. The church includes a model of the *Brig Thaddeus*, the ship upon which the first missionaries sailed 157 days from Boston Harbor to Kailua-Kona in 1819.

St. Philomena Catholic Church

Kalaupapa Leprosy Settlement, Kalaupapa National Historical Park, Kalaupapa, Hawaii 96742
Phone: 808-567-6802
Hours: Monday through Friday
Admission: No fee charged
Wheelchair Accessible: No access
Website: www.nps.gov/kala

The small wooden structure that served as St. Philomena Catholic Church in 1873 was twice enlarged by Father Damien, a Belgian priest, on the Kalaupapa Leprosy Settlement on the island of Moloka'i. When leprosy, now called Hanson's disease, began to spread throughout the Hawaiian islands in 1866, the Board of Health took those afflicted away from their families and friends and sent them to the isolated settlement on the Kalaupapa Peninsula of Moloka'i. Some Hawaiians, called *na kokua*, chose to accompany their loved ones into isolation, but many of the patients depended on the charity of religious workers such as Father Damien and Mother Marianne Cope from the Sisters of St. Francis in Utica, New York. Father Damien eventually contracted the disease, which led to his death in 1889. Plaques outside the church describe the church's history, construction, and its connection to Father Damien. The restored St. Philomena Catholic Church stands on the windward side of the peninsula in Kalawao. The nearby graveyards are filled with the many who succumbed to leprosy in the 1800s.

Mokuaikaua Church

INDEX

PHOTO CREDITS